Pablo Neruda's Ship Figureheads

MARITIME CURRENTS: HISTORY AND ARCHAEOLOGY

Series Editor

GENE ALLEN SMITH

Editorial Advisory Board

JOHN F. BEELER

ALICIA CAPORASO

ANNALIES CORBIN

BEN FORD

INGO K. HEIDBRINK

SUSAN B. M. LANGLEY

NANCY SHOEMAKER

JOSHUA M. SMITH

WILLIAM H. THIESEN

Pablo Neruda's Ship Figureheads

A Poet-Collector's Muses and Companions

Carol A. Olsen

Foreword by Fernando Sáez Garcia

The University of Alabama Press

Tuscaloosa

The University of Alabama Press
Tuscaloosa, Alabama 35487–0380
uapress.ua.edu

Copyright © 2025 by Carol A. Olsen
Foreword by Fernando Sáez Garcia © 2025 by the Pablo Neruda Foundation
All rights reserved.

Inquiries about reproducing material from this work should be addressed
to the University of Alabama Press.

Typeface: Minion Pro

Cover image: Cymbelina figurehead, face detail; © Fundación Pablo Neruda
Cover design: Terrell Harris

Cataloging-in-Publication data is available from the Library of Congress.
ISBN: 978-0-8173-2244-1 (cloth)
ISBN: 978-0-8173-6215-7 (paper)
E-ISBN: 978-0-8173-6572-1

To Lee

Contents

Illustrations

Foreword

FROM THE NUMEROUS and varied collections of Pablo Neruda spread across his three museum houses, the figureheads (*mascarones*) adorning the living room and dining area of Isla Negra undeniably possess a unique allure, both in their individual appeal and their arrangement, heightening the theatrical, phantasmagorical, and impressive essence of these pieces. The sea, rocks, voyages, sand, and all elements associated with navigation hold an enduring significance in Pablo Neruda's works and his diverse collections.

Conch shells, compasses, telescopes, as well as doors, ceilings, and windows, all hinting at their nautical origins, are prevalent in his poetry and the exploration of his three museum houses. This underscores that Isla Negra and La Sebastiana in Valparaíso represent two dimensions of the nearby sea, serving as witnesses to the profound impact of these images on the poet's life.

Carol Olsen's investigation in this book is truly exceptional, comprehensive, and captivating. With genuine dedication, she unravels the mysteries of these Nerudian figureheads (*mascarones*), delving into their origins, transfers, searches, and commercial negotiations, and the poet's fervent pursuit to be closely connected to all the adventures encapsulated within these enigmatic pieces.

For the Pablo Neruda Foundation, entrusted with safeguarding his legacy, this work stands as a magnificent contribution, unraveling the journey of the poet-collector.

Fernando Sáez Garcia
EXECUTIVE DIRECTOR
PABLO NERUDA FOUNDATION

Preface

THE DRAW OF watching ships of all sizes transit beneath the Golden Gate Bridge in San Francisco influenced my studies in art history and nautical archaeology when, for me, those academic disciplines repeatedly raised questions about how and why people around the world have, differently and intermittently, decorated hulls for at least five thousand years. A career in satellite communications for ships enabled me to travel, and I found some answers in worldwide maritime museums, as well as from a range of other resources. It also became clear that the search for answers regarding ship figureheads is persistently accompanied by a wealth of unknowable mysteries.

Key to my learning about nineteenth-century ship figureheads was an internship at Mystic Seaport Museum in Connecticut, home to one of the world's best figurehead collections, where, in the early 1980s the museum director, J. Revell Carr, hired me to write about the museum's figurehead collection for an upcoming monograph funded by the Mellon Foundation. John O. Sands, then curator at The Mariners' Museum and Park, also hired me to do ship figurehead research about its outstanding collection.

Giving life to this Neruda book was a 2013 gathering in Washington, DC, where friends casually mentioned they had recently seen poet Pablo Neruda's ship figurehead collection at a house museum in Isla Negra, Chile. Surprised I had never heard of it, I found it was barely covered in any published form. An inquiry to the Neruda Foundation elicited a quick reply from Collections Director Javier Ormeño Bustos, who invited me to examine the foundation's carvings if I ever made the trip to Chile, which I did in November 2015. Javier Ormeño Bustos personally drove me between Neruda house museums at Santiago and Isla Negra and Valparaiso, at times flooring the gas pedal of his car as we barely crested the narrow and immensely steep streets of Valparaiso. At Isla Negra, Neruda's former home resembles a ship with narrow passageways, with a ladder leading to the second story, and thick, overhead wood beams complementing his carved wood ship figureheads that dominate the living room.

Back in Santiago, Javier and I agreed that creating a timeline of Neruda's acquisition of figureheads would be important and yet after months in the

United States of my trying to resolve date and acquisition conflicts, an obvious thing occurred to me: Neruda was not a historian. Although he used figureheads—sometimes the same one in one story or another—he was loose with facts. I came to understand that I could not rely for my research on Neruda's memoirs, books, poems, or movie clips, so I started all over again, acknowledging the shifting sand on which this project rested, and I began to approach it anew.

Studying Neruda's carvings firsthand made me think of the countless times a nineteenth-century ship carver would have blown on those wood surfaces to remove bits of wood after fast, deft cuts with a razor-sharp steel chisel. I imagined how people on a ship and those in worldwide ports might react to one figurehead or another, and how each ship's crew likely came to look to its figurehead for luck. The social, political, economic, and ideological aspects of figureheads enrich the research experience; yet, beneath each figurehead there still remains some mystery that cannot quite be grasped.

Poetry attempts to magnify that mystery. Neruda's poems transport readers to surreal places to wholly expand our thinking about figureheads, particularly when he held as precious the very trees from which figureheads were carved. His verse creates otherworldly visions, such as a salt-tear figurehead grieving in mortuary waters, or one of great strength set up for all to see on land, or one he pitied as a dethroned queen. Glimpsing Neruda's ship figureheads as he tells us he does, is possible through his poems and stories, and those very strange places Neruda goes in his thinking about ship figureheads offer memorable journeys on which we all may travel.

Acknowledgments

In Chile, expert help from Pablo Neruda Foundation staff was generously provided to me. Most significantly I benefited from guidance by Javier Ormeño Bustos, director of collection and conservation, who expertly assisted me with respect to known information about Neruda's figureheads and figurehead-like décor pieces. His help has been immense. I also thank Fernando Sáez Garcia, executive director, for recognizing a need for this book when we spoke in 2015, and Dario Oses Moya, library director, for his help and knowledge of material resources. Thank you also to Carolina Rivas Cruz, director of Isla Negra Museum House, and to Carolina Briones Mendez, of the Neruda photographic archive, who uncovered new materials in the course of this study.

I also greatly appreciate the work of Lorena Ormeño Bustos, who in 2019 and 2020 photographed Neruda's ship figurehead collection at Isla Negra for the Pablo Neruda Foundation. That work was possible due to a grant to the Pablo Neruda Foundation from Fondo Mejoramiento Integral de Museos, Servicio Nacional del Patrimonio, and the photographs used here, that are so important to helping to tell this story, are shown with permission from the Pablo Neruda Foundation.

I am grateful to the people and organizations whose support made this book possible, particularly Gene Smith, series editor of the Maritime Currents: History and Archaeology publications at the University of Alabama Press, Dr. Alicia Caporaso, and University of Alabama Press Editor Dan Waterman. I also deeply thank my longtime friends Debby Rubin, Dan Sherbo, and Tom Nixon for making me aware of Neruda's figurehead collection in Chile.

At Texas A&M University's Nautical Archaeology Program, George F. Bass, J. Richard Steffy, and Frederick van Doorninck Jr. supported some of my earliest research into worldwide figureheads in relation to the history of seafaring. At the University of California, Berkeley, art historian Larry Silver encouraged my independent studies of ship figureheads, and at Mystic Seaport Museum in Mystic, Connecticut, J. Revell Carr employed me to research and write about that museum's ship figurehead collection for a Mellon

Foundation–funded book the museum published in 1984. These ship figurehead study opportunities gave me firm foundations for researching and communicating to a wide array of art and maritime audiences.

My salaried position as a ship figurehead consultant at The Mariners' Museum in Newport News, Virginia, existed thanks to Collections Curator John O. Sands, and I have benefited over the years from figurehead discussions at that museum with Jeanne Willoz-Egnor, director of collection management, and Lyles Forbes, vice president of collections.

In Canada, I am grateful to Beatriz Hausner for speaking with me about her childhood recollections of Neruda and, from Mexico, her mother Susana Wald corresponded with me about the family figurehead sold to Neruda.

At the National Maritime Museum in Valparaiso, Chile, in November 2015, I benefited from artifacts shown to me by Eduardo de Rivera Silva, who is now the museum's curator. I also thank Christophe Pollet, marine archaeologist with the Instituto de Arqueologia Nautica y Subacuatica (IANS) in Chile for information about the *Ambassador* figurehead.

Key institutions and invaluable staff include the following: the Library of Congress, Washington, DC, Motion Picture, Broadcasting, and Recorded Sound Division (Jerry Hatfield); The Mariners' Museum Library, formerly located at the Paul and Rosemary Trible Library on the campus of Christopher Newport University, Newport News, Virginia (Bill Barker, archivist); the State Library of South Australia (Chris Read, reference librarian).

At the Bostonian Society, Sira Dooley Fairchild, collection manager and exhibition coordinator, provided key information to me concerning a figurehead traditionally attributed to Isaac Fowle.

In 2017 at the National Gallery of Art, Washington, DC, Charlie Ritchie showed me all the original figurehead renderings in the Index of American Design, which included the so-called Commodore Perry, and in 2001 I had discussions with Deborah Chotner, assistant curator at the National Gallery of Art, regarding "Commodore Perry" as shown in the Index of American Design. At the National Gallery of Art Archives, I benefited from assistance provided to me by Michele Willens.

Capt. Greg Lemons kindly provided materials to me regarding the *Mary Celeste* ghost ship.

And in the United States I thank Dr. James Delgado, Dr. Laura Feller, John Fleckner, Janet Donahue, Sandi Amendola, Keith Fawcett, as well as Richard Hunter in England, for key conversations concerning ship carvings.

Material and literary resources at the following locations have been invaluable: Independence Seaport Museum, Philadelphia; Isla Negra House Museum, Chile; La Sebastiana House Museum, Valparaiso, Chile; La Chascona House Museum, Santiago, Chile; The Mariners' Museum and Park,

Newport News, Virginia; Museu de Marinha, Lisbon, Portugal; Mystic Seaport Museum, Mystic, Connecticut; National Gallery of Art Archives, Washington, DC; National Gallery of Art, Prints and Photographs, Washington, DC; New Bedford Whaling Museum, New Bedford, New Jersey; Newark Museum Archives, New Jersey; Old State House, Boston; US Naval Academy, Annapolis, Maryland; The Åland Maritime Museum, Finland; Norwegian Maritime Museum, Oslo; *America* figurehead private collection in Washington state; German Maritime Museum, Bremerhaven; Hellenic Maritime Museum, Athens; Naval and Oceanographic Museum in Rio de Janeiro, India House, New York City; Peabody Essex Museum, Salem, Massachusetts; Farnsworth Museum, Rockland, Maine; Valhalla Collection, Royal Museums Greenwich, Tresco, Isles of Scilly; South Street Seaport, New York City; and San Diego Maritime Museum.

Thank you to museums that make figureheads and other types of hull art prominent, which helps preserve otherwise largely overlooked sculptural history and cultural content. Those artifacts provide our best possible opportunities to understand and appreciate the work of talented and hard-working nineteenth- and twentieth-century ship carvers.

Most especially, I thank the love of my life, my partner Capt. Lee Black, for his cheerful and supportive encouragement throughout this book project.

Pablo Neruda in living room with collectibles. © Fundación Pablo Neruda.

Pablo Neruda's Ship Figureheads

Introduction

How Pablo Neruda Collected Ship Figureheads

POWERFUL CULTURAL AND ARTISTIC OBJECTS

A CANDID REMARK made fifteen years ago by a prominent curator of maritime and art history is still true today. Daniel Finamore of the Peabody Essex Museum in Salem, Massachusetts, which exhibits its own highly significant nineteenth-century ship figurehead collection, said, "Figureheads are at the nascent stage of scholarship and not many people really know a lot about attributions, that is, who carved what and what attributes relate to which carvers. I believe we'll figure it out a lot more in the future."[1] One purpose of this book is to raise awareness of Neruda's Chile-based collection of ship figureheads so that the myriad details of their surfaces, the investigated facts behind their salvation from obscurity, and their various meanings before and after use on a ship are able to contribute to the larger compendium of worldwide ship figurehead information.

A second purpose of this book is to see details of the larger-than-life persona of famous poet Pablo Neruda juxtaposed with his figureheads, and how his identity and history, along with aspects of his homeland of Chile, intertwine. As nautical archaeologist James P. Delgado points out, "Figureheads are not only important for heritage issues but they are powerful for their artistic and cultural associations."[2]

Prominent art historian Larry Silver notes that "Conventional art museums seldom present or preserve ship carvings." He adds, "For those interested in the subject, visit maritime museums. You don't have to be either a sailor or an art historian to delight in these glorious vestiges of a bygone era, and once you begin to notice them, your glance will eagerly go to the bows of any preserved sailing ships you encounter."[3] In that regard, a third primary

purpose of this book is to spark more general interest in hull art by offering powerful stories of its identity, meaning, and use, and to help raise awareness of how hull art has varied through time.

Pablo Neruda remains the primary focus of this book. He seemed to love the figureheads he collected, and he shaped their stories, real or imagined, in poems and prose, some examples of which are included in this book. But did Neruda also use figureheads to help shape some of his own persona in what was essentially a lifetime of public-relations outreach? He wanted the world to recognize him and find him an interesting character. In stories Neruda crafted about figureheads, he made himself a savior, a hero, a protector. He showed himself as worldly by procuring them in different countries, and as rich for being able to afford such things, and as the owner of a house strong enough to keep these special figures near him in a room with a large window with a view onto the Pacific near a tall, stone fireplace. Neruda spoke often about figureheads. He made sure people knew he wanted them, and his message was conveyed in his poetry and news articles, and through interviews for journals, newspapers, television, and film documentaries.

Neruda's comment that originality is overrated signals his comfort in borrowing ideas, examples of which will be brought to light. He had no compunction about altering information about figureheads as it suited him.[4] Neruda massaged his messages depending on his audience, and, as a writer, he offered the public what most successfully brought him attention. He needed for people to know him, and that meant keeping the public entertained. Neruda's figureheads helped him to stand out and be different. In a life that was already highly unusual because of his communist politics, dissidence, and international acclaim as a writer, Neruda made it seem that he shared the secrets of his figureheads with the public, but this research shows he likely did not.

This book delves into new areas with respect to Neruda's figureheads, including what information from him can be relied on, what we know from other people and written sources, and what information connects Neruda's carvings to other figureheads like them in the world.

Neruda's imaginative poetry to and about his figureheads does not substitute for documentation. The near-total absence of paperwork related to Neruda's figurehead purchases and the void of clear facts causes us to scrutinize his figureheads even more closely as art objects, ship remnants, and storytelling devices. Neruda may also have preferred to obscure information about some of his figureheads due to matters of personal ego, rivalries, and even political concerns about where he got them, since Neruda's collection may contain a figurehead from a ship that later came to be nationalized by Gen. Augusto Pinochet. This book seeks frank examination of what Neruda

says and sorts Neruda's carvings in order to address questions about where and how Neruda came by his figureheads. Answers more fully discussed in this book take us to Chile for the initial acquisition of the Woman Holding Hair figurehead by a man whose political views differed greatly from Neruda's. Also in Chile, a cut-apart figurehead found on a beach was later mended by antique dealers before its sale to a customer who soon provided it to Neruda. It was also in Chile that the presumed sale of an Indian figurehead was transacted with Neruda.

Additional answers appear in Peru, where Neruda bought for himself the burlesque figure he named after a beautiful young girl with whom he, as a youth, had been wildly infatuated. In Peru he also made his admiration for a male bust known to colleagues, after which it was gifted to him at a party in his honor.

Opportunities in New York and Paris allowed Neruda to add to his collections by including affordable décor pieces that looked like figureheads. They include the figures referred to as Jenny Lind, Shawl Lady, Marie Celeste, Henry Morgan, and Octant Man.

Available information is shared concerning what are unclear acquisitions of the figureheads referred to as Shakespeare, Cymbelina, and Sirena, as well as the figurehead-like décor pieces of "Sailor Girl with Rose," "La Bonita," and "La Novia."

It was an unusual quest to form a ship figurehead collection in the south of Chile, that long ribbon of a country with 4,000 miles (6,435 km) of coastline, a maximum width of 61 miles (91 km), and populated near the end of Neruda's life by ten million people. Yet, Neruda's house was close to Cape Horn, which was famously rounded by great sailing ships, especially prior to changes initiated by the opening of the Panama Canal on August 15, 1914. Neruda was ten years old when shipping patterns would start to change that ultimately affected the prosperity of Chilean ports.

Today, more than fifty years after Neruda's passing, a time-sensitive thrust to document Neruda's ship figureheads is heightened by Chile's environmental challenges. Neruda's carvings remain in a house facing the sea at a time of increased incidents of earthquakes and tsunamis. The 2019 photographs of Neruda's figureheads, shown in this work, provide outstanding documentation of a collection at high risk. Even though Neruda's house has granite as part of its foundation and structure, Chile is within the Ring of Fire zone, also called the Circum-Pacific Belt that runs from eastern Australia and Asia to the western coasts of North and South America.[5] The entire Ring of Fire is 24,900 miles (40,000 km), and 90 percent of the earth's earthquakes happen along it. The 8.3 magnitude Illapel, Chile, earthquake in September 2015 lasted three to five minutes and was due to the subduction of the Nazca plate

under the South American plate. When I visited Valparaiso two months later in November 2015, flood damage had caused some lower-floor areas of the hotel where I stayed to remain inaccessible.[6] Many websites today show the intensity and location of daily earthquakes throughout Chile, and the strongest yet reported is the Valdivia earthquake, with a magnitude of 9.6 on May 22, 1960, when Neruda was fifty-six years old. It brought a tidal wave of 82 feet (25 meters) and killed 2,333 people.[7]

Neruda's home at Isla Negra lacks humidity and temperature controls. The figureheads are positioned toward daylight that streams in through the large window facing the Pacific Ocean, although Neruda may have placed the figures differently at times. Now, as a house museum, Isla Negra has the addition of about 110,000 visitors per year in relatively close proximity to these carvings. So far, X-ray equipment has been unavailable to document the condition of the carvings' interior fastenings and joined wood areas. Photos show that most of the figures are without the addition of new paint, and this book offers detals of Neruda's attitudes about letting wood grain show. It also provides details of any known changes made during Neruda's time and for later exhibition, and it offers information relevant to future conservation strategies.

The camera lens in the 1967 documentary *Yo Soy Pablo Neruda* is a close-up of Neruda, a stout man, early sixties, with round shoulders, thick belly, thinning hair, and wearing a white shirt and dark belted pants as he moves leisurely and talks in soft, slow English. His poetry is among the most admired in the world and whether speaking of his figureheads in movies, memoirs, his own poems, articles by him or about him, figureheads were one of the wheels on Pablo Neruda's public relations juggernaut that was heading toward the Nobel Prize in Literature which he ultimately claimed in 1971. They add whimsy, drama, and color, and for a man well-known for everything from strident political views to fiery-hot love poems, figureheads add to the mix by softening, shaping, and recasting Neruda, if one believes him, as a great rescuer and sometimes even as a kind of odd suitor who looks through a keyhole at an attractive figurehead, eventually taking her home.[8]

Neruda died on September 23, 1973, twelve days after the start of the military coup in which Gen. Augusto Pinochet violently overthrew Chile's President Salvador Allende, Neruda's longtime close friend. Citizens of the country lived in tremendous fear of the militants' widespread violence, and that violence did bring vandalism to Neruda's homes in Santiago and Valparaiso, while his third house, seaside Isla Negra where he kept his figureheads and other collectibles, somehow was spared. It was surely the remoteness of Isla Negra that offered some barrier; yet, harm eventually did come to the figureheads for quite another reason. As they sat enshrouded for nearly twelve

years between Neruda's passing in 1973 and the death of his wife, Matilde Urrutia, in 1985, they suffered termite damage.[9]

From available evidence, this book describes how Neruda collected ship figureheads, what poems he wrote to them and shares how he treated figureheads with the mastery of a dexterous storyteller, shaping and reshaping what he had to say about them depending on the circumstances.

KEY EVENTS IN THE LIFE OF PABLO NERUDA

Neruda collected seashells, ship models, ships in bottles, carved masks, and more. Collecting had been part of who he was ever since, as a child, he plucked up pieces of wood or unique bugs, or other things small enough to take to his family's compact house. In the 1940s when Neruda was himself in his forties, ship figureheads also became part of his collecting passion. The first one, he says, was acquired from the Magellan Strait area—in some cases he says fishermen sent it to him; in other instances, he claims to have visited the area and had one sent from a shipwreck—but throughout his adult life he made sure to tell people he wanted figureheads. To the extent that others could locate carvings that Neruda could buy, they did, and he received at least one, and perhaps more, as a gift. Neruda was also satisfied with décor pieces that merely resembled figureheads.

A chronology offers some key events in the life of Pablo Neruda.[10]

1904–1924. Born July 12, 1904, the boy Ricardo Eliecer Neftali Reyes Basoalto later named himself Pablo Neruda to help distance himself from his harsh father's attitudes and behavior concerning Neruda's choice of writing as a profession. Neruda's closest family consisted of his father, stepmother, and half-sister, Laura Reyes Basoalta; Neruda's birth mother, Rosa Basoalto, had died of tuberculosis soon after he was born. Neruda speaks of a family vacation to a friend's house when he was fifteen. He describes the first time he saw the sea's immense swells and power, and he describes the terror he felt when his father would direct him, along with his sister, to swim until his father's whistle blew for them to come out of the water.[11]

In 1921 Neruda moved to Santiago for schooling at the University of Chile. Having signed his writings as Pablo Neruda since 1920, under that pen name his *Twenty Love Poems and a Desperate Song* was published in 1924.

1927. In 1927 Neruda began a diplomatic career outside of Chile.

1929. While living in Colombo, Sri Lanka, where he worked as consul, Neruda admits to having raped a woman who worked at his residence. His *Memoirs* describe that her job was to carry away on her head the toilet bucket from the back of his small house, and later Neruda wrote, "She was

right to despise me." Today, Neruda is emphatically re-contextualized. For example, in 2018, in Chile, #MeToo movement protestors against sexual violence, along with others concerned about abuse against women, successfully fought against renaming Santiago, Chile's main airport, for Pablo Neruda. Also, author and women's rights advocate Isabel Allende, who has said she too is disgusted by some aspects of Neruda's behavior, added, "We cannot dismiss his writing."[12] And Mark Eisner in his 2018 biography of Neruda says it is impossible not to see this as rape and that Neruda acted as a narcissist with a sense of entitlement.[13]

1930. Neruda soon finished his first post as consul in Burma (Myanmar), and his work took him to other countries that he was seeing for the first time. In 1930 he married "Maruca," whose full name was Maria Antonia Hagenaar Vogelzang, and, in 1932, the couple returned to Chile.

1933. The first edition of *Residence on Earth* was published, and Buenos Aires, Argentina, became home with Neruda assigned as Chile's consul to that country.

1934. Neruda and Maruca had a prematurely born daughter who suffered from severe health problems. With respect to Neruda's career, in this year he was named Chile's consul in Madrid, Spain.

1936. July 18, 1936, in what became the Spanish Civil War, Gen. Francisco Franco led troops in opposition to the elected Spanish government, and he came to reign as Spain's dictator for nearly forty years. In 1936 Neruda continued in his post as Chile's consul in Madrid. His friend Spanish poet Federico Garcia Lorca was among those murdered by the Franco regime, and Neruda began to write the series of poems that became *Spain in Our Hearts*.

1937. Neruda left his ill child and his wife, Maruca, to be with Delia del Carril who later became Neruda's second wife.

1938. A collection of poems by Neruda appeared as a book titled *Spain in Our Hearts*.

1939. Franco announced victory in Spain. Neruda arranged for 2,000 Spanish Civil War refugees to sail to Chile aboard the vessel *Winnipeg*. Later renamed *Winnipeg II*, the vessel was struck and sunk by a torpedo from German submarine U-443 on October 22, 1942.[14]

1940. Neruda became consul general of Chile in Mexico.

1943. At the age of eight, Malva Marina Trinidad Reyes Basoalto, daughter of Pablo Neruda, died.

1945. In Chile Neruda assumed the office of senator when, as a Chilean Communist Party member, voters chose him for the office of senator of the republic.

1947. Neruda visited the Strait of Magellan. On October 28 at Punta

Arenas, Antonio Sapunar Ojeda wrote a letter saying the *Lonsdale* wreck was nationalized, and he permitted the *Lonsdale* figurehead to be taken north. As virtually the only document Neruda retained about any figurehead he possessed, it is significant that Neruda kept this letter, and it raises the question if what has come to be called the "Medusa" figurehead is from the *Lonsdale*. Photo FB01988 at the Pablo Neruda Foundation, which foundation staff date to 1949 or earlier, shows the "Medusa" figurehead at Isla Negra.

1948–1949. Senator Pablo Neruda on January 6, 1948, Neruda gave his famous "I Accuse" speech, criticizing Chile's current regime and denouncing worker oppression.[15] He invoked words from US President Franklin Delano Roosevelt's message to the world delineating four freedoms for which people should fight: freedom to free speech, freedom to worship, freedom from misery, and freedom from fear. Neruda continued by saying that in Chile there is no freedom of speech and that people do not live free from fear, and that hundreds of men who fight, so our homeland can live free from misery, are persecuted, mistreated, insulted, and condemned. Neruda went on to call out specific names of wrong-doers and to further challenge the government. Reprisal was swift, and Neruda's life was soon at risk. To avoid arrest Neruda hid in safe houses in Valparaiso until his extraordinary horseback escape from Chile over the Andes Mountains enabled him to arrive in Argentina, acquire false identity documents, and leave for Europe on a steamship.

1949. Neruda and Matilde Urrutia lived together as lovers on the island of Capri, Italy. Years later, in Chile, she became Neruda's third wife.

1950. Neruda was awarded the International Peace Prize by the World Peace Council.[16] His major work *Canto General* moved toward publication and a poem in it, "To a Ship's Figurehead (Elegy)," indicates that a female figurehead has come to him from the Strait of Magellan. He describes her in terms of tragedy, kisses, breasts, nipples, wooden eyelids, and the term "Sea rose" that is shown in the Woman with Rose section of this book to have special meaning to Neruda. In *Canto General,* there are also poems about conquerors and fighting and chiefs that may reveal something of what Neruda came to see in his Indian figurehead. And *Canto General*'s scathing poem "United Fruit Co." vilifies companies that have taken fruits and coffee and other resources from lands and left workers nameless, abused, and hungry. Social justice alarm bells ring throughout *Canto General,* but he made room for figureheads as well.

1952. Neruda's second wife, Delia, returned to Chile, unaware of Neruda having lived with Matilde Urrutia in Capri in the hilltop home that a supporter had made available to them. Neruda and Urrutia had fallen in love and although they could not legally marry, they had a ceremony at their

home in which Neruda had the moon marry them. Neruda's ring to Matilde was inscribed, "Capri, 3 May 1952, Your Captain."[17] *The Captain's Verses* contains love poems inspired by Urrutia, but the volume was published anonymously in 1952 to avoid hurting the feelings of Delia. But the image on the cover spoke volumes. It was the mythological head of Medusa, which was Urrutia's nickname, and Medusa came to be the name of one of Neruda's ship figureheads. Sadly, during their time in Capri, Urrutia, who had already lost one child before, suffered a miscarriage of the child she wanted to have with Neruda.[18] When Neruda was able to safely return to Chile in 1952, he promoted his image as a collector, memorably in his October 22, 1952, article "El Olor del regreso" published in the *Vistao,* which tells of his receiving the Marie Celeste figurehead shipped in a box that seemed like a long, casketlike drawer.

1953. Joseph Stalin died and Neruda honored him with the poem "On His Death." When 2021 finally marked fifty years since Neruda's 1971 receipt of the Nobel Prize in Literature, newly available deliberation documents revealed that Neruda's admiration for Stalin had nearly eliminated him as a Nobel Prize candidate. The monumental question had been whether his politics could be reconciled with the awarding of the Nobel Prize.[19]

1954. Neruda's "Ode to Wood" is in the published volume *Elemental Odes.* Neruda wrote a total of three books of odes, with *Nueva sodas elementals* and *Tercer libro de las odas* following in later years. Also in this year, Neruda made known his preference for living with his lover, Matilde Urrutia, rather than his wife, Delia.

1958. *Estravagario* was published.

1958–1959. Neruda visited Venezuela for about four months and briefly met Fidel Castro during Castro's speaking engagement. At a separate event in Venezuela, Neruda was gifted by fellow writers with the Venezuela Man carving. Further, newspaper reporters, interested in Neruda's travels in their country, highlighted him as the author of *Canto General* (1950), and in 1959 Neruda's *One Hundred Love Sonnets* appeared.

1961. Sales pushed past one million for *Twenty Love Poems and a Desperate Song.*

1962. Neruda's *Fully Empowered* became a newly published offering.

1964. Neruda translated Shakespeare's *Romeo and Juliet.* Also, *Memorial de Isla Negra* was published.

1966. Neruda arrived in New York to speak at the PEN Club. A New York shopping expedition turned up the Jenny Lind figure, and possibly also the Shawl Lady figure. This was also the year that Ludwig Zeller in Chile acquired the Woman Holding Hair figurehead that later would come to be owned by Neruda. In the fall, Neruda acquired the Guillermina figure in

Peru. Neruda's return home from New York included a stop in the San Francisco Bay Area, where he saw the all-white female figurehead on the bow of *Balclutha* and kept a souvenir photograph. At the University of California, Berkeley, Neruda spoke to an overflow audience of two thousand, including poet Fernando Alegría, who had been born in Santiago, Chile, and earned his PhD at UC Berkeley. He taught Latin American literature there from 1964 to 1967. From 1967 to 1998 Alegría was an educator at Stanford University, and publications and a film documentary about Neruda have come from UC Berkeley and Stanford.[20] Had Neruda's California visit also included the San Diego Maritime Museum, he would have been rewarded with the sight of a figurehead representing the muse of lyric poetry on the bow of the 1863 iron barque *Star of India* (ex-*Euterpe*).[21]

1967. *Yo Soy Pablo Neruda,* a twenty-nine-minute documentary filmed at Isla Negra, includes Neruda giving a tour of his figurehead collection. On May 22 Neruda attended The Congress of Soviet Writers in Moscow. On July 20 he became the first recipient of the Viareggio-Versilia prize, which was established in 1967 to honor figures of world stature whose work makes a "major contribution to culture and understanding between nations."[22]

1968: Neruda received the Joliet-Curie gold medal, an award previously known as the Medal of Peace, given by the World Peace Council.[23] On August 14, a friend who signed only as "Norge" sent a note to Neruda from St. Paul de Vence in France, with paragraphs written alternately in red and blue. It began "De touts les figures de proue, c'est Pablo Neruda lui-meme qui is le plus magique . . ." (Of all the figures of the prow, it is Pablo Neruda who is the most magic . . .).[24]

1970. Salvador Allende, with whom Neruda was friends, became president of Chile.

1971. From March, Neruda was Chile's Ambassador to France, living in Paris, where he bought the Henry Morgan and Octant Man carvings. In this year a television series *Historia y Geografía de Pablo Neruda* aired, which included the Guillermina carving Neruda had received in 1966. In October, the Nobel Prize in Literature was awarded to Neruda.

1972. December, reportedly ill from cancer, Neruda returned from France to Chile.

1973. September 11 in Santiago, Chile, Gen. Augusto Pinochet overthrew President Salvador Allende. On September 23, Pablo Neruda died, and, despite mourners' fear of reprisal from the Pinochet regime for doing so, crowds turned out for Neruda's funeral.

Epilogue

1975. Matilde Urrutia received an invitation to attend a ceremony in Riga, Russia, for the christening of an oil tanker named *Pablo Neruda.*

1985. On January 5, 1985, Matilde Urrutia died in Santiago, Chile.

1986. The Pablo Neruda Foundation was created June 4, 1986, based on the last will and testament of the poet's widow Matilde Urrutia. The document facilitated the creation of the foundation, outlined its rules, and appointed its directors and advisors.[25]

2000. The Federation of American Scientists released "CIA Activities in Chile, Report to Congress," dated September 18, 2000, describing United States and corporate actions with respect to concerns about President Salvador Allende's government and specific actions taken up to and following the coup.[26]

2013. At Isla Negra, where his gravesite is shaped like the bow of a ship, the body of Pablo Neruda was disinterred for medical experts to determine whether he died of cancer or whether there was foul play from those who overthrew the government twelve days before his death.[27]

2016. Findings are that Neruda did not succumb to cancer cachexia as a result of prostate cancer, as had been reported at the time of his passing. A member of the investigative panel, Niels Morling, said, "There was no indication of cachexia. He was an obese man at the time of his death. All other circumstances in the last phase of his life pointed to some kind of infection."[28] Researcher Aurelio Lunda said, "We still can't exclude or affirm the natural or violent cause of Pablo Neruda's death."[29]

2023. Based on ten years of study by forensic experts, the answer to whether Neruda's death was due to poisoning was reported in 2023 as a possibility.[30]

Chapter One

Neruda's Male Figureheads

SCORES OF EXCELLENT male-subject figureheads from the nineteenth and twentieth centuries survive that offer great visual interest through dramatic facial expressions, posturing, gestures, weaponry, and attire, ranging from uniforms to indigenous apparel to detailed contemporary clothing. From Neruda's collection, three male figureheads carved in wood are reviewed in this chapter, and, in his poetry, Neruda made powerfully clear the personal treasure that wood was to him.

INDIAN: SYMBOL OF STRENGTH

Neruda's "Ode to Wood," as translated by Margaret Sayers Peden, indicates that the smell of red wood is the smell of Neruda.[1]

> Oh, of all I know
> and know well,
> of all things,
> wood
> is my best friend.
> I wear through the world
> on my body, in my clothing,
> the scent
> of the sawmill,
> the odor of red wood.

Neruda's poetry about this Indian figurehead, titled El Gran Jefe Comanche is shown in Appendix A. The translated version below is from the book *The House in the Sand*.[2]

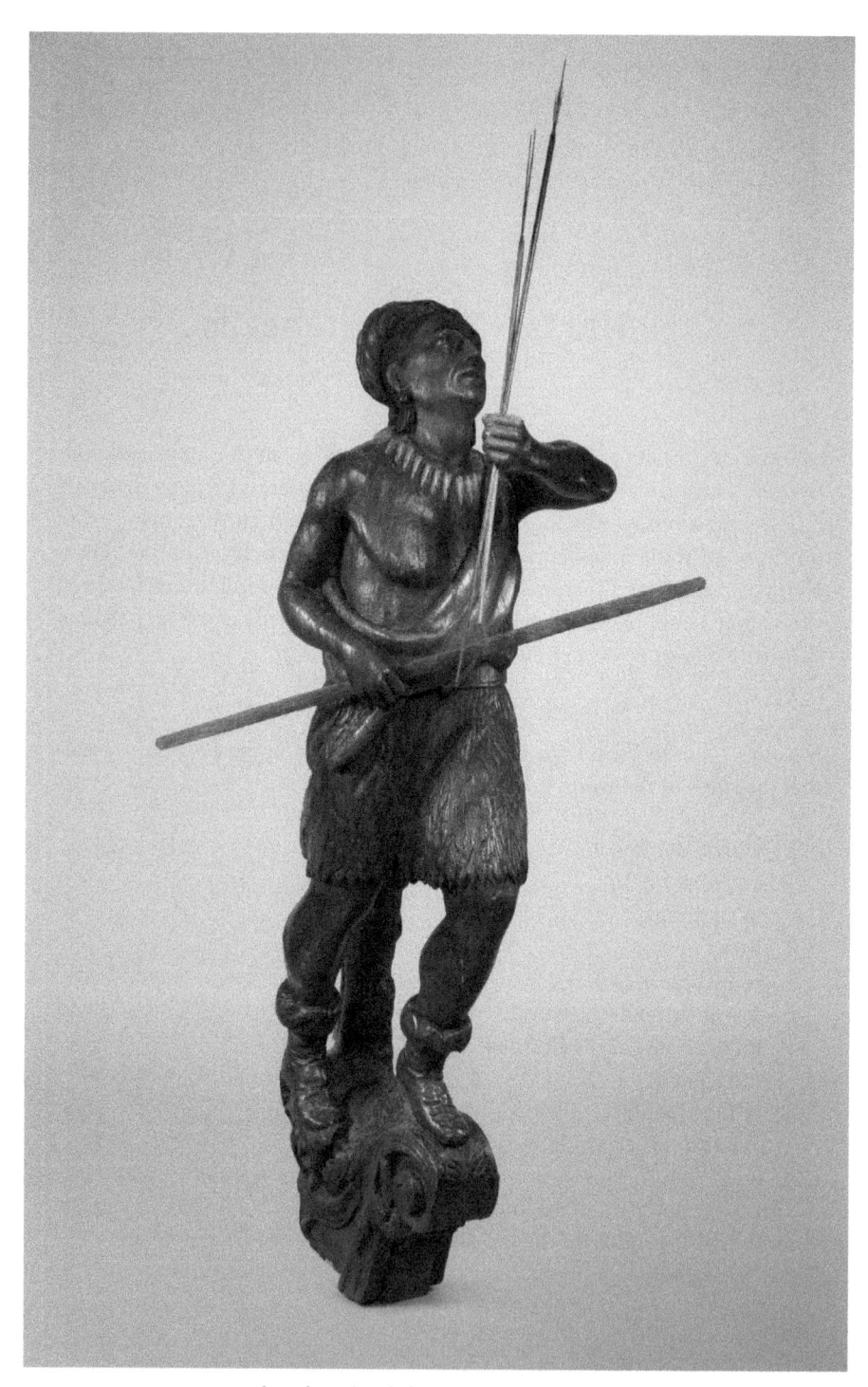

Fig. 1.1. Indian figurehead, front. © Fundación Pablo Neruda.

Fig. 1.2. Indian figurehead, detail. © Fundación Pablo Neruda.

Big Chief of the Comanches

I don't know how that colossal statue and the
menacing quiver were able to get inside. But here it is, and
lords it over the others, because of its feathers, its indomitable
profile, and the hardness of its sequoia redwood, that withstood
the fierce tides.

A Redskin from a whaling vessel out of Massachusetts,
like the one that may have guided young Melville's ship
through the Peruvian and Chilean ports. It is known that it was
the favorite statue of the whale hunters, and the artisans of
Nantucket sculpted more than one. With the advent of the
steam engine, when sailing ships were forgotten, the old artisans
continued to carve this Redskin, converted into the insignia for
a pharmacy or cigar store. (Those "Indian drugstores" with their
aroma of a hundred roots, where alchemists prepared ointments
and pills with mortars and with delicacy!)

The truth is that he never unfurrowed his brow; that
with his bow, tomahawk, knife and gesture he is the brave one
among my unarmed sea-maidens. Not even Buffalo Bill with his
fusillades of gunpowder, nor the ocean filled with recalcitrant
monsters could lessen his power. Here he remains intact and
tough.

Neruda's figurehead does not appear to be made of redwood, but it may
be apparent why he used that word: a tree species growing in Chilean forests
that Neruda would have known is the giant redwood Alerce (*Fitzroya cupres-
soidis*), and there is an alliterative effect of red wood and red skin. If Neruda's
figurehead was carved in North America, as visually comparable Indian fig-
ureheads suggest it may have been, the wood type is more likely pine. Red-
wood is prone to splintering and is not a typical choice for figurehead carving.

Neruda also says in "Big Chief of the Comanches" that his Indian is from
a nineteenth-century whaleship, but in reality it is too large for a typical ves-
sel of that type.[3] We must question, too, whether Indians were the favorite
sculpture of whalers, as he suggests.[4] And Neruda's notion that sailing ships
were gone when cigar and drug store Indians were first carved is unfounded.[5]
As one seeks what is factual about Neruda's figureheads, his poetry, does not
seem the place to find it.

Notably, Neruda points to Buffalo Bill, born William Frederick Cody, who
was famous for staging the "Wild West Show," in which Buffalo Bill feigns
killing Indians. Buffalo Bill was also known to Neruda as a character in the
works of one of his favorite authors, Emilio Salgari.

Additionally, in "Big Chief of the Comanches" Neruda spotlights author Herman Melville, who sailed from New Bedford, Massachusetts, on the whaleship *Acushnet* in January 1841. That was the voyage that began Melville's writing career. Ten years later, Melville's novel *Moby Dick*, based on actual events, described the 89-foot (27.1-m), 238-ton whaleship *Essex*, which was attacked and sunk by a sperm whale. *Essex's* crew had hunted whales in the Pacific, intent on a prosperous return with a hold full of barrels of whale oil to be sold for making lamp oil, candles, soaps, and machine lubricants. But of the twenty men who left the *Essex* wreck site in three small whaleboats few ultimately survived. In one boat, after 89 days and 2,500 miles of drifting, near-death survivors First Mate Owen Chase, boatsteerer Benjamin Lawrence, and cabin boy Thomas Nickerson were rescued and transported to Chile by Capt. William Crozier in the British brig *Indian*. Presumably Neruda knew this.

No history is available of the vessel from which Neruda's Indian figurehead comes but a surviving 1960s photo in Neruda's materials shows this carving outside what may have been an antique shop in Chile, while men nearby appear available to move it.[6] Perhaps the carving was taken off a ship during a refit or was removed from a vessel whose career had ended in South America. The existence of this photo amidst Neruda's belongings could suggest the figurehead was to go to Neruda, and the figure appeared in the 1967 film *Yo Soy Pablo Neruda*.

Neruda's connections with this Indian figurehead transcended any maritime world. He says he thought deeply about Alonso de Ercilla's sixteenth-century epic poem *La Araucana*, relating to Spanish conquest of Chile and the harsh treatment of indigenous Indians. That literary masterpiece influenced Neruda's own "Education of the Chieftain," written in praise of South American Indian hero Lautaro (1534–1557), whose legacy extends to teaching indigenous Mapuche people warfare methods, including the use of horses to fight conquistadors.[7]

Injustice toward Indians was a source of lifetime anguish for Neruda. As a young diplomat working overseas, he saw bias up close in the Chilean Foreign Ministry and lamented that his own work for that body included checking the ethnic origins of immigrants to make sure that Africans, Asians, and Jews did not enter Chile. Eventually, a defiant Neruda, who founded the magazine *Araucania*, for which he says there was retribution, wrote of the resolute strength of the defeated and crushed Araucanians, whose stories had been skewered by their conquerors. Neruda railed against certain South Americans of mixed heritage who sought to benefit from posturing, as if they were "scrupulously white or light-skinned," and Neruda observed that, with the UN adding language about people of color, "the foliage of all the races is gradually displaying all the colors of its leaves."[8]

Photographs of author Walt Whitman, whom Neruda greatly admired, were prominent in Neruda's Paris Embassy office and at his home.[9] Whitman wrote in *Song of Myself* about the "friendly and flowing savage," and Whitman empathized, as Neruda came to, with indigenous peoples. Within Whitman's lifetime, Cherokee people were made to walk some 5,000 miles (8,000 km) to a region, now the state of Oklahoma, during the infamous Trail of Tears event. Whitman was also still alive when the 1890 massacre of close to 300 Lakota people by US Army soldiers occurred in the Battle of Wounded Knee. That was just thirteen years before Neruda was born.

Neruda would have been versed in cultural clashes that permanently tore apart Native American homelands and familiar with themes of displacement and conflict found in works like James Fenimore Cooper's five-novel *The Leatherstocking Tales*. Challenges in the lives of untold numbers of Indians and their need to fight back surely filled Neruda's mind at times when he looked at his tall fierce Indian ship figurehead with its determined, charging-forward pose.

GENERAL
Museum: Isla Negra House Museum, Pablo Neruda Foundation
Type and Material: Sculpture, wood
Name Used: Indian is chosen here as the name to be used for this figurehead. Pablo Neruda referred to him as El Gran Jefe Comanche and titled a poem by that name.

DIMENSIONS
Length: 76 inches (193.04 cm) top of forehead to lower right foot
Length: Added feather height is about 1.5 inches (3.81cm)
Length: 93½ inches (237.49 cm) overall
Width: Unrecorded due to unknown changes to left arm
Lacing: 6½ inches (16.51 cm) taken at upper level
Stem: 11½ inches (29.21 cm) total based on 5½ inches (13.97 cm) across front of stem, plus 3 inches (7.62cm) also extending to either side
Face Length: 10 inches (25.4 cm) measured from top of forehead to chin
Face Width: 8 inches (20.32 cm)

FEATURES
Style: Full length.
Pose: Rigorous stride with left leg forward. Face looks forward and head is held high. Left arm appears to be a replacement and, based on two stylistically comparable Indian figureheads, Indian Chief and Seminole, as discussed later in this chapter, the original left arm of Neruda's carving was likely positioned lower.

Attire: Garment is carved to look like fur and has a carved belt. Carved, high-cuff moccasins also give the impression of having sewn soles.

Face, Eyes, Ears: Facial features are strong and noble, eyes look upward, lips are slightly parted, and the ears are well rendered.

Arm, Left: The left arm, with an exaggerated bicep, is a modern addition.

Hair: Pulled back smoothly and tight toward the top of the head.

Feathers/Jewelry: Three large, dense, and bending feathers are prominent atop the figure's smoothed-down hair. On each ear is carved, all in wood, an earring in the shape of a small hoop attached to a ball, under which dangle leather-like strings. The figure wears a graduated-size bear-claw necklace similar to those seen in portraits of high-status Indians recorded by painter George Catlin, such as the 1834 image of Kee-o-kuk (The Running Fox), Joc-O-Sot 1844, Boy Chief—Ojibbeway 1843, Shon-ta-yi-ga (Little Wolf) 1844–45, and the White Cloud, Head Chief of the Iowas, 1844–45.[10]

Attribute: What appears to be the surface of a carved oak tree, as though it were growing, is visible behind the legs of the Indian figure. Oak is an enduring symbol of strength and power.[11]

Weapons: Handheld weapons are not seen as part of the Indian figurehead in a late 1960s street photo. Neruda did, however, write about a bow, tomahawk, and knife in his poem "Big Chief of the Comanches." Today, at the left front, the figure brandishes one weapon before him and another in the right hand that is held close to the figure's side. A carved tomahawk tucks into the right waist area while a handsome quiver, filled with carved arrows, fits firmly on the left side of the figure's back.

Drapery: None.

Scroll: The middle topside of the scroll on which the figure stands has been textured by the carver to make it appear as if the figure walks on soil. Also, the scroll front has a large leaf, made in relief with a prominent center stem, which corresponds to the head feathers with prominent stem centers. Even though damage has occurred to the end of the rounded front scroll, Neruda, in looking at it in a side view, saw the design as "curling like waves."[12]

Surface Treatment: This tall, muscular Indian figurehead has rich surface details, particularly through the necklace, head-feathers, earrings, and cuffed moccasins atop what appears to be textured ground. Its colors today are shades of dark brown for the skin, clothing, and scroll; black hair and earrings; red feathers; and white at the eyes and on the bear-claw necklace.

CONSERVATION

The Neruda Foundation's 1989 Technical Restoration Report suggests the weapons in the Indian figure's hands may be modern additions, and that due to dark varnish previously applied, efforts were unsuccessful in bringing out color when using solvent to clean the necklace, feathers, and eyes. That

information came from Ricardo Garreton in November 1989, but in 1990 Ricardo Mesa tells of recovering color by rinsing off and scraping blackened patina. Interestingly Mesa also refers to a change of location for figures because of lighting, which suggests their spatial arrangement at Isla Negra during Neruda's time did not necessarily have them facing the sea.

STYLISTIC COMPARABLES

Following are Indian figurehead examples that bear some stylistic comparisons to Neruda's Indian figurehead.

USS *Delaware*'s Tamanend portrait-like bust figure has some similarity to Neruda's image with respect to facial features, head-feathers, hair, quiver, and arrows. At its base, this figure features carved oak leaves with acorns, rather than traditional base drapery. No direct association of Neruda's figurehead to this carver or ship is suggested. Figurehead at US Naval Academy, Annapolis, Maryland.

Indian Chief figurehead. 1877 Quebec-built vessel, 1,238 tons and measuring 198 by 33 by 22 feet (60.3 by 10.05 by 6.7 m). This figure has the appearance of a carved oak tree behind the legs. No direct association of Neruda's figurehead to this carver or ship is known. Figurehead at Peabody Essex Museum, Salem, Massachusetts.

Seminole figurehead. 1865 Mystic, Connecticut, clipper built by Maxon and Fish, 1,439 tons and measuring 196 by 41.6 feet (59.7 by 12.6 m). Operating after the end of the United States Civil War, *Seminole* sailed New York to San Francisco in 97 days carrying Central Pacific locomotive CP10.[13] No direct association of Neruda's carving to this figure is known. Figurehead at Mystic Seaport Museum, Mystic, Connecticut.

Drawing of a King Philip figurehead, as shown in Pinckney, *American Figureheads and Their Carvers* (1940), plate IV. No direct association of Neruda's carving to this image is known.

SUBJECT COMPARABLES

While the figureheads mentioned above have stylistic connections to Neruda's figureheads, information below more broadly surveys ships carrying Indian figureheads.

Indian figureheads helped individualize commercial ships.[14] Some figureheads represented Indians with political reputations, while others represented popular literary or theatrical characters. Indian figureheads conveyed strength and courage and were used on the vessels *Sierra Nevada*, *Westward Ho!*, and *Red Jacket*, which are chosen here as examples, not only for their Indian figureheads, but because the vessels had histories in Chile, Peru, or Cape Horn.[15]

Sierra Nevada was described as having a "nearly upright stem [that] carried as a figurehead an Indian warrior."[16] Launched May 29, 1854, by shipbuilders Tobey & Littlefield of Portsmouth, New Hampshire, for Boston owners Glidden & Williams, the vessel name recalls the mountains where the California Gold Rush was then in full progress. The original figurehead was lost in an 1855 collision, and two decades later, with an undescribed figurehead or possibly none at all, the vessel wrecked off of Chile in 1877.[17]

Westward Ho! came to be owned in Peru, ending her career in Callao. Her figurehead was described as an Indian in pursuit: "The full figure of an Indian warrior, represented as advancing rapidly in the chase, placed on a pedestal of ornamental flowering, with her name on each curve of the bow, are her principal ornaments forward."[18] *Westward Ho!* had impressive beginnings. Built in 1852 for Sampson & Tappan in Boston by famous shipbuilder Donald McKay of East Boston. Her dimensions were 210 feet by 40.6 by 23.6 (64 by 12.37 by 7.19 m), and her tonnage 1650. Purchased about 1857 by Don Juan de Ugarte of Lima, she ended her days under the Peruvian flag still called *Westward Ho!* As Howe and Matthews related, "Her end came on February 27, 1864, when, at anchor in the harbor of Callao ready to leave for China, she caught fire and burned until she sank at her moorings, proving a total loss."[19]

Red Jacket met her end in transatlantic work, but a famous Currier & Ives print shows the vessel earlier in Cape Horn ice.[20] This North American merchant vessel was named for the famous Seneca tribe orator and chief of the Wolf clan, Chief Sagoyewatha (he that keeps them awake). Often called "Red Jacket" because of the garment he wore that had been given to him by a British officer in appreciation for help during the American Revolutionary war, Chief Sagoyewatha also came to be admired by many Americans, including by one modern-day boater, who in 1987 had three hatches of his Cheoy Lee Clipper '42 sailboat decorated with Red Jacket themes.[21]

It happened that *Red Jacket*'s figurehead and stern carvings were from two carvers, one in Maine and one in Massachusetts. We learn this from the November 4, 1853, *Rockland Gazette,* which noted that the ship's figurehead of *Red Jacket* "came up from Boston [Massachusetts] carved by 'Mason'" [but] (o)n her "light round" stern was a moulding which included "a bust of an Indian in the centre . . . very chastely executed by our townsman S. L. Treat."[22]

Red Jacket, modeled by Samuel H. Pook and built by George Thomas at Rockland, Maine, was 251 feet long (76.5m), with a tonnage of 2305. When he was nearly at the end of his life there is a story that Red Jacket spoke directly to a vessel that would carry his name, instructing it to be worthy.[23]

SHAKESPEARE: SLICED IN HALF

Overview

The need to provide a nineteenth-century commercial ship with an interesting name could be solved by looking to literature, and perhaps also choosing a complementary figurehead. Examples include the 1869 clipper *Cutty Sark* at Greenwich, England, that still carries at its bow a carving of the witch Nannie Dee grasping the captured tail of Tam's mare named Meg, as described in Robert Burns's epic poem *Tam O'Shanter*. The story is of a drunken farmer who, in desperately trying to preserve his own life one dark night, fled on horseback toward the River Doon bridge, knowing that the witch in wild pursuit of him would be unable to fly over running water.[24] And from another classic, the gorgeous Lallah Rookh figurehead personifies the princess in Irish author Thomas Moore's 1817 narrative poem "Lalla Rookh" that tells of her journey from Delhi to Kashmir during which the supposed storyteller in her entourage is revealed as the King of Bucharia, whom she was to marry. And an image of Hiawatha, a powerful leader of Indian tribes, whose memory is honored in Henry Wadsworth Longfellow's popular 1855 epic, *Song of Hiawatha*, survives as one of many noteworthy male figureheads from nineteenth-century ships.

Figureheads representing authors recall for us those individuals and their written work. Prolific writer Lus Vaz de Camões is best known for his epic and masterful poem, *The Lusiads,* which honors intrepid Portuguese explorers. A handsome portrait figurehead of Luis Vaz de Camões is at Museu de Marinha in Lisbon. And Joseph Conrad's portrait figurehead, cast in metal, is on the *Joseph Conrad* square rigger at Mystic Seaport Museum in Connecticut. Among Conrad's best-known novels are *Heart of Darkness, Lord Jim,* and *Typhoon.* There is also a portrait figurehead of author Robert Burns in the collection of the Smithsonian's Museum of American History in Washington, DC. Burns has been called the national poet of Scotland.

The worlds of literature and ship figureheads are, in fact, fabulously intertwined, and a remarkable question before us is whether Neruda owned a figurehead of Shakespeare.[25] Chances seem hugely improbable that the winner of the 1971 Nobel Prize in Literature, who considered himself Chile's national poet, would in fact come to own an authentic and immensely rare figurehead of the man often referred to as England's national poet.[26]

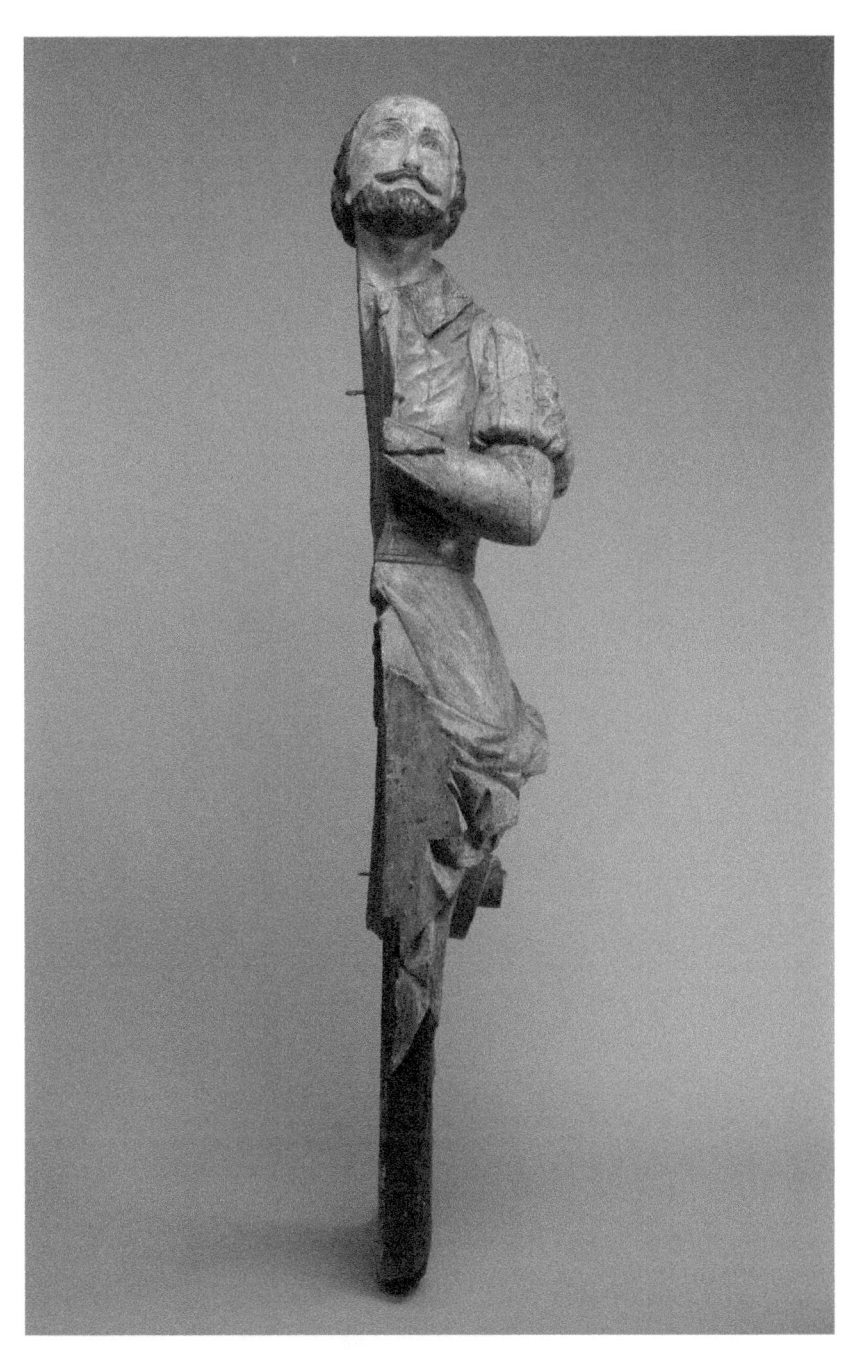

Fig. 1.3. Shakespeare figurehead, front. © Fundación Pablo Neruda.

Fig. 1.4. Shakespeare figurehead, face detail. © Fundación Pablo Neruda.

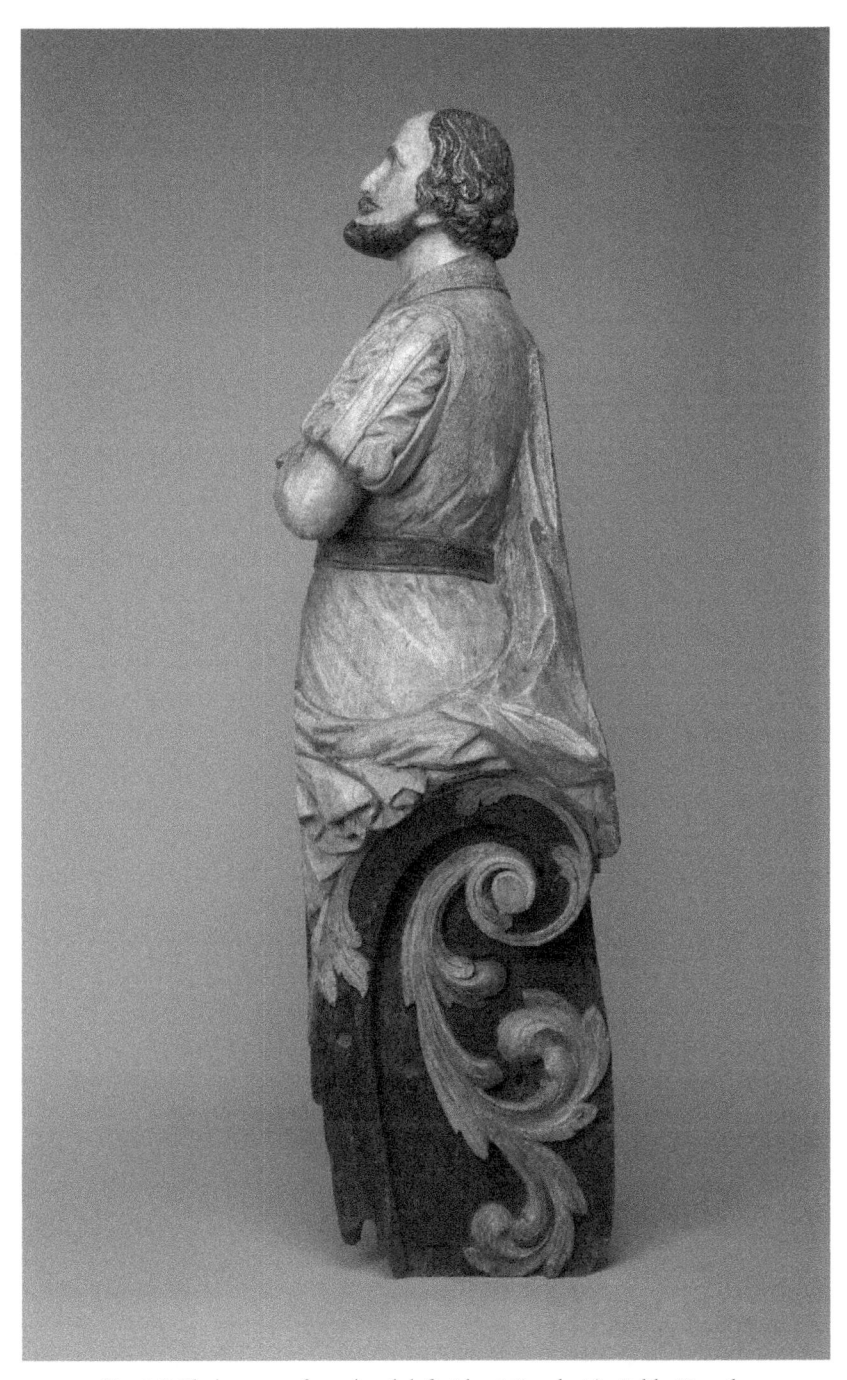

Fig. 1.5. Shakespeare figurehead, left side. © Fundación Pablo Neruda.

We know that Neruda translated *Romeo and Juliet* in 1964 for the four-hundredth anniversary of Shakespeare's birth, that Losada published it in September, and that in October 1964 it was staged as a play.[27] The carving that may be a figurehead of Shakespeare is not in the film *Yo Soy Pablo Neruda*, however, it is in later 1960s photos taken in the Isla Negra living room. Neruda would have had many opportunities to brag about having a rare Shakespeare figurehead but, in fact, no reference is found of Neruda mentioning it at all. Even though the figurehead looks like Shakespeare and the name "Shakespeare" appeared in the Neruda Foundation's Technical Report as late as 1989, something strange occurred. "Shakespeare" was crossed off in the report and "Francis Drake" was handwritten instead. That 1989 report was created sixteen years after Neruda's passing.[28]

In Neruda's time, it is easy to imagine that he may have preferred to think of the image as Sir Francis Drake, the famous English explorer and privateer who had sailed to Chile, was injured by hostile Mapuche warriors on Mocha Island, and was infamous for having sacked the port of Valparaiso. A figurehead of Shakespeare, on the other hand, may well have been irrelevant to Neruda, whose ego was such that the Bard's notoriety may have been seen as detracting from Neruda's own stature. When Francis Drake sailed his 1577-launched galleon *Pelican* into the Strait of Magellan, near the southernmost tip of Chile in 1578, he gave it the now-famous name of *Golden Hind*, which was to honor his sponsor, Christopher Hatton, whose crest was a golden hind. When modern-built *Golden Hinde II* was launched in 1973, it had a figurehead of a golden deer at the bow and a large image of a deer at the stern. The sixteenth-century *Golden Hind* completed the first circumnavigation by a British vessel, and its modern likeness was meant to commemorate the four-hundredth anniversary of that feat, which was completed in 1580. With respect to the vessel name, the archaic term "hind" refers to a mature female red deer of two or three years in age, and her counterpart, a mature male, is referred to as a stag. Shakespeare sometimes writes of a golden hind, as in *All's Well That Ends Well* (act 1, scene 1, lines 85–87), where Helena proclaims, "The hind that would be mated by the lion must die for love," meaning that some relationships do not work.

The Strait of Magellan is named for the Portuguese-born Fernão de Magalhães (anglicized as Ferdinand Magellan), who, on behalf of the king of Spain, sailed the world in 1519 until his death in the Philippines in 1521. The expedition he began completed its circumnavigation in 1522, after which it returned to Seville. Magellan's five-vessel fleet was manned by 270 seafarers, and his flagship *Victoria* has been replicated. Named *Nao Victoria*, it is on display at the Museo Nao Victoria in Punta Arenas, Chile, a part of the country Neruda visited in his lifetime.

It is unknown how Neruda acquired this presumed Shakespeare figurehead or why it was sawn in half. One thing seems certain though: Neruda would not have sliced away any part of a figurehead. He wanted his carvings to show their pounding from the sea, and he speaks of wood breaks and tears as though they are a sort of sublime aesthetic to be embraced as symbolic of the sea's ferocity.

Shakespeare also found advantage in exploiting and manipulating ideas of disasters and atrocities at sea, as he bountifully offered up storms and shipwrecks in *The Winter's Tale*, *The Comedy of Errors*, *Twelfth Night*, *Pericles*, and *The Tempest*.

While a specific ship is not identified for this Neruda figurehead, Shakespeare was indeed the namesake of some nineteenth-century vessels, as other ships were named after notable Shakespearean actors. Examples include Edward Knight Collins's Dramatic Line vessels, named *Shakespear* [sic], *Garrick, Roscius, Siddons,* and *Sheridan,* the latter honoring William Edward Sheridan, famous as Shylock in *The Merchant of Venice*. The poet's name appears in this 1871 *Australia Medical Journal* post: "the immigrant ship *Shakespeare* arrived in Brisbane with sixty-six cases of smallpox on board."[29]

GENERAL

Museum: Isla Negra House Museum, Pablo Neruda Foundation
Type and Materials: Sculpture, wood
Name Used: Shakespeare is chosen as the name to be used for this carving in this book.

DIMENSIONS

Length: 69 inches (175.26 cm) from head to current base
Width: Full width estimated at 22 inches (5.588 cm) at shoulders since surviving half of figure is about 11 inches (27.94 cm) at shoulder
Lacing: 3½ inches (8.89 cm) of lacing remains and it is somewhat inset with ¾ inch (1.91 cm) edge, measured at chest level
Face length: 9 inches (22.86 cm) from top of forehead to chin
Face Width: 5½ inches (12.7 cm)

FEATURES

Note: It is unknown when the right side of this figurehead was separated from what now remains.
Pose: The torso is in a frontal position with the figure looking slightly to the left. The left arm rests above the figure's waist.
Attire: Elizabethan attire including slashed sleeves and a 2-inch-high (5.08 cm) carved belt that stops at either side of the lacing board. The broad, convex

surface of the figure's back reflects light in a way that contrasts to the patterned lines on the carved sleeve and drapery.

Decorative Incising: Thinly gouged channels are near the edge of the shirt collar. Similar lines also appear on the sleeve and belt.

Face, Eyes, Ears: The long, narrow portrait-like face has well-carved eyes that include indentation for the pupil. The left earlobe is visible below the hair.

Hair: Beginning well beyond the forehead, the figure's relatively thin hair is close to the head and shows some curl around the ears and neck.

Drapery: Accented by deep linear cuts, carved drapery at both sides of the lacing board drops down in uncomplicated fashion, becoming more detailed at the sides and front. The deeply recessed side scroll features swirling foliage in high relief. The side scroll has overhanging side drapery that, in some places, projects out beyond the scroll eye.

Lacing Board: There is a projecting lacing board at the back of this figure.

Side Scroll: The surviving side scroll's dramatic depth extends from the flat ground area out to the scroll eye and resembles pulled-out parchment. The well-proportioned volutes have a graceful mix of rounded and pointed foliage, along with half-moon shapes that could be quickly cut. The side scroll work is 32 inches (81.28 cm) long, which is about half the length of the entire carving. When mounted on its ship, the long, rich foliage imagery could have had even greater length by being matched up to similarly carved trailboards.

Surface Treatment: Varied colors remaining on this figurehead are light beige for the facial tone and clothing, along with blue for the eyes, collar, and cuffs. Brown is the color of the hair, and red has been used for the doublet. The scrollwork is light green on a purple-tone base. There is a mottled and glazed appearance to the figure's paint that is an uncommon finish for figureheads.

Wood Joins: Most prominently these are seen at the left arm and sleeve and at the front of the base drapery.

Conservation

Conservation records show that intervention for the Shakespeare figure was to rub the wood surface in an effort to recover color. For display purposes, workers anchored the figure to the side of the staircase. No information is provided about the figure being cut in half before or after its arrival at Isla Negra.

The 1989 "Technical Restoration Report" also documents treatment for termites during two weeks in November 1989, when the Isla Negra living room and contents were treated with the gas called Phostoxin. Where wood cracks appeared in figureheads, the 1989 report indicates there was use of the chemical Xylamon, an active ingredient deadly to larvae.

STYLISTIC COMPARABLE

The handsome *Mary Hay* figurehead in the "Valhalla" Tresco Collection in the Scilly Isles has dimensions and deep side scrolls that are similar to this Shakespeare figurehead. As a 258-ton barque built at Peterhead, Scotland, in 1837, *Mary Hay* was inbound to the Scilly Isles from Jamaica carrying rum, sugar, and a mix of other goods. It was reported that the local pilot, rather than having his meal on deck, went below instead. The vessel hit Steeple Rock where anchoring was possible yet the strongest pumping efforts did not stave off sinking. Much cargo was salvaged, and once the vessel was refloated, it was taken to a dock for breakup, during which time the figurehead was removed.[30] It is possible that Neruda's carving may have come from a similar-size vessel.

VENEZUELA MAN: FIDEL CASTRO AND SCHOOLYARD BULLIES

OVERVIEW

Neruda had been a member of the Communist Party fourteen years when, during a 1959 trip to Venezuela, he joined an excited crowd listening to Fidel Castro as he gave a rundown on recent success in Cuba against the Fulgencio Batista-led government. Afterward, surprised to find himself invited to meet privately with Castro, Neruda says they had barely spoken before a photographer took unauthorized photos that so infuriated Castro he bolted.[31]

Throughout four months in Venezuela, Neruda gave well-attended poetry readings. He also attended classes, and it was in a school courtyard, he says, that Neruda first saw the "Venezuela Man" figurehead that had some small physical damage. Neruda ascribed to it a likeness of Russian poet Alexander Pushkin, whose work Neruda had admired from youth.[32] Neruda said, "The sea and [a local] schoolboy's pebbles rupture the nose and accentuate the romantic face so similar to Pushkin."[33] Neruda knew Pushkin's work well. When Neruda was still a child, future Nobel Prize winner Gabriela Mistral highly recommended Russian writers to him, and, by 1945, when Neruda was forty-five years old, his first visit to Russia was to celebrate Pushkin's one-hundred-fiftieth anniversary. Neruda returned to Russia several times. Two years after Neruda's passing, his wife Matilde Urrutia received an invitation to come to Riga for ceremonies for the newbuild oil tanker *Pablo Neruda*,[34] She accepted despite the difficulty of the journey from Chile.

Neruda's interest in ship figureheads was known to his colleagues everywhere, and in Venezuela, by communicating clearly and admiringly about this one, unsurprisingly, when he was honored at an evening gathering of poets,

Fig. 1.6. Male bust carving, front. Named here Venezuela Man.
© Fundación Pablo Neruda.

that figure was given to him as a token of their esteem. Photographs of Neruda receiving this gift are at the Pablo Neruda Foundation.

Close to the time of his departure from Venezuela, Neruda rode with other poets to Port Cabello, where he had heard there might be another figurehead. None was found, but on February 27, 1959, the *El Nacional* newspaper contained information about the excursion anyway.[35]

Pablo Neruda will sail to Chile from Venezuela taking a figurehead. For the purpose of locating a Spanish sailing vessel and its figurehead, Neruda came to Pta. Cabello with poets José Ramón Medina and Luis Pastori.

These details are communicated by the poet Felipe Herrera Vial, who said that the author of "*Canto General*" had great interest in seeing the figurehead of a Spanish ship that is in Puerto Cabello. The Correspondent later spoke by phone with Pastori and was told that Neruda is a collector of this type of

Fig. 1.7. Artist Elizabeth Moutal rendering of male figurehead. Courtesy National Gallery of Art, Washington, DC.

antique, and that he was interested in looking in this port before leaving for Chile.

The only figurehead Neruda took from Venezuela is the one referred to in this chapter. When Neruda later saw a picture in a book of a vaguely comparable carving, he used his favorite green ink to pen this message in the margin: "similar to the figurehead given to me in Caracas in 1959 when I was regaled by friends there."[36]

General

Museum: Isla Negra House Museum, Pablo Neruda Foundation
Type and Materials: Sculpture, wood
Name Used: Venezuela Man is the name chosen to be used for this carving in this book to help simplify references to it. Photographs show the figure being

given to Neruda in Venezuela, Historical information does not appear to exist, including whether it came from a ship.[37] Neruda called the figure El Armador, Spanish for shipbuilder and in the translated version in *The House in the Sand*, a prose poem is titled "The Shipwright I," but no evidence supports this carved figure as representing a shipbuilder.

DIMENSIONS

Length: 27 inches (68.58 cm)
Width: 19 inches (48.26 cm) wide to top of shoulders
Width: 11 inches (27.94 cm) at mid-waist
Depth: 13 inches (33.02 cm) from back to front of jacket
Depth: 14½ inches (36.83 cm) jacket front to back drapery
Face length: 7 inches (17.78 cm) top of forehead to chin
Face width: 5 inches (12.7 cm)

FEATURES

Style: Bust figure.
Pose: Frontal; head turns slightly to right.
Attire: Jacket fits snugly with five fastened buttons plus a sixth carved button that is visible just under the figure's right coat lapel. Stress of the fabric due to a supposed tight fit of the coat is suggested with carved vertical folds across the mid-front. The shirt collar is snug under the chin, and a bow-tied cravat is above lines of a vest and frock coat collar.
Face, Eyes, Ears: Looking out from a handsomely modeled face, the eye irises are incised but pupils are not. The upper and lower lids are well rendered, and there is a slightly raised surface at the eyebrows.
Hair: Four cascading curls accent the center forehead, and gently twisting curls are brushed forward from the center back of the head. Some curls overlap the back of the collar.
Drapery. Carved drapery appears beneath truncated arms and in relief above the scroll and is also prominent at the front of the figure where it overlaps in a style used on other figureheads as noted in the Stylistic Comparables section of this chapter. Carved drapery also goes over the top of the lacing board.
Lacing Board: In this case, the flat lacing board is nearly as wide as the figure.
Side Scroll: The upper portion of the side scroll has a slightly hooded rim above the deep flat "dishing" or "ground" area and the scroll eye is dramatically pulled out.
Surface Treatment: Some paint remains, but a modern application of wax has been applied to the face that would have the effect of producing a shimmering glow on the sculpture surface, particularly when seen in candlelight.
Fastening to Ship: A 1¼-inch (3.175-cm) fastening hole goes completely

through the figure. It is placed at the front center above the base drapery. No evidence remains of an original metal fastening or any bung that may have fit over the metal fastening. In addition, there is no apparent base recess cut into the underside of this carving. However, the carving may have had a longer base, as shown on the drawing of the Unidentified Woman figurehead published in Clarence P. Hornung, *Treasury of American Design and Antiques,* as referenced below.

CONSERVATION

In the Pablo Neruda Foundation's 1989 Technical Restoration Report, **Venezuela Man** is called Armador Venezolano. It was reported as being in good condition, except that the nose was missing.[38]

STYLISTIC COMPARABLES

Gentleman, figurehead OF72, at The Mariners' Museum, in Newport News, Virginia. See "Discussion" below for more about this carving and why it no longer carries the name Commodore Oliver H. Perry.

Elizabeth Moutal drawing for the Index of American Design of The Mariners' Museum figurehead OF72 which carving was previously said to represent Commodore Oliver H. Perry (fig. 1.7).[39]

Figureheads with base drapery similar to this include Mystic Seaport Museum's "Fredericka" figurehead.[40]

Unidentified female figurehead in Clarence P. Hornung, *Treasury of American Design and Antiques.*[41]

A more formal version of this bust figurehead style and base drapery type is seen in the male figurehead at the former Handels-og Søfartsmuseet, which was at the Kronborg Castle at Helsingør until 2011.[42] An image of that bust figure is published in Hansen, *Galionsfiguren.*[43]

A beautiful female figurehead with similar base drapery is said by the Naval and Oceanographic Museum in Rio de Janeiro, Brazil, to represent Dona Januária from the corveta *Dona Januária.*

In the same general style as Neruda's Venezuela Man figure is the previously designated *Commodore Perry* figurehead at the Farnsworth Museum, Rockland, Maine, with accession number 1320. That figure is no longer referred to as Perry.

Neruda saw in a book by Julian Amich Bert a picture of a male carving that Neruda considered highly similar to his own figurehead. Neruda penned a note to that effect in the page margin, but that figure is without the base drapery style that is such a prominent feature of the Venezuela Man carving.[44]

DISCUSSION

There is no definitive way to ascertain that this Neruda figure was made by a ship carver for the purpose of being a figurehead. It is very similar to The Mariners' Museum OF72 figure, but there are notable differences in size, buttons, and more. Neruda's carving could be either a figurehead made in a general style or a likeness intended for some other decorative purpose. Since figureheads almost never have a carver's signature or a date or a ship name, it is necessary to examine and judge surface and stylistic details and make comparisons to as many other similar figureheads as possible.

While the author was studying Neruda's Venezuela Man carving in relation to carving OF72 at The Mariners' Museum, a remarkable 1931 letter, written by a Boston antique dealer, came to light.[45] It tells that the man who owned the figure (OF72) before the antique dealer took possession of it from him, died before he told the antique dealer anything about the figure's history. The dealer said he never had been able to line up where the figure was used. This evidence raises questions about how Commodore Perry's name first came to be attributed to the carving. Whether it began with an earlier owner, or with the later antiques dealer and letter writer, R. W. Burnham, the specific basis for calling the figure Perry is not known. Indeed, since the image does resemble Commodore Oliver H. Perry, the attribution to that military hero stayed with the carving for many years, despite the notable fact that the carving shows civilian rather than military attire.

What further developed is significant and covers a period before this figure reached The Mariners' Museum. In 1931 the so-called Perry figure went on display at the Newark Museum as part of art historian Holger Cahill's early folk art exhibit. The figure was listed in Exhibit Catalog Newark 1931, no. 2, and that gave the carving greater standing in the art world.[46]

In 1938 when The Mariners' Museum bought, displayed, and referred to the figure as Commodore Oliver H. Perry, Index of American Design artist Elizabeth Moutal, described by her colleague Lucille Chabot as "brilliant, beautiful and charming," came to The Mariners' Museum to draw this figurehead (fig. 1.7).[47] The resulting image went out to schools, artists, and manufacturers for the purpose of promoting the Index of American design images in its task of creating a "useable past" that could be copied or altered or changed in imaginative ways. The index's drawn images were meant to spread ideas that could help contemporary artists make new, sellable art. Just two years later, in 1940, Pauline Pinckney's book on figureheads labeled a photo of The Mariners' Museum's figure OF72 as the "*Commodore Perry* figurehead."[48] Pinckney suggested it was from an 1822 packet, although no supporting evidence is found. Subsequently, suggestions that OF72 is from the 1854 *Commodore Perry* by the famous American shipbuilder Donald McKay

are also unjustified for two reasons. First, an 1854 newspaper reporter who had been aboard McKay's new vessel mentioned it had the figurehead of a man in uniform, but the so-called Commodore Perry figurehead, OF72, is in civilian attire. Second, McKay's *Commodore Perry* was clearly meant to honor not Oliver H. Perry but Perry's older brother Matthew Perry inasmuch as the sister ship being completed was named *Japan*. The two ships were a tribute to Commodore Matthew Perry for having opened up America's trade with Japan, and the figurehead OF72 at The Mariners' Museum bears no resemblance to Commodore Matthew Perry. It remains unknown who OF72 represents or anything about a ship related to it.

Where does this leave us with respect to Neruda's carving? It appears to be a portrait bust that is stylistically similar to figures named above, and it is unknown what person it represents or what maritime history it may have had.

Chapter Two

Neruda's Female Figureheads

WOMAN HOLDING HAIR: SHE WAS A KIND
OF A CHARACTER IN OUR LIFE

Overview

One of Neruda's figureheads is unusual for portraying a woman who holds a section of her long hair falling forward over her left shoulder. The figure's identity is unknown and there are no photos of Neruda standing beside her; yet her pose, the quality of the carving, and surprising firsthand accounts concerning her, set this figure apart.

An article mentioning the purchase by Neruda of a figurehead owned by artist Ludwig Zeller made possible my locating Beatriz Hausner, Zeller's stepdaughter, living in Canada.[1] Since this turned out to be the only opportunity I had for firsthand discussion with a family that had known Neruda, I immersed myself in details they told, from the figurehead's bumpy vegetable truck ride, family visiting with the carving in their fresh-smelling garden, and other personal facts that add color to this story. Hausner recalled that as a young girl, she had peered down from the second floor of the Santiago home shared by Zeller and her mother, artist Susana Wald, to see Pablo Neruda talking quietly with her stepfather. Everyone fully understood Neruda and Zeller's big political differences, so Neruda's presence in their house seemed surreal.

That occasion was prompted by Zeller's plan to move his family from Chile to Canada and the fact that the beautiful figurehead he owned had quick-cash value to cover the family's flight. To Hausner, who was under five feet (1.54m) in height, the figurehead that seemed tall was an indelible family favorite: "We really liked her. She was kind of a character in our life. We referred to her almost as a person, saying we were sitting in the garden next to 'Eleonora.'"

I deeply hoped Hausner's recount had also just given me the name of the

Fig. 2.1. Woman Holding Hair figurehead, front. © Fundación Pablo Neruda.

Fig. 2.2. Woman Holding Hair figurehead, lacing board at back.
© Fundación Pablo Neruda.

ship from which the figure came; however, searches of ship directories, shipwreck records, and other sources did not reveal an appropriate vessel by that name. What I did find in that search, though, was Edgar Allan Poe's "Eleonora," a short story written about not feeling guilty for having found a new love and remarrying. That prompted a question.

On my next telephone call with Beatriz Hausner, I cautiously asked, "Were Susana Wald and Ludwig Zeller ever married?" I knew that Chile did not then permit divorce, and each had been previously married. Hausner's reply was quick and clear: "No, they weren't. And it caused great difficulty for everyone in the family." When I asked Hausner if she thought the figurehead was called Eleonora because of a connection with Poe's "Eleonora" story, rather than it being a ship name, she was quick to accept that possibility. She said Zeller was, indeed, a big fan of Edgar Allan Poe, and it was absolutely the case that there had been considerable strife in their home about Zeller and Wald being together.[2] One day later, however, my Poe theory was dashed. Hausner by then had spoken to her mother, Susana Wald, living in Mexico, who said, "No, no, the figurehead's name was 'Leonora,' not '"Eleonora".'"[3] Whatever the Zeller family did call the figure, they had their personal reasons, just as Neruda had his.

When I asked where the figurehead had come from, Wald restated much of what her daughter Beatriz had already told me. The figurehead was from a German ship up north that had burned. Wald said it was probably in the port of Tacna, Peru, and she emphasized that Zeller was German and "very close to high-ranking people in the Ministry of Education." He seems to have used his connections to have the figure transported over the short distance from Tacna to Arica, Chile. When Hausner described her stepfather Zeller retrieving the figurehead, however, she instead named the famous Chilean nitrate port of Antofagasta, but she too said the figurehead was from a burned German ship. Some charring on the carving is visible.[4]

The family story continues that, from that northern location, Zeller rode south eight hundred miles beside the carving on a vegetable truck that was being driven to Santiago, Chile. He took up residence with Susana Wald soon thereafter. As Wald described to me by email, "When Ludwig moved in with me in December of 1966, he left behind his art collection, but (did bring) several thousand books, some clothes, and 'Leonora.'"

About the family home that included Ludwig Zeller and his figurehead, Hausner said, "Our living areas were small; we had no space for Leonora inside. We installed her under a tree in the front yard. We used to sit there every day in the evening at sunset, and each morning Ludwig would call out a zesty

Fig. 2.3. Woman Holding Hair figurehead, right side. © Fundación Pablo Neruda.

Fig. 2.4. Woman Holding Hair figurehead, left side. © Fundación Pablo Neruda.

'hello' to Leonora." And sometimes Zeller entertained his little stepdaughter Beatriz by telling her the figurehead was fashioned after a nineteenth-century captain's daughter, an idea that enchanted her, she said. Key words in Hausner's retelling of Zeller's description suggest he knew Henry Wadsworth Longfellow's celebrated poem "The Building of the Ship," which contains these lines:[5]

> And at the bows an image stood,
> By a cunning artist carved in wood,
> With robes of white, that far behind
> Seemed to be fluttering in the wind.
> It was not shaped in a classic mould,
> Not like a Nymph or Goddess of old,
> Or Naiad rising from the water,
> But modelled from the Master's daughter!

Hausner also told me, "We knew through gossip that, previously, every time Neruda got a new figurehead people would say to him 'Ahh, nice, but if you only saw Zeller's figurehead, you would die for it.'" Neruda had wanted Zeller's figurehead for years, and now with Zeller's planned departure for a new life in Canada, Neruda was in the driver's seat. The amount paid is not given but we know that Neruda arrived with his charming wife, Matilde, and a bottle of wine to help smooth the sensitive transaction, and eventually the moment came when the heavy figurehead was loaded into the back of Neruda's station wagon. Of Leonora, Hausner said, "That was the last I saw of her, except for a few photos published here and there." She further explained that they had no more dealings with Neruda because their relationship was "not rosy," which may also explain why Neruda did not retain information about this purchase nor indicate anything about the figure's name.

Neruda likely admired in this figurehead the long, wavy lengths of carved hair, since hair was often a focal point for him regarding the women in his life. Matilde's wild tresses earned her the nickname Medusa when they lived on the Isle of Capri in Italy, and Neruda playfully called their Santiago home "La Chascona," which Matilde described as Spanish for "curly hair." Neruda also commissioned Mexican artist Diego Rivera's oil painting of a front and a side view of Matilde's face, copiously framed by her wavy red hair, and on that front view, Neruda had the artist embed with paint a small side view of Neruda's nose, lips and chin. To Neruda, hair mattered, and his poetry speaks of "all the hair that I have learned." This carved-wood figurehead of a beautiful woman forever poised to hold her long hair would have spoken in intimate terms to him.

GENERAL

Museum: Isla Negra House Museum, Pablo Neruda Foundation

Type and Materials: Sculpture, wood

Name Used: Woman Holding Hair is the name chosen to be used here for this figurehead. If Neruda gave this figurehead a name, it is not recorded. Some have called this carving "Medusa II" on the assumption that Neruda's poem "Medusa II" was written for this figurehead. It appears to me that "Medusa II" was a second poem about the so-called Medusa figurehead that is discussed elsewhere in this book.

DIMENSIONS

Length: 56½ inches (143.51 cm)

Width: 21½ inches (54.61 cm) at shoulders

Depth: 15 inches (38.1 cm) at chest from outside left hand to figure's back (not to outside the lacing board)

Depth with Lacing: 18 inches (45.72 cm) outside left hand to outside lacing board

Lacing board: 7 inches (17.78 cm) is width taken at chest level

Face Length: 7½ inches (19.5 cm) top of forehead to chin

Face Width: 6 inches (15.24 cm)

FEATURES

Style: Scroll-skirt.

Pose: This figurehead with the uncommon design of a forearm bent back toward the shoulder, is distinguished from more typical figurehead designs of an outstretched arm, or of one arm pressed against the chest in pledge-like fashion. With this buxom young female figurehead having the left arm away from the body, attention is focused on the long hair she holds and to the fullness of the upper body. A few figureheads with similar bended-arm designs are discussed below in Stylistic Comparables.

Attire: Belted, classical-style gown with each sleeve draped off the shoulder.

Face, Eyes, Ears: Beautiful, serene face turns slightly to the left with almond-shaped eyes looking up, and the sinuous tresses covering the ears, leaving bare just a bit of the left earlobe.

Hair with Ornament: With a subtle center part to the hair front, long, wavy locks are a focal point. Adorning the hair is a narrow band, intermittently decorated with leaves and with flowers that match those on the belt.

Jewelry: There is a large gold bracelet with incised geometric lines at the left wrist and a similar partly missing bracelet at the right wrist. The smooth, reflective surface of the left bracelet contrasts to the appearance of soft, waving hair.

Belt: At the belt front is a six-lobed flower with a round center that is similar to the blossom on the hair ornament.

Drapery: Falls of fabric at the figure's back change into side and front drapery. Seen from the figure's left, the entire curving drapery line beginning at the back of the head frames the complexity of the hair, face, and bent arm. Drapery on the figure's right mirrors the curve of the arm, taking the eye to the now-charred right hand, where folded-under fingers lie within what is carved to appear as lush fabric.

Side Scrolls: The right scroll has traditional hard edges, but the left scroll is more rounded in a way slightly suggestive of thick-rolled dough, and it would be interesting if the difference indicates the work of a carver's apprentice. That is something we cannot know with any certainty about Neruda's carving, but years ago modern woodcarver David Calvo, working in Gloucester, Massachusetts, mentioned that his early training required him to emulate the work of a master carver, who had already completed one side of a wooden mirror frame. Calvo was to repeat the pattern on the other side. Likewise, nineteenth-century ship carving was an arduous trade learned through years of apprenticeship.

Wood Joins: Three wood joins are apparent on the left arm and hand.

Surface Treatment: Traces of burned wood are on the right-side scroll and right hand. The figure is white overall, except for traces of gild at the bracelet and some dark paint at the belt. Areas of paint are removed.

Fastening to Ship: Two metal through-bolts are visible on the middle and lower areas of the lacing board.

CONSERVATION

WOMAN HOLDING HAIR was called Medusa II in the Pablo Neruda Foundation's "Technical Restoration Report." About museum display, mention is made of removal of superfluous paint from face and hand areas and that scraping and recovery of forms and materials in some areas is noted. Patina was enhanced by rubbing with rags. Mounting in the display area was achieved using an anchor of chain, and lower support was provided in the back of the carving. It was recommended that the figure continue to be observed and treated for disintegrated wood.

STYLISTIC COMPARABLES

The following figureheads, comparable to Neruda's Woman Holding Hair, date to the last quarter of the nineteenth century and later.

The winged figurehead from *St. Michel*, a scroll-skirt carving at The Mariners' Museum, Newport News, Virginia, has the left lower arm bent up to

the shoulder and both the left and right hands hold long, wavy hair that falls forward over the left shoulder. That figurehead measures 85½ inches (217.17 cm) in length and may have been carved around 1909, when new owners gave the 1879-built barque, formerly named *Okeia*, the new name of *St. Michel*. Photos of *Okeia* show it had a female figurehead without wings. When the vessel became St. *Michel*, it carried a female figurehead with wings. *Okeia* was built by Flensburger Schiffbau-Gesellschaft, in Flensburg, Germany; her dimensions were 178.3 by 31.3 by 18.0 f, 721 gross tons and 688 net tons.[6]

A photograph of a female with wings in the style of a scroll-skirt figurehead is labeled as being from the vessel *Iris*, which presumably draws on the Greek mythological personification of the rainbow. The figure's left arm bends up to the upper left side of the body. This photo is in the Figureheads of Ships VM308F47 folio at The Mariners' Museum, where the file shows a ship date of 1877, but no further information about the vessel.

Jessomine (later *Heldos*, later *Fidelo*), carried a scroll-skirt figurehead of a woman with the right arm bent against the body while holding hair that falls over her shoulder. Approximate figurehead measurements were taken while visiting the Norwegian Maritime Museum in Oslo, Norway, some years ago. The figurehead was around 100 inches (254 cm) in length, including carved wheat in the hair; its width was 22.8 inches (58 cm at shoulders), 15.7 inches (40 cm) depth back to right hand at chest, 8.6 inches (22 cm) face length from top of forehead to chin and 7 inches (18 cm) face width at the ears, and an 11-inch-wide (28 cm) recessed lacing as measured at chest level. Record of the vessel shows it was built by W. H. Potter in Liverpool in 1881, and it was 270 feet in length, 39.86 feet in breadth, and 34.1 feet in depth (82.2 by 12.1 by 10.3 m) and official number 84166.

MICAELA: GAUDY PAINT AND HOPE FOR GOLD

Overview

A surprising letter dated 1964 and uncovered in 2017 by the Pablo Neruda Foundation staff reveals that its author, Mr. Jorge Celery Zolezzi, who was deceased by 2017, once offered to sell Neruda a ship figurehead.

The full story was provided by the man's widow, ninety-two-year-old sculptor and painter Marta Espinoza, in a November 2017 interview with the foundation staff at her Santiago home.[7]

"On our honeymoon in Chile," Marta Espinoza said in her native Spanish, "my husband and I learned from the proprietor of our rental lodging in Huasco that a ship figurehead had earlier been found on a nearby beach." The timing of this discovery was perfect because, since her new husband

Fig. 2.5. Micaela figurehead, front. © Fundación Pablo Neruda.

already owned a furniture factory at Calle Compañia 1349 in Santiago, it was their goal to add an antique shop. "We even brought extra funds on the trip for any great finds," she added.

Intriguingly, the couple learned that when two unidentified men found what was to them just a large, abandoned wood figure on the Huasco beach, its condition was good, except for years of buildup of gaudy paint, but what they did next was striking. The men sawed off the head of the figure, purportedly in hopes they would find gold inside. Perhaps it was that they saw a bit of exterior gild trim, so common to large figureheads, that conjured the improbable idea of hidden wealth, or perhaps it was just desperation that something inside was of greater value to their lives than a large wood carving.

Locals around Huasco felt sure the wood figure was still in the area and even volunteered that it might have come from an American vessel, but no one really knew. On that trip, the newlyweds did locate, purchase, and transport the carved body with its separated head to their Santiago shop for rudimentary patching, still visible today.

In 1964 when the repaired figurehead was in a letter from Celery Zolezzi, offered to Pablo Neruda, the poet could not afford it. Instead, it went to another buyer, but perhaps on special terms. According to Marta Espinoza, the figurehead was later sold by that buyer to Neruda once Neruda had earned money from his copyrighted translation of a play by Shakespeare.[8]

The ship the carving had once decorated remains unknown. Neruda called the figure Micaela, but no ship registry includes a suitable vessel by that name and Neruda provided no historical reference.[9] Neruda almost certainly chose the name Micaela for personal rather than historical reasons.

Neruda was too colorful, playful, and prideful to ever simply say he purchased a figurehead from a man who had earlier bought it from a dealer. At the very least it would squander superb story-telling opportunities. Instead, it seems Neruda's imagination conjured a Chilean garden near an agricultural field, which he said was Micaela's temporary home before he rescued her and placed her close to the seas. Neruda's Spanish original of "La Micaela" is shown in appendix A. Translated into English in *The House in the Sand* , it reads:[10]

Micaela

The last one to arrive at my home (1964) was Micaela.
She is corpulent, sure of herself, with colossal arms. After her
sea crossings, she was set up in a garden, among the farmlands.
There she lost her maritime condition, was stripped of the
mystery she certainly had (because she was brought from the

Fig. 2.6. Micaela figurehead, right side.
© Fundación Pablo Neruda.

Fig. 2.7. Micaela figurehead, left side.
© Fundación Pablo Neruda.

wharves) and was transformed into a purely terrestrial being,
Into an agricultural figurehead. She appears to carry in her
raised arms not the gift of the twilight at sea but an armful of
apples and cabbages. She is rustic.

There is no evidence that Neruda ever found Micaela in a garden, although outdoor placement does make it easier to address figurehead display issues of weight, transport, and available space. Too, Neruda may have been aware of articles like "The Garden of Figureheads" featuring Robert E. Peabody's figurehead collection in a garden, and other stories such as those that follow.[11]

The carving from a vessel named *Race Horse* became a garden ornament in Chile's Biobío region on Mocha Island, and, in North America, entrepreneur and former shipbuilder Robert Moran put the 1874 figurehead of Columbia, removed from the shipwrecked *America,* on the grounds of his Rosario estate on Orcas Island, Washington. Likewise, the Admiral Farragut figurehead from the 1869-built *Great Admiral* stood in the garden of New York shipbuilder William Weld, and its photo appears in Pauline Pinckney's 1940 book *American Figureheads and Their Carvers.* Neruda became a collector of ship figureheads in the 1940s.

Figureheads placed outdoors could also be memorials; an example is the replacement *Caledonia* figurehead recovered after that vessel's 1842 wreck. The carving became a grave marker for her lost crew.[12] So, too, the figurehead from *Derry Castle,* wrecked in 1887.[13] At Virginia Beach, Virginia, a likeness of the female figurehead from the Norwegian commercial vessel *Dictator* faces the site of the 1891 shipwreck, where lost lives included those of the captain's wife and young child. In remembrance of the *Dictator* tragedy and many heroic efforts to save those onboard, an annual ceremony is held in Virginia Beach, now a sister city to Moss, Norway, the vessel's homeport. Moss citizens also position a duplicate of that ship figurehead to face Virginia Beach.[14]

GENERAL
Museum: Isla Negra Museum House, Pablo Neruda Foundation
Type and Materials: Sculpture, wood
Name Used: Micaela is the name used here. Neruda called her La Micaela.

DIMENSIONS
Length: 80 inches (203.2 cm) current base to top of approximately 4½ inches (11.43 cm) tiara
Width: 19½ inches (49.53 cm) measured at shoulders

Depth: 13 inches (33.02 cm) from back to right chest
Depth: 15½ inches (39.32 cm) back to outside right wrist
Lacing: 11½ inches (29.21 cm) lacing width taken at chest level but lacing gets wider and then less wide below this and is 12½ inches (31.75 cm) at waist
Face Length: 8 inches (20.32 cm) top of forehead to chin
Face Width: 6½ inches (16.51 cm)

<div align="center">

FEATURES

</div>

Style: Scroll-skirt.
Pose: Calm frontal pose, head turned slightly to right, right hand holds item to center of chest.
Attire: The figure's attire is a long gown with banded, draped, and deeply undercut sleeves. At the sleeve tops, gouge shapes catch the light, and finishing carved touches offer shallow fleur-de-lis and repeated leaf decoration at the neckline.
Face, Eyes, Ears: The nicely modeled face features a strong chin. The brow ridge is made clear, rather than having eyebrows carved in relief. Eyelids are well-defined and the eyes have modestly incised irises and pupils. Ears are rounded at the top and at the earlobes. Rounded curls are in front of each ear.
Hair: Tight curls frame the face. The hair is otherwise pulled back and then gathered and uplifted at the back of the head.
Jewelry: The tiara with palmette-like design has a high centerpiece and, on either side, two shorter curving sections each have with a thick inscribed line about 1 inch (2.54 cm) from the outer edge. A headband also appears on either side of the tiara. There is a 1-inch-wide (2.54-cm) necklace at the base of the neck, and the ornament hanging from the necklace is obscured by the unidentified item held in the right hand of the figurehead.
Object Held to Chest by Right Hand: This may be intended as a handkerchief, which is a common device for female figureheads, yet it has angular edges at the top. The figure's right hand goes into this object, with the exception that the forefinger of the right hand remains outside.
Medallion Features: Two large decorative oval fastenings on opposite sides and different planes provide three useful design solutions. First, they create surface shapes from which light bounces. Second, the right medallion is made to look as though it secures fabric going in different directions. Third, on the left, the medallion works to fill space where the carver chose to keep solid the area between the left arm and body.
Decorative Inscribing: Decorative design over large areas on this carving is handled through generous use of incised-line leaf shapes that edge the

bodice neckline and garment surfaces. The incised leaflike design also accents both of the scrolls' raised-wood and ground areas.

Drapery Design: That the full width of side drapery is lost is apparent from the large flat areas behind the scrolls where, on each side, a single additional piece of wood would have been attached. On this figure the back drapery offers deeply cut channels that would facilitate water runoff, while also providing the essential play of light and shadow that is the bedrock of sculpture.

Lacing Board: Fastening and fastening holes are visible at the graduated-width lacing board.

Side Scrolls: Tops of the side scrolls have overhanging carved drapery, and decorative lines are inscribed on the scroll's recessed, flat ground space.

Surface Treatment: Traces of colored red, blue, black, and white paint remain on the figure.

CONSERVATION

The Pablo Neruda Foundation's 1989 "Technical Restoration Report" indicates there was use on these figures of the chemical Xylamon, an active ingredient deadly to larvae, and that also one time per year for six years the Micaela figure was wrapped in plastic as part of further chemical treatment to kill termite larvae. Micaela was also described as having a regular state of conservation but that in the lower front, wood was not integrated. There is also a report about "elimination of superfluous paint on the face and reintegrating a piece of the upper lip." Recovery of the original color is said to have been done on the right side. Mounting the figurehead was with an anchor with chain, and a different chain was recommended. There was also a rcommendation to continue checking on wood decay.

STYLISTIC COMPARABLES

Micaela is a scroll-skirt figure with semiclassical attire, a prominent tiara, and arms held to the body. Figureheads in the general style of Micaela were on these British iron and steel vessels of the 1880–90s.

> *Birkdale* was a 1,388-ton, steel-hull, three-masted barque with dimensions of 248.5 by 37.5 by 21.7 feet (75.7 by 11.4 by 6.6 m) that was built in 1892 by Bigger of Londonderry, Ireland, for J. H. [Henry] Iredale. The vessel wrecked in 1927 on Lobos Island off southern Patagonia. *Birkdale*'s figurehead also included classical attire with banded elbow-length sleeves and a prominent tiara. A surviving photograph, accessed Sept. 12, 2017, from the State Library of Victoria in Melbourne, Australia, shows that a piece of the skirt front had to be cut away to clear the bobstay.
>
> *Rhine* was a three-masted, iron-hull vessel of 1,556 gross tons. *Rhine*

measured 257.2 feet in length, 38.3 feet in breadth, 23.1 feet in depth (78.3 by 11.6 by 7.09 m in depth) and was built in Greenock, Scotland, by Russell and Co. for James Nourse (1827–1897). P. N. Thomas's research on British carvers indicates that the figurehead for *Rhine* was assigned to John Roberts on November 30, 1886.[15] My opinion is that Neruda's Micaela figurehead is somewhat more finely carved and presumably not from the same hand as the *Rhine* figurehead at Mystic Seaport Museum. As the successful London owner of a large fleet of ships, Nourse utilized different shipyards for newbuilds, which helps account for variations in ship carvers who made his figureheads. He also bought vessels from other ship owners and possibly retained some of those figureheads. Nourse's vessels, typically named for rivers and carrying allegorical female figureheads, included *Liffey* (1876), and more is described about that intriguing figurehead in the chapter on Bonita and Novia.

Derry Castle's figurehead with classical attire and a tiara, looks to the right and holds a hand to the center of the chest. The figure was sculpted for the 1883 Glasgow-built iron barque *Derry Castle*, 1,367 tons and measured 239.8 by 36 by 21.4 feet (73.09 by 10.9 by 6.5 m). A recount of the vessel's tragic shipwreck at Enderby Island, New Zealand, and her figurehead ultimately serving as a grave marker for those lost at sea is referenced in 1887 news reports.[16]

CYMBELINA: BURY THE UNLUCKY FIGUREHEAD

OVERVIEW

When Neruda spoke of artists successfully borrowing from one another to create new visions, he was quick to point to a painter like Pablo Picasso, who elicited fresh ideas from African art. While Neruda did not mention it, his work suggests he drew on another author for some of his Cymbelina figurehead story, which he situated in a Chilean bay.[17] "Cymbelina" is a prose poem with features also seen in Jean Lipman's *American Folk Art in Wood, Metal, and Stone,* a book that is still in his library at the Pablo Neruda Foundation.[18] Lipman wrote that a ship's compass was securely stored within a wooden binnacle carved in the image of a man whose eyes were believed to move and cause the ship to go off course. In desperation, the crew of the ship removed the binnacle, rowed it ashore, and buried it.

Neruda's version featured a nameless, somber cove in wintertime Chile with rain, birds, and cliffs that enshroud the reader with a sense of remote desolation. Neruda changed the carving to a figurehead wearing white and gold attire, which he mentions early in his prose poem *Ceremonia,* shown in appendix A. The following English translation is from the book *The House in the Sand.*[19]

Fig. 2.8. Cymbelina figurehead, face detail. © Fundación Pablo Neruda.

Fig. 2.9. Cymbelina figurehead, front. © Fundación Pablo Neruda.

Ceremony

In 1847 an American vessel, the clipper *Cymbelina*, landed in some nameless cove in northern Chile. There the men of the sea proceeded to take down the figurehead from the prow of the sailing vessel. This white-and-gold statue seemed to be a very young bride garbed in Elizabethan costume. The face of that wooden girl was astonishing because of its wrenching beauty. The seamen of the *Cymbelina* had mutinied. They maintained that the prow figurehead moved its eyes during the voyage, putting them off course and terrifying the crew.

It is not an easy thing to dethrone the queen of a tough, old vessel. But impelled by that religious terror, the sailors sawed through the powerful bolt that fastened her to the bowsprit, cut through nails and screws until they were able, not without certain fear or respect, to lower it and place her in a launch that carried them to shore.

The sea was choppy that July day. It was in the middle of winter, and a heavy, slow rain, strange in that desertlike region, was falling on the world.

Seven crewmen carried on their shoulders the wooden girl strangely separated from her ship. Then they dug a ditch in the sand. The *guanayes*, stercoraceous coastal birds, were flying in circles, cawing and shrieking while the unsettling chore lasted. They laid her on the ground and covered her with the nitrous sand of the desert. It isn't known if any of the men who buried her attempted to pray or felt some sudden pang of regret or sadness. The *garuga*, a slow rain borne on the north wind that oscillates between fog and phantasmagoria, soon covered the seashore, the yellow cliffs, and the boat which in the great silence brought the seafarers back to the sailing ship *Cymbelina* on that morning in July 1847.

Neruda used his figurehead burial story elsewhere too, describing how two friends broke into a wealthy Chilean's home to steal a beautiful female figurehead. Its owner had refused to sell it to Neruda, and the poet says that when friends eventually dropped off a carving for him at Isla Negra, it was only then that he realized it was the same figurehead once buried in sand on the beach in northern Chile. His devoted, thieving friends were buddies from his own drinking club "The Boot."[20]

Neruda writes in that prose poem that this is from the clipper ship *Cymbelina,* operating in 1847, but that is unverified. He generally mixed,

Fig. 2.10. Cymbelina figurehead, right side. © Fundación Pablo Neruda.

Fig. 2.11. Cymbelina figurehead, left side. © Fundación Pablo Neruda.

repurposed, and adapted material, but one appearance of that name that caught my eye involves Neruda's contemporary, Argentine poet Alfonsina Storni, whose writing about politics, sex, and love gained her a reputation as a great Spanish American writer. She and Neruda knew each other; her work appeared in *La Nation*, as did Neruda's, and Neruda hosted her at a party at his ultra-modern apartment in Buenos Aires according to one modern author.[21] In 1931 Storni's farcical play called *Cimbelina En 1900 Y Pico* combines strong women characters from Shakespeare's seventeenth century *Cymbeline* and Euripides' fifth-century BCE Greek tragedy *Hecuba*.[22] Shakespeare's play *Cymbeline* is named for a British king whose beloved daughter Imogen weds despite his demands she not do so. Neruda's own words about his figurehead are "This white-and-gold statue seemed to be a very young bride. . . ."

It is unknown whom this figurehead represented in Neruda's eyes, or the truth about the carving's identity and ship. The Pablo Neruda Foundation's 1989 "Technical Conservation Report" reiterates "From an American clipper; purchased," in keeping with Neruda's poem, but no associated shipping or other records have been found.

GENERAL

Museum: Isla Negra House Museum, Pablo Neruda Foundation
Type and Materials: Sculpture, wood
Name Used: Cymbelina is the name Neruda used for this carving. His poem "Cymbelina" suggests it is from an American clipper, but there is no evidence that this is the case.

DIMENSIONS

Length: 47 inches (119.38 cm) from top of head to current base, left side
Width: 16 inches (40.64 cm) with no arm on her right, to outside arm on left
Lacing: Width, taken at chest level
Face Length: 7 inches (17.78 cm) from top of forehead to chin
Face Width: 5½ inches (13.97 cm)
Neck length: 3¼ inches (8.26 cm)

FEATURES

Style: Scroll-skirt figure.
Pose: The body, although mostly frontal, leans a bit to the figure's right, with the head angled right and eyes looking upward. Body lines suggest that the right arm, now missing, may have been raised.
Attire and Arms: Horizontal gathers of what appears to be light fabric at the bodice are set off with a bit of carved trim that only close observation reveals. The upper garment, cinched in by taut, zigzag strings, finishes below

the waist with small, separated vertical panels that lie over a gathered skirt. The now-missing right arm was designed for removal, based on the visible mortise into which the arm's tenon would have locked. The surviving upper left arm, showing the gown's cap-sleeve, appears original and may also be removable. Future X-rays could shed more light on this. The lower left arm appears to be a replacement.

Expression, Face, Eyes, Ears, Hair, Veil, Flowers, Jewelry, Drapery: As is common on figureheads, wood has broken at the tip of Cymbelina's nose. The figure's expression conveys both sweetness and melancholy, an effect achieved partly through eyes having the iris and pupil defined with light circular incisions. The lovely face and mouth are attractively framed with a dangling earring on the right, and a cluster of whirling flower petals and leaves on the left. Ample piercing of the mantilla-like head covering conveys the lightness of that fabric placed over hair held high at the back of the head, presumably by a bun or hair comb.

Decorative Incising: An incised line along the edge of the figure's skirt creates a small border where contrasting paint or gold was likely applied.

Side Scrolls: Attractiveness of this figure's deep-shadow side scrolls is heightened by the uninterrupted clarity of their lines. Left- and right-side scrolls are typically approximate mirror images, but the small difference here is that, on Cymbelina's left scroll, the acanthus foliage sits nearly at the scroll's highest point, while on the right scroll, the acanthus is further forward. Scrolls often seem to suggest strong opposing forces. Here leaves push forward, while scroll lines thrust back and eventually dissolve into the eye of the scroll. An added feature in Cymbelina's design, too, is the small, plain arc, slightly raised in the interior of the scroll's ground area, that represents a vine.

Surface Treatment: Current paint color is white. Neruda's poem "Ceremony" calls this figure a white and gold statue. Indeed, gold leaf was frequently used to trim nineteenth-century figureheads, but, despite Neruda's words, gold is not now evident on this figurehead.

Fastening to Ship: A hole at the center of the waist shows placement for any drift bolt used to secure the figurehead to its ship.

Lacing Board: Flat traditional lacing board.

CONSERVATION

The 1989 "Technical Restoration Report" asserts that Cymbelina was in a reasonable state of conservation, despite lacking the right arm and fingers of the left hand and having several loose parts. The face was cleaned and retouched. There was disintegrated wood, but display of the figure was made possible through an anchor with two chains. The photograph in the "Technical Restoration Report" shows the highly-cracked Cymbelina having surface wear that is no longer visible today.

STYLISTIC COMPARABLES

STYLISTIC COMPARABLES

Mary Hay figurehead, 258-ton wooden barque, built 1837 in Peterhead, United Kingdom. This figure, with two removable arms, is in the Royal Museums Greenwich, Valhalla Collection, at Tresco Abbey Garden, Isles of Scilly, United Kingdom. Also stylistically similar is the Gold Earrings Woman figurehead in Carol A. Olsen, Bengtsson Collection, Stockholm, Sweden.

SIRENA: A CLIPPER CAME TO CHILE AND LEFT MANY THINGS HERE

Fig. 2.12. Sirena figurehead, front. © Fundación Pablo Neruda.

Fig. 2.13. Sirena figurehead, left side. © Fundación Pablo Neruda.

Overview

And you alone among the faces paralyzed
by the threat, submerged in sterile grief,
received the spattered salt on your mask,
and your eyes stowed the salty tears.
More than one poor life slipped through your
 arms
To the eternity of the mortuary waters
And the contact of the living and the dead
Consumed your sea-wood heart.[23]

...

From unknown tragic events, a broken yet beautiful figurehead in Neruda's collection is so ravaged that her face seems a partly severed mask. More than any other, this figurehead typifies Neruda as a collector of worn objects, an identity he fully chose to project. Neruda called this female figure La Sirena, although no ship by that name or Serena is yet associated with it. On the other hand, since Neruda gave to another figurehead in his collection the ghost-ship name *Mary Celeste*, it is reasonable to question whether Neruda chose the name Sirena from a folk story known in the Chillán area where Neruda's wife, Matilde, grew up.

A three-masted, five-sail ship named *El Caleuche* protected the community from intruders. Sailing on dark nights with brilliant lights and blaring music, the onboard sea king and queen were accompanied by their children, brother Pincoy and sister Pincoya. And there was another, their mermaid-like daughter, Sirena chilota, whose duty was to retrieve and revive drowned mariners.[24]

Neruda's accounts of his figurehead acquisitions are inconsistent.[25] His *Memoirs* point to his personal rescue of the Greek lady Medusa as his first figurehead acquisition. But in the film *Yo Soy Pablo Neruda* he says a different figurehead, one called Sirena, was his first collected figurehead, as a gift from friends in the South who retrieved it from a storm-ruined clipper ship.

Neruda's comments about the Sirena figurehead create an intimate mood in a broad panorama: "The first [figurehead] [was] sent to me by the seamen of Punta Arenas in the Magellan Strait. She's called Sirena because the boat was called *Sirena*. It was an English boat that sunk in the Magellan Strait. You see the sea around this Magellan Strait is famous for storms, and many ships have sunk there, and clippers [had these] figureheads fastened to the ships of the sailing time. A clipper came to Chile and left many things here."[26]

No supporting documentation about a related vessel for this figurehead is found in Neruda's archives or the public records I have examined. Separately, in considering whether this might be the figurehead from the vessel *Lonsdale,* which was broken down to a pontoon and came to rest in southern

Chile, the problem is that the Sirena figurehead in Neruda's collection differs stylistically from what can be seen of *Lonsdale*'s figurehead in a historic ship photograph, as discussed in the separate Medusa chapter.

GENERAL

Museum: Isla Negra House Museum, Pablo Neruda Foundation
Type and Materials: Sculpture, wood
Name Used: Sirena. Neruda called this figurehead La Sirena

DIMENSIONS

Length: 90 inches (228.6 cm) from top of head to current base
Width: 20 inches (50.8cm) at shoulders
Depth: 22 inches (55.88cm) from outside left arm to outside back drapery
Depth: 12 inches (30.48 cm) from left breast to back
Face Length: 8 inches (10.21 cm) top of forehead to chin
Face Width: 7 inches (17.78cm)
Lacing: 10½ inches (26.67 cm) taken at chest level

FEATURES

Style: Scroll-skirt.
Pose: Body in frontal pose with head turned and tilted to left, and left hand to center of body and right hand at side.[27]
Attire: Classical dress with undraped and modestly rendered chest partly shielded by carved fabric held to the center of the body. The slipping left sleeve's medallion detail is in relief at the sleeve front and a distinctive belt is carved in relief at the waist front.
Face, Eyes, Ears: A wood crack encircles the face. Iris and pupil of eyes are defined and only lobes of the ears are shown.
Hair: Full, wavy hair is pulled back from the face, gathered at the back of the neck, and one long strand of curls falls forward over the left shoulder.
Drapery: Lush, thick fabric draperies swirl around this figure at the back and side in deep, complex channels that would shed water. Overlapping the lines of the left side scroll, shaped drapery echoes the raised left arm, with base drapery also coming to the front of this carving.
Lacing Board: The projecting lacing board wood has decay.
Side Scrolls: A large amount of base drapery covers the side scroll, and incised decorative lines are on the flat ground of the left side scroll.
Surface Treatment: Bare wood predominates. White base paint survives, and in several places a more light-gray color remains. The bright white face has a line around its edges where the wood is cracked.
Fastening to Ship: A rectangular opening on the front centerline of the figure,

just above the base drapery, represents placement for one fastening that secured the figure to its ship.

CONSERVATION

Photographs at Isla Negra detail the left hand with the fabric at the chest. Sirena in the 1989 foundation "Technical Restoration Report" was said to have papers stuffed into disintegrated sections of the figure. Later, after inspections of advanced wood disintegration on the back and interior, it was decided not to try consolidation because it would not be reversible and because the figure's formal structure was not affected. Some scraping, as well as white paint application to back and face, was done, but the severe facial break itself is not discussed. It says that, using a double anchor and chain for support, the figure was mounted with a slight change of direction from the way Neruda had positioned it. Further, in 1995, this figure was requested for a show in Madrid, Spain, but museum records disclose discussion about sending a replica instead, though it does not appear that a replica was made nor that the original was sent. Notably, too, the conservation form, completed long after Neruda's time of collecting figureheads, says that Sirena de Glasgow's point of origin was Punta Arenas but there is no further substantiation.

STYLISTIC COMPARABLES

Traditional arm poses for larger nineteenth-century figureheads often show one hand across the chest in a virtuous, pledge-like position. It is rare to find the pose Sirena has, with the left arm held just off the middle of the chest and the figure gently holding a swath of fabric. However, another figurehead similar to Sirena is full-length, rather than a scroll-skirt. That full-length figurehead was reportedly sold by the India House to a private collector in 2021.[28] It is said to represent the goddess Athena from Donald McKay's *Glory of the Seas*, launched October 21, 1869, in East Boston, Massachusetts. In *Portrait of a Port: Boston, 1852–1914*, author W. H. Bunting shares aspects of that launch event: "A famous photograph taken on the launching day of the ship *Glory of the Seas*, East Boston, October 1869. Her builder, Donald McKay, stands center under a high hat. The coppering has not been completed, but she'll float high. Apparently the paint will not yet stick to her bow planking. The figurehead is the goddess Athene—McKay had a romantic streak to his soul that wouldn't quit. . . . The *Glory* was built on speculation, and except for two sloops-of-war, was McKay's last creation. . . . [She was built] for the California grain trade. . . ."[29] If, as Bunting says, the figurehead on *Glory of the Seas* does represent Athena, it is of interest that Athena's shipbuilding knowledge is what guided Argus's construction of a vessel for Jason, that she was patron to architects and sculptors, and, for a ship destined for the nineteenth-century

California grain trade, Athena's connection to agriculture was particularly apt.

Neruda's partially nude figurehead likely also represents a mythological subject, perhaps Venus, for whom a half-fallen sleeve can be a visual clue.[30]

<div align="center">SIMILAR NAME VESSELS</div>

Sirena of Glasgow. Neruda's figure is sometimes referred to as Sirena of Glasgow.[31] Thousands of vessels have been built in Scotland along the River Clyde where Glasgow and Port Glasgow were among primary shipbuilding locations, and Neruda would have been aware of that.

Serena 1893. The Watt Library Ship Index lists *Serena*, built in 1893 by Russell and Co., Port Glasgow, for MacDonald, Adams & Co., Greenock. The vessel was renamed *Alcyon* and then renamed again as *Mattanja* before being broken up in Denmark in 1924.[32]

Serena 1881. The Pacific Steam Navigation Co.'s (PSNC) vessel *Serena*, 2,394 tons, built in 1881 and hulked in 1903, was in South American coastal service.[33] Among its functions, PSNC had the British government mail contract for many years. A view of this *Serena's* bow does not show her carrying a figurehead.

A handful of other *Serena* entries in ship registers did not produce a likely candidate, and although A. D. Bordes & Co. of Bordeaux, France, built beautiful vessels named for locations in Chile, no vessel of theirs is found that seems a candidate, including the one named for the Chilean town of La Serena.

<div align="center">

MEDUSA: STONES AND SHELLS, THE
THINGS THAT WOMEN LOVE

</div>

<div align="center">OVERVIEW</div>

By the 1940s few large sail-powered vessels carried cargo long distances; most had been replaced by steamships. Exceptions included vessels like the Flying P Line square-riggers *Pamir* and *Passat*, which operated between South Australia and England as late as 1949. Neruda, who described being emotionally moved by the sight of ships in Chilean harbors and underway, witnessed some of the last great working square-rigged vessels in the Pacific. Yet, an abrupt jolt from any such joys occurred as Neruda's fortunes turned, and he became politically persecuted. A speedy retreat from his homeland is all that saved his life.

As a member of the Chilean Communist Party, Neruda served as a single-term Senator in Chile until severe reprisal for his January 6, 1948, "I Accuse" speech forced him into a series of Valparaiso safe houses. His daring 1949 horseback escape over the 4,598-foot (1400m) elevation Lilpela Pass of the Andes Mountains into Argentina ultimately made it possible for him to sail to Europe.

Fig. 2.14. Medusa figurehead, right side. © Fundación Pablo Neruda.

Fig. 2.15. Medusa figurehead, face detail. © Fundación Pablo Neruda.

Fig. 2.16. Medusa figurehead, left side. © Fundación Pablo Neruda.

Those matters are not in dispute. But what might we make of Neruda's figurehead story around that time of hiding? He says that from a safe house in Valparaiso he directed two dockworkers to salvage a female figurehead he had never seen and knew only from their verbal descriptions of it.[34] The men allegedly stored the carving; however, when Neruda returned from Europe in 1952, he says the figurehead (by which we may take him to mean Medusa) was gone, until he somehow rescued it from a garden. Neruda also used a similar garden theme with respect to his carving Micaela.

Adding doubt to Neruda's account of recovering the figurehead from a field in 1952 is the fact that the Medusa figurehead is seen at Neruda's Isla Negra house in photo FB01988 dated by the Pablo Neruda Foundation to the later 1940s. Clearly, by that time the stone wall facing the sea already had the Medusa carving placed by it.[35] That was also a time in Neruda's life when he enjoyed having a bell rung and his personal flag raised to indicate his presence on the property.

In the prose poem below, Neruda writes about hiding in Valparaiso, and when he mentions a figurehead that resembles the author Gabriela Mistral, it is hard not to conjure the similarly austere Medusa figurehead. Gabriela Mistral was significant to Neruda for having introduced him to Russian authors, and because, in 1945, Mistral was chosen as the first Latin American author to receive the Nobel Laureate Prize for Literature based on her "lyric poetry which, inspired by powerful emotions . . . made her name a symbol of the idealistic aspirations of the entire Latin American world."[36] Today portrait busts of both Mistral and Neruda are on the grounds of the Organization of American States in Washington, DC.

Pablo Neruda's poem "La Medusa. I" is reprinted in appendix A. The English translation, below, is from *The House in the Sand*.[37]

The Medusa. I

They hid me in Valparaiso. Those were turbulent days
and my poetry circulated in the street. This disturbed the
Sinister One. He demanded my head.

It was in the hills above the port. The boys arrived
during the afternoon. Sailors without a ship. What had they
seen in the harbor? They would tell me everything.

From my hiding place, I could see only through the
glass medium of the lofty window. It looked out over an alley.

The news was that an old ship had broken down. Does
it have a figurehead on the prow? I anxiously asked.

Of course, it has a *mona*, the boys said. A mona, or
mono, which in ordinary Spanish is a monkey, is for Chileans
the term of any kind of statue.

From that moment on I directed the activities from
the shadows. Since it was very difficult to take her down, she
would be given to whoever carried her off.

But the figurehead was to share my destiny. She was
very large, and she had to be hidden. Where? At last, the boys
found an anonymous and spacious shed. There she was buried
in a corner while I crossed the mountains on horseback.

When I came back from exile, years later, the shed
had been sold (perhaps along with my lady-friend). We searched
for her. She was proudly erected in someone's garden inland. No
one any longer knew whose she was or what she was.

It was as hard to take her out of the garden as it had
been to take her out of the sea. Solimano brought her to me
one morning in an immense truck. With great effort we

unloaded her and left her leaning on the stone bench with her
face to the ocean.

 I didn't know her. I had directed the entire operation
on the wreck from my darkness. Then violence separated us;
later, the land did.

 Now I saw her, covered with so many coats of paint
that neither the ears nor the nose could be seen. She certainly
was majestic in her flowing tunic. She reminded me of Gabriela
Mistral, when I, a small child, met her in Temuco, when she
would walk around wrapped in Franciscan robes from her
topknot to her overshoes.

 Neruda's poem "La Medusa. II," also reprinted in appendix A, tells of a
figurehead placed outdoors that became a religious object to certain visitors.
Neruda took the figurehead indoors, where he and others used tools to make
changes to the figure's appearance, as is evidenced by a photo in the collec-
tion of the Pablo Neruda Foundation. The poem, translated into English in
The House in the Sand, reads:[38]

The Medusa. II

 "The Medusa" remained with her eyes pointed
northwest and her large body arranged as on the prow of her
ship, leaning out over the ocean. Like that, so well positioned,
she was photographed by the summer tourists, and she
managed frequently to have a bird on her head, a wandering
tern, a passing turtledove. All of us in the house, including
Homero Arce, to whom I often dictated my verses beneath the
ashen brow of the statue, grew accustomed to her.[39]

 But then the candles started. We found the devout
women of the village kneeling, praying to the adventurous
figurehead. And in the afternoon they lit candles to her, which
the wind, an old connoisseur of saints, would extinguish with
indifference.

 It was too much: From the harbor of Valparaiso, the
constant company of sailors and longshoremen, to an illegal life
in the political underground of the homeland, to end as a
garden ornament, a sonorous priestess and now most holy
sanctuary. Since I get blamed for everything that happens in
Chile, they would have pinned the founding of a new heresy
on me.

 Matilde and I dissuaded the devout, telling them the

private story of that wooden woman, and we persuaded them
not to keep lighting candles to her, candles which besides could
set fire to the sinner.

But at last, against the menace of the wax that dirties,
the flames that incinerate and the rain that rots, we carried
Medusa inside. We set her up in the figurehead choir.

She came to life once more. When we took her inside,
with chisels and gouges we stripped away an inch of the thick,
disgusting paint that hid her, and one could see her decisive
profile, her exquisite ears, a medallion that no one had ever
noticed, and a jungle of hair that covered her bright head like
the foliage of some petrified tree that still remembers flocks of
birds.

Neruda was not religious, but he speaks of candles that could set fire to "the
sinner" and he speaks of a "figurehead choir."[40] Indeed religiosity has been as-
sociated with many figureheads throughout history and Neruda might have
enjoyed the following story, had he ever heard it, concerning the 1796–99
voyage of the 353-ton ship *Neptune.*

Eben Townsend, the onboard representative of that vessel's merchant
owners in New Haven, Massachusetts, said he watched things pretty closely
because there were "about twenty pretty crazy fellows" in the crew that to-
taled thirty-six men and boys. The ship's stop in Patagonia gave Townsend
business access to an armed Spanish garrison with a nine-foot-high stock-
ade, barracks, blockhouse, church, and bake house that "at the principal
entrance gate . . . had a poorly carved female figurehead of some ship that
had been cast away." Townsend concluded, "They called it the Virgin Mary;
[they] never passed it without a bow and crossing themselves."[41]

Any historical documents about Neruda's figureheads or their ships, if in-
deed any such documents ever existed, are gone. Just as a handful of Spanish
soldiers at a garrison chose to call their carving Virgin Mary, Neruda gave
names to his figureheads that were meaningful to him.

Medusa appears in various Neruda writings and seems to harken to 1952,
when Neruda and Matilde lived together on the Isle of Capri. Unable to le-
gally wed, since Neruda already had a wife in Chile, Neruda suggested that
their wedding ceremony be officiated by the moon itself so they would be
married when their baby, which Matilde was carrying, was born. It was also
the time frame when Neruda finished *The Captain's Verses,* which was in-
spired by Neruda's love for Matilde. Urrutia describes that the book had
only fifty copies, one of which was inscribed to the child they lost, whose
last name would have been "Neruda Urrutia" and it spoke volumes that the

book's cover showed a Medusa head because Medusa was Matilde's nickname from that time in Capri, when locals teased that her wild hair was like the great snake-headed gorgon in Greek mythology.[42] The location of the Isle of Capri is where, in Homer's *Odyssey*, sirens sang to lure sailors to shipwreck and Odysseus' sailors put beeswax in their ears to avoid hearing them. Instead of using beeswax, Odysseus chose to be secured to his ship's mast so he could hear the siren songs without yielding to them. Neruda and Urrutia's time together in the early days when she gained the nickname Medusa held great significance and forever changed their lives.

Years later when Matilde and Neruda lived together in Chile, she enjoyed wearing jewelry made from agates found on the sandy beach outside their Isla Negra home. A photo taken during Neruda's lifetime shows an agate placed on the wooden finger of the Medusa figurehead. Additionally, Medusa's necklace appears to have modern-made, seashell-like cuts.[43] These two items help conjure second-century Roman poet Ovid's work *Metamorphoses*,[44] in which the sculptor Pygmalion falls deeply in love with the beautiful female sculpture he has created, and he brings her . . . stones and shells, the things that women love. Might Neruda have had this in mind as well with shell and stone alterations to the Medusa figurehead?

General

Museum: Isla Negra House Museum, Pablo Neruda Foundation
Type and Material: Sculpture, wood
Name Used: Neruda gave the name *La Medusa* to this figurehead. Its title in a translated version of his prose poem is "*The Medusa*" in *The House in the Sand*. In Greek mythology Medusa is the Gorgon with a headful of wild snakes and Neruda nicknamed his lover Matilde Urrutia Medusa because of her wild hair. No association to a vessel named *Medusa* is found for this carving.

Dimensions

Length: 96 inches (243.84 cm) head to current base
Width: 23 inches (58.42 cm) at shoulders
Depth: 19 inches (48.26 cm) from chest to outside hand
Lacing: 13½ (34.29 cm) taken at chest level
Stem: 4 inches (10.16 cm) stem at front; about 3½ inches (8.89cm) each side
Face Length: 8 inches (20.32 cm) top of forehead to chin
Face Width: 7 inches (17.78 cm)

Features

Style: Scroll-skirt.
Pose: With head held high, this figure looks forward. The right arm has a pledge

pose across the chest. The left arm is at the side and the figure's long fingers appear to hold fringed fabric.

Attire: The classical gown has carved circular clasps at both shoulders. The sleeve edges are trimmed with thin decorative circles and half-circles.

Face, Eyes, Ears: Expression is noble and serious. Within well-defined upper and lower eyelids, the iris is outlined and the pupil given depth. Whether Neruda added any of these accents is unknown. Carpenter Rafael Plaza confirms that during his work to expand the house for Neruda, while he had the task of chaining some figures to the wall, he confirms he did no carving modifications.[45]

The placement of the ears at the jawline is noteworthy on this figure, and others exist with such low placement as well.[46] Often in sculpture, the highest part of ears is ideally on a line with the eyebrows and the lowest part of ears is on a line with the underside of the nose. One possibility is that changes made on figureheads were implemented to address high angles at which the figures were viewed.

Hair: Wood cuts on the hair appear crisp and the small curls around the forehead are not common.

Jewelry: A bracelet is on the right wrist and the figure has a necklace. Several large female figureheads in other collections have big and rather geometrically shaped necklaces; the shell shape on Neruda's figure is an exception. It seems very likely that some change was made to Neruda's figurehead's necklace during his period of ownership.[47] A Pablo Neruda Foundation photograph also shows an agate having been placed as a ring on this figure's finger.

Drapery: A carved-fringe edge is especially apparent on the left side of the figure. There is also a thinly cut gouge line about 1 inch (2.54 cm) away from the fabric edge, which may, in part, have been a delineation for gild or painted trim. Some of this figure's complexly shaped drapery is created by deep gouge cuts. Also, wood shaped for flare at the back of the skirt has been added to provide needed fullness for the figure's integration with a large ship's bow.

Decorative Lines: Shallow decorative lines can be seen on the surface of the left scroll, where paint has been stripped away.

Side Scrolls: The side drapery swirls into the space of the side scroll on Medusa, in contrast, for example, to the smaller Cymbelina carving in Neruda's collection, where the drapery stays atop the side scroll. These types of stylistic differences in figureheads can be apparent even in long-distance photographs of ships.

Lacing Board: Traditional flat lacing board with protruding metal fastenings that previously helped secure this figurehead to a ship.

Base Recess: Figureheads often have at the base of the carving a base recess corresponding to a projecting tenon on a ship's bow. The very large and heavy Medusa figurehead features two diagonal base recess areas.

Surface Treatment: Figure is white with areas of gold trim. On the side scroll is black paint and gold trim. Neruda's poem "Medusa II" tells of paint removal and his use of chisels and gouges on this figure.[48]

<div align="center">CONSERVATION</div>

Neruda's figurehead referred to in this book as Woman Holding Hair had erroneously been referred to as Medusa II in some early museum references. For the Neruda museum inauguration, there was removal of superfluous paint on the face and hand and scraping and recovery of forms and materials in some areas. Patina was enhanced by rubbing with rags, and mounting was achieved using an anchor of chain and there was lower support in the back. It was recommended the figure continue to be observed and treated for disintegrated wood.

<div align="center">STYLISTIC COMPARABLE</div>

The Carla figurehead[49] Bremerhaven's maritime museum (Deutsches Schiffahrtsmuseum) in Germany is visually comparable and has a double-strand necklace made to look like small-cut pieces. The Carla figurehead dimensions are approximately 97 inches in length, 1 inch in depth, and has a 13½-inch lacing board (97 by 35.5 by 34.2 cm) measured at chest height. The face length and width is 9 by 7 inches (22.8 by 17.7 cm). Carla was built 1899 by Schömer & Jensen, Tönning, Germany. The Carla figurehead also has low-set ears. No specific association with Neruda's carving is documented at this time.

Fig. 2.17. *Lonsdale* in an unidentified port. Courtesy State Library of South Australia.

LONSDALE: ABLAZE AT SEA

THE ONCE-PROUD SAILING vessel *Lonsdale* is in a perpetual state of disintegration, beached in Punta Arenas at Maria Behety Park in southernmost Chile.[50] For even the most casual observer, the hull evokes a solemn response, as does a commemorative plaque nearby.

Neruda visited the Magellan Straits in 1947. On October 28 of that year at Punta Arenas, a man named Antonio Sapunar Ojeda wrote a letter saying that, although it is known that the area's *Lonsdale* wreck was automatically nationalized by virtue of the vessel being wrecked there, he permits transport of the *Lonsdale* figurehead.[51] This letter basically confers new ownership of that figurehead and the matter has not been challenged in the intervening decades. But in 1974, the year after Neruda died, Neruda's archenemy Gen. Augusto Pinochet, issued a formal, signed declaration concerning a number of shipwrecks, including the *Lonsdale*, emphasizing that they are Chile's cultural property.[52] Perhaps understandably Neruda never claimed to have a figurehead from any specific ship and certainly not one from the *Lonsdale*; yet, until the day he died, twenty-five years after the letter was written by Antonio Sapunar Ojeda, Neruda assiduously held on to the statement, which reads in translation:

> I certify that a wood figure of approximately 551 pounds proceeds from pontoon *Lonsdale* from my property where [the vessel] is scrapped on the beachfront of the "Maria Behety" park and which was declared "technically shipwrecked" and the materials from this pontoon being automatically nationalized. I give the present petition to Señor Antonio Peruzovic to take the named effects to the north of the country.
> Punta Arenas, 28 October 1947
> ANTONIO SAPUNAR OJEDA[53]

A historic photograph taken at some distance of *Lonsdale* as a working vessel (fig. 2.17) shows basic features of the bow carving. It had a scroll-skirt figurehead posed looking ahead rather than to one side, the hair is combed back, sleeves have some length, and the right arm to the elbow seems to be against the body. Antonio Sapunar Ojeda described the figurehead as weighing 551 pounds (250 kg), and each of these characteristics corresponds to Neruda's Medusa figurehead.[54]

Until some closer view becomes available of *Lonsdale*'s figurehead in place on the ship's bow, it remains conjectural whether Neruda's Medusa is the figurehead from the wrecked *Lonsdale*, but if it is, the following ship history adds to our view of the carving.

Dale Line ships, named for valleys and lakes, had various builders and figurehead carvers.[55] *Patterdale, Wasdale,* and *Eskdale* were built by Whitehaven Shipbuilding Company, while W. H. Potter at Liverpool constructed *Borrowdale, Ennerdale, Langdale,* and others. *Lonsdale,* built by C. J. Bigger of Londonderry, England, was larger than the fleet's earlier ships, registering 1,865 tons, and official records give her dimensions in feet as 266.6 length, 39.4 breadth, and 23.2 depth (81.2 by 12 by 7.07 m).[56]

It was said that the Dale Line was reputedly one of the best known and best run of the sailing ship lines in the Cape Horn trade of the 1870s and 1880s, with ships of 1,200 to 1,400 tons loaded with wheat, barley, and flour for runs to Australia, San Francisco, and Liverpool.

But *Lonsdale* was launched at a critical time. Although planned for the Dale Line, that distinguished company ceased business two months before *Lonsdale's* launch because of the passing of company founder J. D. Newton on September 2, 1889. The Dale Liners were noted for their good living. "Be Just and Fear Not" were words inscribed within Dale Line ships, and Mr. Newton was described as always looking for their prominent display when he came onboard any of his vessels.[57]

However, with J. D. Newton's death, *Lonsdale's* working career from 1890 was under ship owners Peter Iredale and his son-in-law John Porter, doing business as P. Iredale & Porter, which, unfortunately, was an entirely different enterprise, as 1910 news articles and other materials make clear.[58] For example, the *Newcastle Morning Herald and Miners Advocate,* on Wednesday, March 16, 1910, reads:[59]

Fire on a Barque

The crew of the barque *Lonsdale,* 1700 tons, belonging to Messrs. Iredale and Porter, Liverpool, and commanded by Captain Dagwell, who arrived in Belfast recently from South America, told a thrilling story of the vessel's voyage from Hamburg to Mazatlan. Leaving the former port on May 28th last, terrific weather was encountered off Cape Horn, and the barque put into Port Stanley (Falkland Islands) with her forestay and headgear carried away. After repairs the vessel put to sea, but when three hours out it was discovered that she was on fire in three different places, evidently the result of incendiarism. The *Lonsdale's* head was immediately turned toward Port Stanley. Every effort was made to subdue the fire, but it continued to gain, whereupon Captain Dagwell ran the barque for the nearest land and beached her. Some of the crew reached the shore in the boats, and others swam ashore. Captain Dagwell is remaining with the ship for salvage purposes, but the greater part of the crew reshipped in [another vessel].

A reward has been offered for information leading to the arrest of the incendiaries.

A Friday, March 25, 1910, article in the Brisbane, Qld adds more details:[60]

Twixt Fire and Flood

Crew's Escape from a Burning Ship

Several members of the crew of the Liverpool barque *Lonsdale,* wrecked on Falkland Islands, have arrived home at Belfast, and tell a thrilling story of the lean of the vessel. Rounding Cape Horn, enroute for Marathon, terrible weather was encountered, the forestay and headgear being carried away, and the captain decided to run for Port Stanley, in the Falklands. Here the necessary repairs were completed, and the vessel resumed her voyage, but when only a few hours out fire was discovered burning in three separate places. Attempts were made to subdue the flames, but without success, and eventually the vessel was beached close to Port Stanley. At the moment she ran ashore she was holed in several places, and seemed within an ace of sinking. Several of the crew had to swim ashore to save their lives, others getting away in the ship's boats. The vessel was soon flooded, and a considerable portion of the cargo was salved. The fire being apparently the work of incendiaries, a reward has been offered for their detection.

A man named Capt. Frank Shaw described much later that shipowner Peter Iredale was a "shameless opportunist, who ran his fleet on the thriftiest lines. [He ran all his vessels] . . . all . . . strictly utilitarian, and run much as he had run his Middle passage contrabandists. He manned his vessels with romantic boys for the most part, supplementing them by the minimum allowable of foredeck hands. He bought condemned Navy stores for feeding his flock. He was a flint-hearted miser, and seldom contacted his victims in person."[61]

In addition to Shaw's searing remarks, Thomas Iredale's biography of Peter Iredale also conjures up a penny-pincher with whom crew would have been dissatisfied. Thomas Iredale cites Mr. A. Leon March, whose own memoir is that of an ex-officer apprentice who became an executive with P. Iredale & Porter and described Iredale this way:

Mr. Iredale had been brought up in a hard school for seafaring life in his early days [and it] was a very different matter from nowadays. He was a great individualist with a wide knowledge of humanity. Apparently rigid in control and stern against wrongdoing he had an

underlying very human understanding and tolerance and a sense of humour known perhaps only to those in intimate day to day contact with him. His memory was astonishing. Almost up to his death, he dealt with the ship's provisioning and stores and I used to have to be at the office at 8 o'clock on those mornings when he went through them. From one voyage to another he could recollect exactly what that ship had received before, and some vessels would be away from home port for over a year and years in cases—and many a time till I got very wary, he slyly tripped me up on details.[62]

The burned vessel *Lonsdale* was converted to a barge and ended up on the beach of the Maria Behety Park in Chile. Whether Neruda's collection indeed includes the *Lonsdale* figurehead at all and specifically whether *Lonsdale*'s figurehead is the one currently named Medusa remain two tantalizing questions.

Another of the Dale fleet also ended her career in Chile. The 1,388-ton steel-hulled *Birkdale* launched in 1892 from the same Northern Ireland Londonderry shipyard as *Lonsdale*. *Birkdale* was built by C. J. Bigger for owners J. H. Ireland & Co. and measured 248.5 feet in length by 37.5 feet in breadth by 21.7 feet in depth (75.7 by 11.4 by 6.6 m). She was registered as 1,390 tons, and much of *Birkdale*'s thirty-five-year career was spent in the Chilean nitrate trade.[63] In 1927, twenty-three-year-old Neruda was just beginning his diplomatic career as consul ad honorem in Rangoon, Burma. At that time, *Birkdale*, a vessel he probably never saw, caught fire and wrecked off Chile's coast.

Neruda's Décor Pieces Resembling Ship Figureheads

JENNY LIND: AN AFFORDABLE LIKENESS

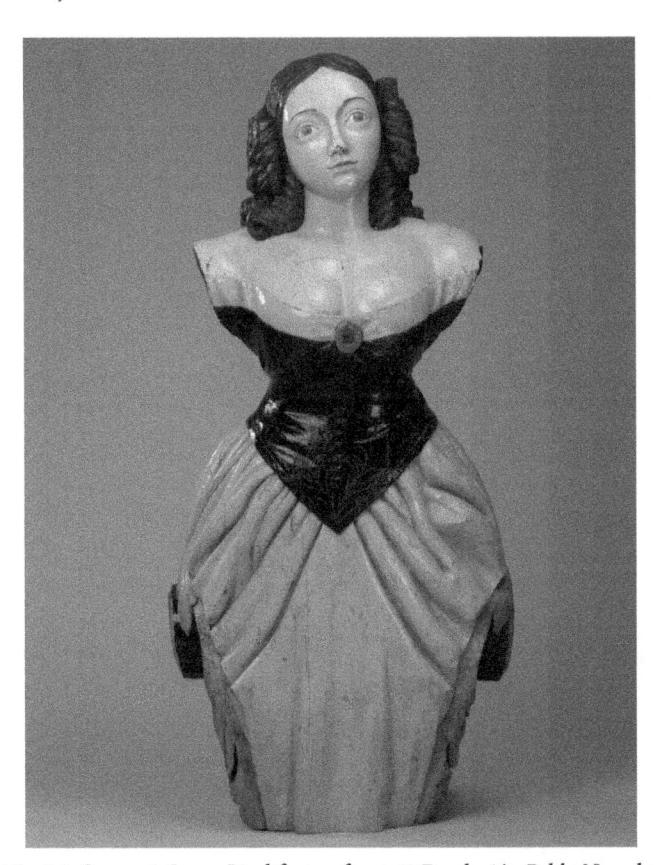

Fig. 3.1. Souvenir Jenny Lind figure, front. © Fundación Pablo Neruda.

Fig. 3.2. Artist rendering of original female figurehead variously named as Jenny Lind.
Courtesy of the National Gallery of Art, Washington, DC.

NERUDA, A COMMUNIST Party member and staunch critic of policies of the United States, would not have been permitted into the United States as an invited speaker at the 1966 PEN Conference in New York City had not President Lyndon Johnson ultimately consented.[1] In New York, Neruda discovered where he could buy a bargain-priced facsimile of a figurehead type that for many years has been referred to as nineteenth-century singer Jenny Lind. Arguably that is not an absolute identification of the original carving.[2] This rough knockoff version was perfect for Neruda's budget.[3] His library also contains Marion V. Brewington's book *Shipcarvers of North America*, showing the beautiful original of this figurehead, which for many years has been in the collection of The Mariners' Museum in Newport News, Virginia.[4]

During the peak of her mid-nineteenth-century career, celebrity Jenny Lind's likeness was among images of singers chosen to be the subject of ship figureheads. One on the clipper *Prima Donna*, built in Connecticut in 1858, was a figurehead of a single female in white with gold.[5] "Prima Donna" means "first lady" and refers to the leading female singer in an opera.[6]

Another prima donna was celebrated Italian contralto Marietta Alboni, whose portrait image on the clipper *Alboni,* built in Mystic, Connecticut, in 1852, was said to depict her carrying a "dove with an orange branch in its beak."[7] Although it is now impossible to know the specifics of that figurehead, it is plausible that the celebrated figure held instead a dove with an olive branch as a biblical reference to Genesis 8:11 that remains emblematic of safe maritime passage.[8]

Lloyds Register shows a handful of vessels named *Jenny Lind*, and *Nightingale* may have been named for Jenny Lind. No photograph survives to provide certainty about the vessel from which The Mariners' Museum's figurehead comes and whether it pertained to Jenny Lind. There have been many debates about the identity of, as well as the ship name for The Mariner Museum's figurehead, but in this brief discussion, it is important to note that Neruda saw his figure as Jenny Lind because it was sold to him as representing that singer.[9]

Jenny Lind's live performances generated tremendous press because of her enormous talent and engaging persona. She benefited, as well, from impresario P.T. Barnum having waged a six-month publicity campaign on her behalf in the United States prior to her arrival from Sweden. Lind's US concert tour began with thousands cheering her New York embarkation from the Collins Line steamship *Atlantic,* and her first performance, held in New York's Castle Garden on September 11, 1850, was a huge success. Abundant surviving literature, memorabilia, and commercial items show tribute paid to Jenny Lind's personal life, professional accomplishments, generosity to charities, and her strong sense of morality.[10] She was a superstar.

Neruda, too "was treated like a rock star" when he arrived in the United States in 1966, and the Library of Congress in Washington, DC, has digitized original recordings of Neruda reading his poem "Alturas de Macchu Picchu/ The Heights of Macchu Picchu," which was printed in 1947.

Back home at Isla Negra in Chile, in his long, glassed-in dining room facing the Pacific Ocean, Neruda placed his Jenny Lind figure across from the carving he called "Sir Henry Morgan" and enjoyed telling people that Morgan and Lind were romantically involved.[11]

Numerous home-décor versions of this Jenny Lind figurehead have existed in the past and continue to be offered for sale. Most are fairly similar to the one that Neruda bought. This may partly be a result of the Index of American Design project, launched during the Great Depression Era of the

1930s, the purpose of which was to locate and document outstanding American art images in order to make them widely available to artists and manufacturers who could then use the images to generate new, sellable art.[12] Mary E. Humes is the presumed artist for the Index of American Design who, in 1938, came to The Mariners' Museum, where she drew in graphite what has become an often-used and famous image of their original figurehead (fig. 3.2).[13]

<div align="center">

CONSERVATION

</div>

The Neruda Foundation's 1989 "Technical Restoration Report" indicated that the Jenny Lind figure was in a good state of conservation.

<div align="center">

SHAWL LADY: CONNOISSEUR CARRIES
LADY DOWN NEW YORK STREET

</div>

Artist Elizabeth Moutal, in the employ of the Index of American Design in the 1930s, made what is now a much-published drawing of an original nineteenth-century female figurehead whose attire includes a shawl (fig. 3.3). Three decades later during a 1966 shopping trip in New York City, Pablo Neruda bought a three-dimensional rough likeness of that original nineteenth-century figurehead.

According to Matilde Urrutia, Neruda considered himself a connoisseur of wooden ship figureheads and felt sure he had come across an original. Stunned to learn from the clerk that the décor piece was instead made of a low-cost synthetic, he jumped at the chance to make the figure his own. On New York City streets, Urrutia says taxi drivers would not stop for them since Neruda juggled a huge, inflexible woman in his arms, and that day of shopping seems to have provided some of the biggest laughs Neruda and Urrutia enjoyed in their remarkable time together.[14]

About fifty years later, in 2015 at Isla Negra, the author walked into Neruda's roomy, rustic barroom, along the dirt and stone path that passes a small wooden boat and the large metal ship bell that long ago rang to signal Neruda's presence on the grounds. Glistening windowpanes shield rows of deeply colored glass bottles that, from inside, shimmer against a backdrop of sea and sky. Among the assorted items fringing the walls are trade signs—one is a shoemaker's gigantic wooden shoe, the other an immense key. Here Neruda placed high entertainment-value items, including his Shawl Lady souvenir-style figurehead whose bounding-forward energy still enlivens the room in which Neruda lifted glasses of Chilean wine with his Boot Club drinking buddies and local and international visitors.

One wonders if Neruda ever realized that this rough figure was clearly based on the beautiful original figurehead owned by the Bostonian Society

Fig. 3.3. Artist rendering of original female figurehead sometimes called Shawl Lady. Courtesy of the National Gallery of Art, Washington, DC.

Fig. 3.4. Souvenir female figure named here Shawl Lady. © Fundación Pablo Neruda.

and formerly displayed at Boston's Old State House. That original figurehead is pictured in a book in Neruda's personal library, yet there is no mention of it by Neruda or his wife.[15] For over a hundred years, authors have said that that original wood Shawl Lady figurehead must have been a shop sign because of its pristine condition, but I am unconvinced.[16] Surely outdoor winter conditions, and even gentler interior display in a woodchip-filled carver's shop, would leave traces of exposure and use that simply do not exist on the original carving in Boston.[17] The beautiful original figurehead, a rough facsimile of which kept Neruda company, still has unanswerable questions about its past—just the kind of mystery Neruda would have enjoyed.[18]

MARIE CELESTE: SHE BRINGS THE MYSTERY OF A LOST BOAT

The carved wood figure that Neruda called Marie Celeste appears not to be a ship figurehead, but Neruda wrote about it as if it were. Despite its general pose and a lacing board design at the back, certain details raise questions, such as porcelain eyes that are only rarely seen on figureheads.[19] It also has an atypically sharp twist of the head, and there is no trace of surface paint, that essential protection against assaults of sun, wind, and water. There is the awkwardly placed, previously conserved, nonremovable left arm with the left hand secured to the skirt, and the skirt itself has fine little folds, rather than more traditional broad surfaces, as seen on Micaela, Medusa, and Sirena, which would be quicker to carve and easier to repaint at sea.

Through the prose poetry of "La Marie Celeste," shown here in appendix A, Neruda acquaints us with his figure's "imponderable presence." He details a visit to a French flea market with his friend Professor Alain Picard, an eminent scholar with the University of Poitiers, France, and Neruda guides our paths to his ultimate claim on the figure, including its sea voyage to a port near his house and his helper wrestling it home following Customs clearance. This is the poem as translated in *The House in the Sand*.[20]

The Marie Celeste
Alain and I got her at the flea market where she lay
under seven layers of oblivion. She really was hard to catch sight
of among dilapidated beds and twisted bars of iron. We took
her away in that car of Alain's, on top, tied down, and later in
a large box, proceeding very slowly, she arrived at Puerto San
Antonio. Solimano rescued her from the customs office,
unconquered, and brought her to me at Isla Negra.
But I had forgotten about her. Or perhaps I kept my

Fig. 3.5. Souvenir female figure Neruda named Marie Celeste.
© Fundación Pablo Neruda.

memory of that dusty apparition on the scrap heap. Only when the small box was opened did we feel the astonishment of her imponderable presence.

She is made of dark wood. Perfect! Sweet! And she is carried on the wind, which lifts her robe! And between her youthful breasts a brooch shields her low neckline. She has two anxious eyes on that head raised against the air. During the long winter of Isla Negra some mysterious tears fall from her crystal eyes and remain on her cheeks, without falling. Concentrated dampness, say the skeptics. A miracle, say I, with respect. I don't dry her tears, which are not plentiful but which shine like topazes on her face. I don't dry them because I have become accustomed to her tears, so well hidden and circumspect they shouldn't be noticed. And then the cold months pass, the sun arrives, and Marie Celeste's sweet face smiles softly like the spring.

But why does she cry?

Neruda emphasizes his oft-repeated myth about her tears, and his likening them to topaz is evocative of amber tears spilled by the mythological Heliades, sisters whose brother Phaetheon died while trying to drive their father's chariot across the sky. And in his poem "The Marie Celete," Neruda says he does not dry the figure's tears, yet we see him appearing to do exactly that for the camera filming *Yo Soy Pablo Neruda*.

In an article "El Olor del regreso" of October 22, 1952, published in *Vistazo*, Neruda writes of opening the box in which the figure is delivered.[21] The carving, he says, is alive again thanks to him.[22]

But from this long casket-like drawer comes a sweet woman's face, high wooden breasts that cut the wind, hands impregnated with music and brine. It is a figure of a woman, a figurehead, I baptized her as Maria Celeste because she brings the mystery of a lost boat. I found its radiant beauty in a bric-a-brac of Paris, buried beneath the disused hardware store, disfigured by abandonment, hidden beneath the sepulchral rags of the suburb. Now placed [upright] it sails again alive and fresh. Her cheeks will be filled every morning with a mysterious dew or sea tears.[23]

In that article, Neruda changed from previously finding the figure in a flea market to finding it in a drawer, and his *Memoirs* offers visions of it on a sailboat moving along the Seine River in Paris. Later, too, he elevated the

carving by declaring that Salvador Allende, who became President of Chile, desired this figure. Neruda's *Memoirs* once again asks us to imagine her crying.

> I own both male and female figureheads. The smallest and most delightful, which Salvador Allende often tried to take from me, is the Maria Celeste. She belonged to one of the smaller French vessels and may possibly have sailed only in the Seine's waters. She is darkish, carved in oak; many years and voyages have given her a dusky complexion for all time. She is a small woman who looks like she's flying, with signs of a wind carved into her lovely Second Empire clothes. Her porcelain eyes look out over the dimples in her cheeks, into the horizon. And strange as it seems, these eyes shed tears every winter. No one can explain it. The brown wood may possibly have pores that collect the humidity. But the fact is that those French eyes weep in winter-time and I see Maria Celeste's precious tears roll down her face every year.[24]

As written in Spanish, the piece above uses the word "encina" for the Mediterranean wood species Holm oak.[25] This may be an allusion to ancient literature in which Jason and the Argonauts search for the Golden Fleece, and the Holm oak figurehead on the vessel *Argo* comes to life at a critical moment. "O daughter of the Talking Oak," Jason begins an urgent plea for help so his stranded vessel can once again make way. Directing all to sit ready with hands on the oars, the figurehead signals the start for Orpheus's lively harp tune, after which the immovable galley surges into navigable water, allowing Jason and his men to flee evil Pelias.

Neruda had a passion for wood. Throughout his life, he lovingly dwelt on the smells, sights and textures of tall, strong trees, broken wood fragments, and leftover roots, all of which enchanted him during his childhood in Temuco. He once said that if he had not been a poet, he would have been a carpenter. Marie Celeste's glowing wood grain surely provided satisfaction to Neruda.

Though Neruda did not directly say so, he clearly called his imitation figurehead Marie Celeste after the vessel *Mary Celeste,* in a ghost-ship mystery popularized in 1884 by Arthur Conan Doyle's published short story "J. Habkuk Jephson's Statement." The vessel and events on which Doyle based his eerie story are real. Neruda's figure is not connected to those fictional or actual events, but Neruda did appropriate the ship name for his collectible.

The real vessel *Mary Celeste,* which was made of wood and launched from

a builder's yard at Spencer Island, Nova Scotia, is the subject of a monument inscription in all capital letters:

NEARBY THE WORLD'S MOST FAMOUS MYSTERY SHIP, THE "MARY CELESTE," A BRIGANTINE, WAS BUILT AND LAUNCHED IN 1861. WAS FIRST NAMED THE AMAZON. IN 1868 SHE WAS DRIVEN ASHORE IN A STORM AND AFTER BEING REPAIRED WAS RENAMED THE MARY CELESTE. IN DECEMBER 1871 SHE WAS DISCOVERED AT SEA WITH ALL SAIL SET AND EVERYTHING IN ORDER BUT NOT A PERSON WAS ON BOARD OR EVER FOUND.

Sailing in 1871 on that ill-fated 103-foot (31.3m) vessel were Capt. Spooner Biggs, his wife, Sarah Biggs, their infant daughter, Sophia, and the seven carefully chosen crew in positions of first and second mate, steward, and four general seamen. There was dangerous cargo onboard: 1,701 barrels of denatured alcohol, sold by New York merchants Meissner Ackerman and Co. for delivery to H. Mascerenhas and Co. of Genoa, Italy.[26] The *Mary Celeste* was found adrift some 800 miles (1,287 km) from Gibraltar, with no one onboard. When the crew of *Dei Gratia*, a vessel that sailed from New York at nearly the same time as the *Mary Celeste*, claimed her as a salvaged vessel, it fed suspicions of foul play that fueled public interest for a long time.

Referring again to the "El Olor del regreso" article of October 22, 1952, published in *Vistazo*, Neruda says he chose the name Marie Celeste because "she brings the mystery of a lost boat," which seems a clear allusion to Arthur Conan Doyle's 1884 story and its source, the *Mary Celeste*. Also, two ship models of *Mary Celeste* on display at Isla Negra are explained in Neruda's *Memoirs*, where he claims, "Captain Hollander delighted me by making me two versions of the *María Celeste*, which in 1882 [*sic*] was converted into a star, into a mystery of mysteries."

CONSERVATION

The Pablo Neruda Foundation's 1989 "Technical Restoration Report" mentions termite treatment for the Marie Celeste, which involved all joints of the arms being separated.[27] At the Pablo Neruda Foundation in a report with a 1995 date at the bottom of the form, sculptor Ricardo Mesa discusses later appearance changes made to this figure, sharing that "intervention was elimination in the face, chest, and head of black varnish that obscured expression and details." He comments about lacquer for the patina, rubbing with wax, anchoring the figure with a chain, and fastening of the dress and arms.

GUILLERMINA: DRAWING ON MEMORIES

In fall of 1966, Neruda acquired a massive, burlesque wood figure that he knew was not a figurehead.

Fig. 3.6. Souvenir female figure Neruda named Guillermina. © Fundación Pablo Neruda.

Neruda was invited by the Chilean Embassy in Peru to give recitations at universities and theaters, and one performance was at the large Lima Municipal Theater. Neruda read sections of his work "The Heights of Macchu Picchu," with alternate parts delivered by Maria Maluena, and their performance was so moving that it brought some people to tears.[28] The performance also included Neruda's very personal reading of his poem "Where Can Guillermina Be?" which pulls the curtain back on Neruda as a young man, awestruck by his sister's beautiful friend Guillermina.[29] Later that night, Guillermina became a topic of conversation.

Emilio Oviedo worked at the Embassy of Chile in Lima, and after the Municipal Theater performance, Emilio and his wife invited Neruda and Matilde to a Chinese restaurant. Talking about Neruda's fascination with ship figureheads, Oviedo soon had everyone laughing as he described a local voluptuous wood carving that was sometimes rented out for placement by a groom at a bachelor party.[30] In less than twenty-four hours, Neruda bought that buxom figure from an antique dealer, causing Oviedo's wife to exclaim, "Pablo has found Guillermina!" which is how Neruda named his carving.

In September 1966 Neruda gave Oviedo $100 to ship the carving. Oviedo labeled the crate "personal material" from Neruda's business trip in Peru and arranged its air transport on Linea Aérea Nacional (LAN) and then contacted Neruda to give him the date the female figure "will fall into your arms." Oviedo did visit Neruda afterward, and he wrote about it in 1979, six years after Neruda's death.

Photographs date the arrival of the Guillermina figure at Isla Negra to late 1966 based on house architectural features. While it came too late to be included in Neruda's 1966 book *Una Casa en la Arena*, the carving was shown in the 1971 television series *Historia y Geografia de Pablo Neruda* based on that work.

In contrast to the overtly sexual imagery of the Guillermina figure, Neruda's poem with that name in the title, written so many years earlier, was more subtle with vivid recollection of a young girl's light, braided hair, penetrating blue eyes, and the potent impact she had on a maturing fourteen-year-old boy. Neruda's poem also delved into his fascination with tree-filled forests preciously enlivened by bees, spiders, and beetles, and his own odyssey through life. In translation, Neruda's poem "Where Can Guillermina Be?" asks:

> . . . I came to live in this world.
> Where can Guillermina be?[31]

Neruda enjoyed friendships and associations through the course of circulating his widely admired work, and he seldom failed to let people know that

his overall collecting interests included ship figureheads, bottles, shells, nautical paraphernalia, regimental drums, popular crafts, masks, and more. His ongoing and extensive public outreach proved highly advantageous to him as a collector.

CONSERVATION

In the Neruda Foundation's 1989 "Technical Restoration Report," Guillermina was said to be in a good state of conservation.

HENRY MORGAN: NERUDA SHOPS
LIKE A PREHISTORIC LIZARD

From 1970 to 1972 Neruda cherished the experiences of what turned out to be his final diplomatic mission. He was Chile's ambassador to France, stationed in Paris, a city he had loved ever since that early glimpse as a twenty-three-year-old enroute to his first diplomatic work in Rangoon.

Fig. 3.7. Souvenir male figure Neruda called Henry Morgan.
© Fundación Pablo Neruda.

Now in his sixties, Neruda was still thrilled by perusing eclectic Paris shops, and in one he found, shiny and dark, the swirling-woodgrain, carved face of an open-mouthed man with bulging eyes and turned-up moustache, framed by carved scrolls. It was said to portray the pirate Henry Morgan, and in time it became a wall-hanging on Isla Negra's north dining room wall, where Neruda pointed to it once as he pressed a reporter with the question "Doesn't he look like Stalin?"[32]

Written thirty-one years after Neruda's death, the 2004 memoir of Neruda's colleague Jorge Edwards, a writer and diplomat himself, gives color and buoyancy to how Neruda came to own this carving:[33] "The poet developed in Paris better than in any other place of the world, with absorbing . . . force, the passion for [collecting]. There lay one of the secrets of his love for that city. He was a born, incorrigible collector, who devoted many hours to the cultivation and enjoyment of this inclination. I . . . watched him with curiosity, with amusement, with amazement. . . . I saw the Poet collector in action in old bookstores, in the Flea Market, in the Village Suisse of the Motte Picquet Avenue, about five or six blocks from the Chilean embassy, as I later saw him in the Persian Market of Santiago or in the maritime tents of the Port Breton of Saint Malo."

Edwards describes Neruda as an intense shopper. He would walk slowly, stopping, sniffing, looking from side to side, with eyes like a prehistoric lizard, until suddenly he would see the gleam of his prey—in one case a bottle opener in the form of a fish with silver scales.[34]

About discovering the Morgan carving, Edwards says that, in addition to Neruda's usual excursions around the hotel of the Rue de la Buchete, one day the poet saw this carving in a room nearly opposite the church of Saint-Julien Payle—even though that was some distance away—and "all of Neruda's collector hormones [boiled] so he could not keep from entering the shop to ask about the powerful and moustached figure carved on a thick trunk of enameled wood."

Once the young antique dealer, Mr. Bazin, explained that the figure represented Henry Morgan, Neruda's interest heightened even more, because Morgan was a notorious buccaneer in South American history. Even though Bazin told Neruda the figure was not for sale because he preferred to keep it for himself, Neruda forced the issue, insisting that he was, after all, the famous poet from Chile in the extreme of South America and a distinguished collector of ship figureheads. By a strange and happy coincidence, that information resonated with Bazin, who had recently heard about Neruda from cousins in Valparaiso. Settling on a payment plan, they agreed that Neruda would receive the carving upon full satisfaction of a certain price.

Payoff came sooner than expected. After reading a telegram delivered to

his hotel, Neruda flung on his coat and sped off. Edwards explains that Neruda normally lumbered like a bear, but something suddenly put a spring in his step as the poet sprinted down the street. News that Neruda rushed to tell Bazin was timely. He was to receive prize money that would more than cover the Morgan carving."[35] A few days later, Bazin invited Neruda and a small group to celebrate in private quarters, where the champagne flowed and music for the cueca, a national dance of Chile, played.[36]

Henry Morgan, who lived to roughly age fifty-three, is said to have been born about 1635 in Wales, and he died in Jamaica on August 25, 1688. Arriving in Jamaica as a young man, Morgan's prosperity increased because letters of marque granted by Jamaica's governor enabled Morgan to lead men into battle under the guise of helping the British military. In one case, using a fire ship, they destroyed the 412-ton *Magdalen* and then went on to conquer other enemy vessels of Spanish opponent Admiral Alonso de Campos y Espinosa.

In November 1674 Morgan received Britain's Knight Bachelor award, after which he became Sir Henry Morgan. After serving some years in government leadership in Jamaica, and with privilege and plunder that included ownership of enslaved people, plantation income expanded Morgan's personal wealth. Four years after Morgan's death and burial at Jamaica's Palisadoes cemetery, the great earthquake of June 7, 1692, dumped his gravesite into the sea.

Henry Morgan mattered to Neruda as a literary character because, as a boy, Neruda was drawn to Italian author Emilio Salgari's depictions of voyages that "carried me far away in the world of dreams."[37] Salgari shaped action-packed legends of seafaring, jungles, plunder, and piracy through characters like Sandokan, and in his 1898 novel *The Black Corsair*, Salgari wrote about the pirate Henry Morgan.

Gatherings around Neruda's lengthy dining table at Isla Negra surely included moments when Neruda glimpsed this carving and remembered his triumphant day of negotiation in a Paris antique shop, or his own youthful fascination with Morgan as a character described by Emilio Salgari, or the real-life atrocities of the swashbuckling Henry Morgan. Neruda's eyes would likely gleam, too, when telling guests that the Morgan figure was romantically paired with the Jenny Lind carving across the room. For entertainment value, the idea probably worked, since greater opposites are hard to image, and Morgan and Lind lived three centuries apart.

<div align="center">CONSERVATION</div>

In the Pablo Neruda Foundation's 1989 "Technical Restoration Report," the Henry Morgan figure is described as being in a good state of conservation.

OCTANT MAN: LORD THOMAS COCHRANE
AND STEAMERS FOR CHILE

Chancing upon this keepsake figurine in a Paris antique shop in 1971, when he was ambassador to France, Neruda displayed it on a shelf in his Paris office near a treasured photo of Walt Whitman. Matilde Urrutia refers to this figurine in *My Life with Pablo Neruda*[38] but no direct Neruda reference appears to exist.

Fig. 3.8. Souvenir male figure named here Octant Man. © Fundación Pablo Neruda.

It is an interesting figure in its own right. First, because the man holds a likeness of an octant, the kind of device that greatly advanced seafaring navigation capabilities in the eighteenth century. In 1730, both John Hadley of England and Thomas Godfrey of Philadelphia invented it at almost the same time. The brilliance of the octant design is that it gives the seafarer the easier task of looking in one place to see both a celestial body and the horizon. When Hadley later expanded this device from one-eighth to one-sixth of a circle, it was called a sextant.

Second, this little carving suggests a figurehead in the straddlehead style, in which a person with bended knees appears to straddle the forward area of a ship. Neruda owned a book with a drawing of a figurehead stylistically similar to this on the bow of the 1776 *Hancock*. [39]

Nothing suggests that Neruda ever saw that the Hellenic Maritime Museum in Piraeus, Greece, has an authentic and rare straddlehead figurehead of a helmeted Greek warrior. That exemplary wood carving, from the British-built sloop of war *Karteria*, launched in 1826, was constructed for the Greek navy and, according to author Lawrence Sondhaus, *Karteria* was expected to rely primarily on sail, but for battlefield maneuverability it had the added advantages of steam power.[40]

Surprisingly, the *Karteria* story has an oblique connection to Chile, where Britain's Lord Thomas Cochrane remains a man of heroic reputation. Cochrane's accomplishments included helping to "instigate the acquisition of British paddle steamers" for Chile.[41] But when the commissioned paddle steamer *Rising Star* arrived too late to help in a military capacity in Chile's War of Independence from Spain, *Rising Star* was employed instead as a merchantman off of Chile's coast.[42] Sondhaus describes how after Cochrane's efforts to bring steamers to Chile, "Cochrane then introduced steamships to Greece, where the 400-ton *Karteria*, the first of the four steamers actually commissioned, is generally accepted to have been the first steam-powered vessel to engage in combat."[43]

CONSERVATION

The Octant Man figure is described in the Pablo Neruda Foundation's 1989 "Technical Restoration Report" as being in a poor state of conservation.

LA BONITA AND LA NOVIA: MODERN
REMINDERS OF OLD SHIPWRECKS

LA BONITA (SPANISH FOR "BEAUTY")

Two carved-wood heads, neither of which was part of a ship figurehead, hang on chains in front of Neruda's living room window facing the Pacific Ocean.

No information remains about how Neruda got them, but still-crisp wooden edges and visual similarities between the two suggest their origins are relatively modern and their purpose was other than to decorate seagoing vessels.[44]

Before looking further into these Neruda carvings and Neruda's poetry concerning them, it is useful to remember that there have been an abundance of incidents resulting in broken-off heads and torsos of figureheads. We do not know if any of those stories influenced Neruda to place these carvings, suggestive of disconnected heads, in his front window.

Nineteenth-century ships lacked wireless communication, and too often shipwrecks were only evidenced through floating debris, cargo, and even decorative carvings. A few clips from nineteenth-century Australia and New Zealand newspapers set the scene for the grim kinds of circumstances to which Neruda's two hanging heads allude.

On July 8, 1879, *The Evening Post* reported that a fiddlehead bow carving with a red shield and green and gold scroll work was known to match colors of the New Zealand Shipping Company's *Pareora*, which was due in from London.

On October 23, 1875, the *North Otago Times* reported that an unnamed Liverpool vessel, seen burning at sea, had on it the figurehead of a woman carrying a child. The same newspaper, on September 27, 1876, when reporting about a found figurehead's subject, colors, and degree of paint freshness noted that the build-up of barnacles on it was slight, suggesting a relatively short time in the water.

The May 25, 1880, *Manawatu Herald* relayed that a wooden male figure, five-and-a-half feet long (1.67 m), with few barnacles, was found on a beach in generally good condition. Without other wreckage nearby, it was assumed the figurehead had been insufficiently secured to its vessel.[45]

Other sources tell of the heads missing from otherwise intact ship carvings. For example, The Maritime Pavilion of the Institute of Patagonia in Punta Arenas displays the headless body of a figurehead from the 692-ton composite-built tea clipper *Ambassador*, which was stranded in San Gregorio in the Magallanes Region.[46] Likewise, in 1867, a New Zealand article reported on locating a headless wooden figurehead depicting a sailor's body.[47] And in the early years after the newly formed United States had broken away from England, the July 4, 1801, *Jenk's Portland* (ME) *Gazette* related that a captain had sighted a wreck with a "woman figurehead, the head part broken off, painted black." The vessel was described as having a flush deck and a waist painted black outside and red inside.[48]

In the National Maritime Museum at Valparaiso, Chile, the sawn-off head of a figurehead is displayed, its condition reportedly the result of two brothers' quarrel.[49] Unable to agree on which of them would own the entire large female carving, they settled the matter by severing it at the neck. The lovely head

appears to me to be crowned with a carved three-leaf clover, popularly called a shamrock, which is Ireland's national flower. The shamrock is also a symbol of the Holy Trinity and of St. Patrick's return to Ireland. The style of the figurehead would have been in the scroll-skirt design, since it decorated the British ship *Liffey* as part of the famous James Nourse fleet and that is the figurehead style commonly seen on his ships. Nourse named each of his ships for a major river and the seventy-eight-mile-long Liffey runs through Dublin, Ireland.[50]

With respect to Neruda's two hanging heads at his picture window, we know that Neruda had woodworker and sculptor connections in Chile, but we have no direct information that he was given these as gifts or that he commissioned the La Bonita and La Novia carvings.[51] These carvings have similar bases and share aspects of their hair and facial features. On La Bonita, there is a likeness of an ancient hair knot, but La Bonita's fresh-looking and large, carved rose, abruptly set above the middle forehead, recalls frequent rose themes in Neruda's poetry, as discussed in the Sailor Girl with Rose section in this chapter.

Fig. 3.9. Souvenir carved head Neruda named La Bonita. © Fundación Pablo Neruda.

In the prose poem "La Bonita" below, Neruda describes rugged scenery in the Strait of Magellan, as well as a never-changing figurehead face, the theme of which is evocative of Oscar Wilde's 1890 gothic novel *The Picture of Dorian Gray.*[52]

Additionally, in the last third of this prose poem Neruda portrays the carved figure as having been scorched when used as a lamp. Close examination, however, establishes that the dark smudges on both sides of the neck are applied black ink and that the carving itself is without any physical evidence of use as a lamp. In the story that Neruda created, he is a savior.

The poem Neruda titled "La Bonita" appears in Spanish in appendix A. Its English translation is shown below.[53]

Beauty

Not only was the barge called "Beauty" but, once
dilapidated, seized by the blasts of wind from the Straits, it
went on to become, still beautiful, a plaything for tempests and
misfortunes. The ribs of the ship managed to remain firm for
years after the shipwreck, but the figurehead shattered into
pieces. The great waves attacked her and her clothing was lost,
her arms and fingers exterminated, until miraculously, that
solitary head, as though impaled, stayed erect in the prow's last
pride.

There, on a peaceful noon rapacious hands found her.
She went along in that way, from hand to hand.

But nothing had happened to the face. Not the
struggle with the sea, nor the shipwreck, nor the tempest-tossed
solitude of the Straits of Magellan, nor the blizzard that bites
with teeth of snow. No.

She remained with her dauntless face, with her doll
features, vacant of heart.

They turned her into a hall light, and I found her for
the first time under a horrible, rayon lamp shade, with the same
smile that never comprehended misfortune. Even one ear, which
the tempest did not destroy, showed a lobe burned by electric
current. Full of wrath I sent flying the cheap hat that seemed to
satisfy her; I liberated her from her ignominious electrification
so that she could continue to gaze at me as though nothing had
happened, as pretty as before going down at sea and
in hallways.

Neruda's multilayered lamplight theme appears in these few lines from

The Captain's Verses, in which he covertly writes to his lover Matilde about their winter arrival on the island of Capri:

> You occupied the house
> that darkly awaited you
> and then you lit the lamps . . . [54]

He also described his stepmother (his "more-mother") as a lamp lighting to show others the way:

> . . . and now, in the morning
> of icy sun, she comes,
> my more-mother, Dona
> Trinidad Marverde,
> soft as the tentative freshness of the sun in storm country,
> a frail lamp, self-effacing,
> lighting up
> to show others the way. . . . [55]

Fig. 3.10. Souvenir carved head Neruda named La Novia. © Fundación Pablo Neruda.

This second head, carved in wood, has an attractive face, a nicely shaped tiara, deeply cut eye features, short, fringe-like bangs that are coupled with a more classical hairstyle, and a low-relief necklace.

The importance of the La Bonita and La Novia carvings to Neruda is reflected in their prominent place in his Isla Negra living room and in how he wove them into his writing. Neruda's carvings filled a potent function for him, that of helping ideas luxuriate and agitate within, which further enlivened his world of imagination. Neruda said, "What the memoir writer remembers is not the same thing the poet remembers. . . . The poet gives us a gallery full of ghosts shaken by the fire and darkness of his time."[56]

CONSERVATION

The Pablo Neruda Foundation's 1989 "Technical Restoration Report" discloses that there was use of the chemical Xylamon, an active ingredient deadly to larvae on these figures, and that also one time per year for six years Bonita and Novia were wrapped in plastic as part of further chemical treatment to kill termite larvae.

SAILOR GIRL WITH ROSE: HALLMARK NERUDA IMAGERY

A red rose is held in the right hand of Neruda's decorative carved wood Sailor Girl figurine. Neruda placed it among his figureheads, even though it was not made for a ship.

In his writing, Neruda frequently used rose imagery. One example is the term "Sea rose" found in "To a Ship's Figurehead (Elegy)," and elsewhere in his title "The Herbalist's Rose." In 2017, when the Pablo Neruda Foundation electronically sorted Neruda's works for rose references, the result was a surprising 721.[57]

Rubilar Solis's research about factors shaping Pablo Neruda's identity within Neruda's writing says that "the rose, a feminine name and a vegetable flower, is the key word of [Neruda's] personal references and of his subsequent experiences with different women . . . Rosauras, Rosias, Rosarios, Rosaledas, Rositas, etc."[58]

Especially important, Rosa Albertina Azocar met Neruda when he attended the University of Chile, and she helped inspire his celebrated work *Twenty Love Poems and a Song of Despair*. Rosa Basoalto Opaza, on the other hand, is the name of Neruda's mother, who died weeks after he was born. Neruda's connections to rose imagery are plentiful and complex.

No information survives about when and how Neruda obtained this modest décor piece that seems meant to suggest a figurehead through its pose, scrollwork, and hint of a lacing board. It is without a signature, date, stamp,

Fig. 3.11. Souvenir carved female figure named here Sailor Girl with Rose.
© Fundación Pablo Neruda.

imprint, or documentation; yet, this modest Sailor Girl with rose imagery is one that Neruda chose to pose with for photographs.

<div align="center">

CONSERVATION

</div>

The Pablo Neruda Foundation's 1989 "Technical Restoration Report" indicates that there was use of the chemical Xylamon, an active ingredient deadly to larvae on Neruda's figures, and that also one time per year for six years this Sailor Girl with Rose was wrapped in plastic as part of further chemical treatment to kill termite larvae. That report also notes this figure was said to be in a good state of conservation.

Conclusion

For more than fifty years since Neruda's passing in 1973, there has been little interpretation of the carved wood figureheads that Neruda collected and celebrated in poems and prose. In taking this new look at Neruda's figurehead collection, investigation has focused not only on his words but also on what is known about Neruda's social, political, and artistic life, along with related overarching issues of ego, rivalry, and financial concerns. A recurring theme became the Neruda-designed juggernaut for public attention and how, partly through his figureheads, Neruda shaped his public persona as hero, protector, and rich man. Arguments were presented suggesting that Neruda gave his figureheads names that had more to do with himself than the history and cultural contexts of the carvings themselves.

This close examination considered Neruda's comment in an interview that originality is overrated, and it helped bring into focus Neruda figurehead stories that appear to have been influenced by other authors' work. It pointed out, too, instances where Neruda may have looked to ancient authors about some of the carvings, a practice he is not generally thought to have done in the rest of his work. Access to archival and library material at the Pablo Neruda Foundation in Chile provided new information for this book as did recently conducted interviews of people who were contemporary to Neruda.

Despite Neruda's achievement in becoming the 1971 recipient of the Nobel Prize in Literature, this book also addressed that, in recent years, Neruda has been re-contextualized by many people. Nonetheless, his writing remains popular, as are his varied and rare ship carvings on display at Isla Negra. Overall, Neruda's collectibles are within three Pablo Neruda Foundation house museums, and tens of thousands of visitors see them each year. Issues concerning the viability of Neruda's figurehead collection include the absence of temperature and humidity controls, and inherent dangers of their Ring of Fire geographic location that makes them vulnerable to potential earthquakes and tsunamis.

Neruda and his ship carvings provide a gateway view to a particular ship figurehead collection in a little-recognized art genre, and Neruda's figures are compared here to other ship carvings from the same era in an effort to

broaden understanding of certain aspects of nineteenth- and twentieth-century hull art. Figureheads have long been devices to help people stand out and provide a compelling and unique identity to others. It is a theme we also see in Pablo Neruda.

Appendix A

Pablo Neruda Poems about Ship Figureheads

Permission is granted for this use of Pablo Neruda's poems in Spanish from UNA CASA EN LA ARENA © Pablo Neruda, 1966 y Fundación Pablo Neruda.

El Gran Jefe Comanche

No sé cómo pudo entrar su colossal estatura y el carcaj amenazante. Aquí llegó y domina por sus plumas, por el indomable perfil, por la dureza de sequoia roja que resistió el oleaje férreo.

Un piel roja de navío ballenero, de Massachusetts, como el que tal vez guiaba el barco del joven Melville por los puertos peruanos y chilenos. Pues es sabido que fue estatua preferida de los perseguidores de ballenas. Y los artesanos de Nantucket los esculpieron más de una vez. Cuando sobrevino el vapor y fueron olvidados los veleros, los viejos artesanos siguieron tallando este Piel Roja, convertido en insignia de farmacia o de cigarrería. (Aquellas "Boticas del Indio" con aroma de cien raíces, cuando el alquímico practicaba ungüentos y obleas con morteros y delicadeza!)

Lo cierto es que nunca desarrugó el ceño: que con arco, hacha, cuchillón y ademán es el valiente entre mis desarmadas doncellas del mar. Ni Búffalo Bill con sus andanadas de pólvora ni el océano lleno de monstruos recalcitrantes pudo alterar su poderío. Aquí sigue intacto y duro.

Ceremonia

En el año 1847 un navío norteamericano, el Clipper
Cymbelina, debió recalar en una caleta sin nombre del Norte de
Chile. Allí los hombres de mar procedieron a desclavar el
mascarón de proa del velero. Esta estatua blanca y dorada
parecía ser una novia muy joven ceñida por un ropaje isabelino.
El rostro de aquella niña de madera asombraba por su
desgarradora belleza. Los marineros del *Cymbelina* se habían
amotinado. Sostenían que el Mascarón de Proa movía los ojos
durante el viaje, desorientando el derrotero y aterrorizando a la
tripulación.

No es cosa fácil destronar a la rectora de un viejo y
férreo navío. Pero, llevados por aquel religioso terror, los
marineros aserraron el poderoso perno que la aseguraba al
bauprés, cortaron clavos y tornillos hasta que pudieron, no sin
cierto temor o respeto, descenderla y colocarla en una lancha
que los llevó a la playa.

El mar estaba agitado aquel día de julio. Era pleno
invierno y una lluvia grave y lentísma, extraña en aquella
desértica región, caía sobre el mundo.

Siete hombres de a bordo levantaron en hombros a la
niña de madera insólitamente separada de su nave. Luego
cavaron una fosa en la arena. Los guanayes, aves estercorarias de
la costa, volaban en círculo, graznaban y chillaban mientras
duró la inquietante faena. La extendieron en tierra, la cubrieron
con la arena salitrosa del desierto. No se sabe si alguno de los
enterradores quiso rezar o sintió alguna repentina racha de
arrepentimiento y tristeza. La garuga, lenta lluvia nortina que
oscila entre niebla o fantasmagoría, cubrió pronto la ribera del
mar, los amarillos acantilados y la embarcación que en el gran
silencio retornó con los hombres de mar al velero *Cymbelina* en
aquella mañana del mes de julio de 1847.

La Micaela

La última en llegar a mi casa (1964) fue la Micaela.

Es corpulenta, segura de sí misma, de brazos colosales. Estuvo después de sus travesías, dispuesta en un jardín, entre las chacarerías. Allí perdió su condición navegativa, se despojó del enigma que ciertamente tuvo (porque lo trajo de los embarcaderos) y se transformó en terrestre pura, en mascarona agrícola. Parece llevar en sus brazos alzados no el regalo del crepúsculo marino sino una brazada de manzanas y repollos. Es silvestre.

La Medusa. I

Me ocultaron en Valparaíso. Eran días turbulentos y
mi poesía andaba por la calle. Tal cosa molestó al Siniestro,
Pidió mi cabeza.

Era en los cerros del Puerto. Los muchachos llegaban
por la tarde. Marineros sin barco. Qué vieron en la rada? Van a
contármelo todo.

Porque yo, desde mi escondrijo, no podía mirar sino a
través de medio cristal de la empinada ventana. Daba sobre un
callejón, allá abajo.

La noticia fue que una vieja nave se estaba
desguazando. No tendrá una figura en la proa?, pregunté con
ansiedad.

Claro que tiene una mona, me dijeron los muchachos.
Una mona o un *mono* es para los chilenos la denominación de
una estatua imprecisa.

Desde ese momento dirigí las faenas desde la sombra.
Como costaba gran trabajo desclavarla, se la darían a quien se la
llevara.

Pero la Mascarona debía seguir mi destino. Era muy
grande y había que esconderla. Dónde? Por fin, los muchachos
hallaron una barraca anónima y extensa. Allí se la sepultó en un
rincón mientras yo cruzaba a caballo las cordilleras.

Cuando volví del destierro, años después, habían
vendido la barraca (con mi amiga, tal vez). La buscamos. Estaba
honestamente erigida, en un jardín de tierra adentro. Ya nadie
sabía de quién era ni quién era.

Costó tanto trabajo sacarla del jardín como del mar.
Solimano me la llevó una mañana en un inmenso camíon. Con
esfuerzo la descargamos y la dejamos inclinada frente al océano
en la puntilla, sobre el banco de piedra.

Yo no la conocía. Toda la operación del desguace la
precisé desde mis tinieblas. Luego nos separó la violencia, más
tarde, la tierra.

Ahora, la vi, cubierta de tantas capas de pintura que
no se advertían ni orejas ni nariz. Era, sí, majestuosa en su
túnica volante. Me recordó a Gabriela Mistral, cuando, muy
niño, la conocí en Temuco, y paseaba, desde el moño hasta los
zapatones, envuelta en paramentos franciscanos.

La Medusa. II

"La Medusa" se quedó pues con ojos al noroeste y el
cuerpo grande se dispuso como en su proa, inclinado sobre el
océano. Así, tan bien dispuesta, la retrataron los turistas de
verano y se las arreglaba para tener con frecuencia un pájaro
sobre la cabeza, gaviotín errante, tórtola pasajera. Nos
habituamos todo los de casa, agregándose también Homero
Arce, a quien dicté muchas veces mis renglones bajo la frente
cenicienta de la estatua.

Pero comenzaron las velas. Encontramos a las beatas
del caserío muy arrodilladas, rezándole al aventurero mascarón.

Y por la tarde le encendian velas que el viento,
antiguo conocedor de santos, apagaba con indiferencia.

Era demasiado: Desde la bahía de Valparaíso, en
compañia continua de marineros y cargadores, haciendo vida
ilegal en el subterráneo político de la patria hasta ser Pomona
de Jardín, sacerdotisa sonora y ahora santísima sectaria. Porque
como de cuanto pasa en Chile me echan a mí la culpa, me
habrían colgado luego la fundación de una nueva herejía.

Disuadimos, Matilde y yo, a las devotas contándoles la
historia privada de aquella mujer de madera, y las persuadimos
de no seguir encendiéndole velas que además podrían incendiar
a la pecadora.

Pero por fin, contra las amenazas del cerote que
ensucia, de las llamas que incineran y de la lluvia que pudre,
llevamos a Medusa adentro. La dispusimos en el coro de los
mascarones.

Vivió una vez más. Porque al sacarla con formón y
gubia retiramos una pulgada de pintura gruesa y grosera que la
escondía y salió a relucir su perfil decidido, sus exquisitas orejas,
un medallón que nunca se le divisó siquiera y una cabellera
selvática que cubre su clara cabeza como el follaje de un árbol
petrificado que aún recuerda su pajarerío.

La Maria Celeste

Alain y yo la sacamos del mercado de las Pulgas donde yacía bajo siete capas de olvido. En verdad costaba trabajo divisarla entre camas desmanteladas, fierros torcidos. La llevamos en aquel coche de Alain, encima, amarrada, y luego en un cajón, tardando mucho, llegó a Puerto San Antonio. Solimano la rescató de la aduana, invicta, y me la trajo hasta Isla Negra.

Pero yo la habia olvidado. O tal vez conservé el recuerdo de aquella aparición polvorienta entre le "ferraille." Sólo cuando destaparon la pequeña caja sentimos el asombro de su imponderable presencia.

Fue hecha de madera oscura y tan perfectamente dulce! Y se la lleva el viento que levanta su túnica! Y entre la juventud de sus senos un broche le resguarda el escote. Tiene dos ojos ansiosos en la cabeza levantada contra el aire. Durante el largo invierno de Isla Negra algunas misteriosas lágrimas caen de sus ojos de cristal y se quedan por sus mejillas, sin caer. La humedad concentrada, dicen los escepticistas. Un milagro, digo yo, con respeto. No le seco sus lágrimas, que no son muchas, pero que como topacios le brillan en el rostro. No se las seco porque me acostumbré a su llanto, tan escondido y recatado, como si no debiera advertirse. Y luego pasan los meses fríos, llega el sol, y el dulce rostro de María Celeste sonríe suave como la primavera.

Pero, por qué llora?

La Bonita

No sólo se llamó *La Bonita* la barcaza sino que, ya desmantelada, cogida por las ventoleras del Estrecho, pasó a ser, siempre bella, juguete de tempestades y desventuras. Las costillas del barco pudieron mantenerse por años después del naufragio, pero la Figura de Proa se desmembró a pedazos. Las grandes olas la atacaron y las vestiduras se peridieron, fueron exterminados los brazos y los dedos, hasta que por milagro, se sostuvo aquella solitaria cabeza, como empalada, en el último orgullo de la proa.

Allí, en un mediodía apaciguado, la encontraron las manos rapaces. Anduvo así, de manos en manos.

Pero por aquel rostro no había pasado nada. Ni la guerra del mar, ni el naufragio, ni la soledad tempestuosa de Magallanes, ni la ventisca que muerde con dientes de nieve. *No*.

Se quedó con su rostro impertérrito, con sus facciones de muñeca, vacía de corazón.

La hicieron lámpara de vestíbulo y la encontré por primera vez bajo una horrible pantalla de rayón, con la misma sonrisa que nunca comprendió la desdicha. Hasta una oreja, que la tempestad no destruyó, mostraba el lóbulo quemado por la corriente elétrica. Lleno de ira le hice volar el sombrero barato que parecía satisfacerla, la libré de su electrificación ignominiosa para que siguiera mirándome como si no hubiera pasado nada, tan bonita como antes de naufragar en el mar y en los vestíbulos.

Appendix B

Two Other Figureheads in Chile

Situated in Valparaiso, 72 miles (116 km) northwest of Santiago, the expansive National Maritime Museum (Museo Naval Y Maritimo) belongs to Chile's Navy. It is located at the former naval school building at Veintiuno de Mayo 45, where there is a commanding view of the seaport's bay onto the Pacific Ocean. Each year, thousands of visitors arrive to enjoy the museum's visually engaging and informative displays, all of which address naval, maritime, and ecological subjects. Special emphasis is on Chile's success in gaining independence from Spain, sea battles in the War of the Pacific, and significant accomplishments by leaders whose memories are honored.[1] Within the museum's collection are ship figureheads, two of which are discussed below.

Esmeralda Figurehead

Of at least six ships of the Chilean navy named *Esmeralda*, it was the four-masted, barquentine launched in 1953 that also gained the nickname of *La Dama Blanca* (the White Lady).[2] Twelve days before Neruda's death, Chile's military dictatorship began on September 11, 1973, with Gen. Augusto Pinochet's overthrow of President Salvador Allende. As part of the terrors that followed, torture and imprisonment of political opponents occurred at sites like *Esmeralda*. Details are reported in works by Amnesty International, the US Senate, and the Chilean Truth and Reconciliation Commission.[3] Pinochet ruled from 1973 to 1990, and the national constitution, which is still in place from his time in office, has had amendments. However, voters in Chile, with its population of nineteen million people, rejected two proposed constitutions, one on September 4, 2022, and the other on December 17, 2023. That addressed in part increased social benefits, as well as improved representation of indigenous peoples, which were the types of concerns Neruda had voiced in his lifetime.[4]

The chilling history of Pinochet's atrocities are now many decades in Chile's past and the barquentine *Esmeralda* has long participated as a distinguished Chilean navy training ship at historic vessel events, such as those sponsored by Tall Ships America.[5] *Esmeralda's* figurehead, in fact, represents the national bird of Chile, the Andes condor (*Vultur gryphus*). With a wing span of up to 10 feet (3.04 m), the mighty condor is considered one of the world's largest bird species, but some reports suggest it could be vulnerable to extinction.[6] An earlier version of *Esmeralda's* condor figurehead was removed and put on display at the National Maritime Museum, Valparaiso, where visitors can see up close that the bird clutches an escutcheon with the nation's coat of arms that traditionally carries the motto "por la Rázon o la Fuerza" ("by Reason or Force"). That condor figurehead is made from several pieces of wood secured in part by metal brackets.[7] It is located in an outdoor setting next to another remarkable Chilean artifact that, while not maritime, also warrants special mention. It is the capsule that was used to save thirty-three Chilean miners who were trapped underground for seventeen days, beginning October 13, 2010, after the cave-in at the San Jose copper mine in northern Chile. At that time, the unfolding story of those men, who were aged nineteen to twenty-three, was captured on television and the heroic and fully successful rescue made riveting world news.[8]

MAJESTIC FIGUREHEAD

In 2015, the Pablo Neruda Foundation arranged for me to have a guided tour of figureheads at Museo Maritimo Nacional in Valparaiso, conducted by Eduardo Rivera Silva, who is now the museum's curator, and one ship carving stood out as especially important.

The carved-wood female figurehead, with catalog number 14–045, appears to represent Queen Victoria. This conclusion is based on the figure's appearance, which includes a small crown set upon well-coiffed hair in a complex style, a riband across the figure's chest and, at the figure's back, the carved appearance of high-status ermine that is typically associated with nobility. Notably, too, the figure came from a vessel named *Majestic*.

When this ship carving was likely made, Queen Victoria had already been a royal monarch for thirty-seven years. The sculpture's label reads: "Figurehead of frigate *Lautaro*, former *Majestic*," which accords with the Belfast-built *Majestic*, hull number 89, that builders Harland and Wolff delivered on June 24, 1875, to owner T.&J. Brocklebank for the merchant sailing trade, which included parts of the Southern Hemisphere.[9] After the vessel was sold to Chile in 1898, it was incorporated into the Chilean navy as a sailing frigate until the hull was finally sold to a private party in 1955. Procured separately at that time by businessman Martin Skalweit Herter, the figurehead

went to the Talcahuano, Chile, office of AGENTAL (Agencia Maritima de Talcahuano/ Talcahuano Maritime Agency), where it stayed for five decades until 2006. Just a few years before his death, Herter gave the figurehead and other items to Museo Maritimo Nacional, and he let it be known that, at the time of the ship's scrapping, the figurehead, as still on the ship, was painted all white. It is unknown whether the multiple colors on the figurehead today reflect how it looked at any earlier period.

Born May 24, 1819, at Kensington Palace in London, Victoria was the sole daughter of Edward, Duke of Kent, the fourth son of George III.[10] Upon her father's death, Victoria was a potential successor to the throne since her uncles, George IV, Frederick Duke of York, and William IV, had no surviving legitimate children. With the death of Victoria's Uncle King William IV in 1837, Victoria was crowned queen of the United Kingdom of Great Britain and Ireland; she was eighteen. In 1840, at the age of twenty, Victoria married her cousin, Prince Albert of Saxe-Coburg and Gotha, and of the couple's nine children, Princess Beatrice, born April 14, 1857, was the youngest. Tragically, not even three years later, on December 14, 1861, at age forty-two, Albert, who had been titled prince consort in 1857, died after weeks of suffering from disease. Victoria's immense sorrow at the loss of her husband was expressed in part by her wearing black clothing throughout her nearly forty-year widowhood, until her death in 1901. Yet *Majestic* was built in 1875, and a capable shipcarver produced this figurehead of the queen. The era was one of widespread scientific, industrial, and military attainment, and in 1876, clearly endorsed by the Queen herself and made possible through the Royal Titles Act, the British Parliament conferred upon her the title Empress of India.[11] The Victorian Age encompasses Queen Victoria's reign of sixty-three years, seven months, and two days, which was only recently surpassed by her great-great-granddaughter Queen Elizabeth II whose seventy-year, 214-day reign ended with her death on September 8, 2022.

A unique aspect of this heavy and large figurehead is that, in the museum, it is affixed to a portable stand that affords the carving some movement from side to side as a precaution against sudden vibrations from earthquakes or tsunamis. The stand also has six bolts into the floor. The figurehead is not made fast to any wall, and there are several large white pegs secured into the figurehead as handles in the event the figure has to be quickly moved.

General

Museum: Museo Naval Y Maritimo, Valparaiso
Type and Materials: Sculpture, wood
Name Used: Queen Victoria. This appears to be the subject of *Majestic*'s figurehead.

<div align="center">

DIMENSIONS
</div>

Length: 90½ inches (229.87cm)
Width: 24 inches at shoulders (60.96 cm)
Depth: 20 inches (50.8 cm) from figure's back to outside right breast
Depth: 23½ inches (59.69 cm) back to right hand
Depth: 26 inches (66.04 cm) back drapery to outside right hand
Stem: 4 inches (10.16 cm) stem width
Face length:10 inches (25.4 cm) top of forehead to chin
Face width: 8½ (21.59 cm)

<div align="center">

FEATURES
</div>

Style: Scroll-skirt figure.
Pose: Body frontal, head held back to look upward.
Attire and Arms: The back drapery, with its heavy looking folds and surface patterning, has the appearance of ermine. The blue sash, called a riband, extends diagonally from the left shoulder to the right side of the waist. The right arm is partially missing, but the direction of lines in surrounding fabric suggests that arm would be at the figure's side. A carved belt has a large tied knot in front.
Expression, Face, Eyes, Ears, Hair, Jewelry, Drapery: The care taken by the carver to create the back of the hair as a complex bun is a noteworthy feature. Also, from the necklace's double strands hangs a medallion with a now-obscured relief image. The medallion is held in the figure's left hand. The small crown, worn as a circlet, is a reminder of Queen Victoria's preference for a small crown, which she could wear in a variety of ways, rather than the single, heavier state crown.
Side Scrolls: Carved gown drapery overlaps the top of the side scroll. The scroll has incised patterning, rather than the flourish of decorative leaves in relief that some scrolls do, and it is a choice that helps heighten attention to the main figure.
Surface Treatment: The rough texture paint at the face is atypical and indicative of late work. The Museo Maritimo Nacional advises that the figurehead had earlier been painted white and that at the time of the vessel's scrapping in Valparaiso, the figurehead was white.[12]
Fastening to Ship: The heavy eyebolt at the figure's upper back likely was used when lifting this figurehead on and off the ship.
Lacing Board: Recessed.

Notes

Introduction

1. Wendy Moonan, "The Auction Block is the Next Step for a Well-Traveled Lady," *New York Times,* Jan. 4, 2008, nytimes.org, accessed Nov. 16, 2023.

2. James P. Delgado, PhD, personal communication to the author, May 21, 2021.

3. Larry Silver, Farquhar Professor Emeritus of history of art, University of Pennsylvania, personal communication to the author, May 10, 2021.

4. Neruda says that to look for originality at all costs is a modern condition. Pablo Neruda, "Pablo Neruda, the Art of Poetry," *Paris Review*, Winter, no. 51 (1971), trans. Ronald Christ, , theparisreview.org, accessed Feb. 10, 2017.-

5. Ring of Fire details, *National Geographic,* nationalgeographic.com, accessed Sept. 6, 2022.

6. "Buildings shake in Valparaiso, Chile after 8.3 magnitude earthquake—video," *The Guardian,* theguardian.com, accessed Dec. 16, 2023. See also "M8.3 earthquake strikes off coast of Illapel, Chile, Tsunami Alert Issued," youtube.com. accessed Dec. 16, 2023.

7. "May 22 1960 CE: Valdivia Earthquake Strikes Chile," *National Geographic,* nationalgeographic.com, Dec. 16, 2023.

8. Harold Mantell, *Yo Soy Pablo Neruda,* USC School of Cinematic Arts, 1967, vimeo.com, 16:23-16:56, accessed Aug. 20, 2022.

9. Matilde Urrutia made arrangements so that, at the end of her life, the Neruda properties and contents were transferred to the newly formed Pablo Neruda Foundation for ongoing inventory, assessment, and conservation. The ship figureheads, which had been enshrouded prior to Urrutia's death in 1985, presumably were unknown to Hans Jürgen Hansen, whose work sought to create a world inventory of ship figureheads (see Hans Jürgen Hansen, *Galionsfiguren: Die figürlichen Burgverzierungen der Schiffe* (Munich: Stalling Verlag GmbH, 1979).

10. With the exception of references to ship carvings, this chronology draws, in part, from Mark Eisner, *Neruda: The Poet's Calling* (New York: Ecco, 2018), 523–25, and the chronology provided in Adam Feinstein, *Pablo Neruda: A Passion for Life* (New York and London: Bloomsbury, 2004).

11. Pablo Neruda, *Memoirs*, trans. Hardie St. Martin (New York: Farrar, Straus and Giroux, 1977), 16.

12. Charis McGowan, "Poet, Hero, Rapist—Outrage Over Chilean Plan to Rename

Airport after Neruda," *The Guardian,* Nov. 23, 2018, theguardian.com, accessed Dec. 15, 2023.

13. Eisner, *Neruda,* 177–78.

14. Winnipeg II British Steam passenger ship, uboat.net (website), accessed Dec. 18, 2023, and SS Winnipeg II at Wreck Site uboat.net (website), accessed Dec. 18, 2023. The ship is described as 9,807 tons, built by Ateliers & Chantiers de France in 1918 for Canadian Pacific Steamships Ltd., Montreal. Originally named *Jacques Cartier,* the vessel became *Winnipeg,* and later *Winnipeg II.*

15. Pablo Neruda, "I Accuse" (1949) speech, trans. Wikisource, accessed Dec. 18, 2023.

16. "World Peace Council Prizes," Wikipedia.org, last modified Sept. 4, 2023, accessed Dec. 16, 2023.

17. Matilde Urrutia, *My Life with Pablo Neruda*, trans. Alexandria Giardino, (Stanford, CA: Stanford University Press, 2004), 107.

18. Urrutia, *My Life with Pablo Neruda,* 113, 128.

19. "Nobel winner Pablo Neruda was almost denied prize because of odes to Stalin," *The Guardian,* Jan. 5, 2022, accessed Sept. 10, 2022.

20. David Schidlowsky, *Pablo Neruda y su tiempo: Las furias y las penas tomo II 1950–1973* (Santiago, Chile: RIL Ediciones, 2008), mentioning Fernando Alegría in *El Siglo* newspaper, Santiago, Sept. 2, 1966. Reference to this material and translation were provided to the author on Mar. 22, 2024, by Javier Ormeño Bustos, Pablo Neruda Foundation.

21. The Euterpe figurehead, restored in 1988 and 2022, was also digitally scanned in 2022, as shown in the University of California San Diego Extended Studies video, *Reverse Engineering the Star of India—3D Scanning in Action.* This was a precautionary measure to facilitate production of a replica when needed.

22. This is distinct from the Viareggio Prize for Literature, which had been awarded for decades prior to this time. Neruda's International Prize is referred to in Schidlowsky, *Neruda Y Su Tiempo: Las Furias Y Las Penas – Tomo 2 1950–1973,* 1189. Reference to this citation was provided to me by Javier Ormeño Bustos at the Pablo Neruda Foundation.

23. "World Peace Council Prizes," Wikipedia.com, last modified Sept. 4, 2023, accessed Dec. 16, 2023.

24. Letter from Norge, Aug. 14, 1968, from St. Paul de Vence, Pablo Neruda Archives.

25. Pablo Neruda Foundation, fundacionneruda.org, accessed Sept. 5, 2022, regarding Matilde Urrutia and start of the foundation.

26. "Report to Congress on CIA Activities in Chile," Federation of American Scientists, fas.org, Sept. 18, 2000, accessed Dec. 16, 2023.

27. Ilan Stavans, "Disturbing Pablo Neruda's Rest," *New York Times,* Apr. 9, 2013, nytimes.org., accessed Sept. 10, 2022. See also "Remains of Pablo Neruda Arrive in Canada to Determine Cause of Death," *Chile Today,* Sept. 2, 2019, cloday.cl, accessed Dec. 16, 2023.

28. Mauricio Cuevas, "Chilean Poet Neruda Reburied at His Coastal Home," *Associated Press,* Apr. 26, 2016, apnews.com, accessed Dec. 15, 2023.

29. Colin Dwyer, "Pablo Neruda Didn't Die of Cancer, Experts Say. So What Killed the Poet?" Oct. 23, 2017, National Public Radio npr.org, accessed Sept. 10, 2022.

30. Jack Nicas, "Was Pablo Neruda Murdered?" *New York Times,* Feb. 15, 2023, nytimes.org, accessed Dec. 15, 2023.

Chapter One

1. Pablo Neruda, "Oda a la Madera," in *Odas Elementales* (Buenos Aires: Losada, 1954), Neruda, "Ode to Wood," in *Selected Odes of Pablo Neruda,* trans. Margaret Sayers Peden (Berkeley: University of California Press, 1990). In *Neruda,* Mark Eisner lists all the published versions of Neruda's odes.

2. Pablo Neruda, "El Gran Jefe Comanche," in *The House in the Sand*, trans. Dennis Maloney and Clark M. Zlotchew (Buffalo, NY: White Pine Press, 2004), 79.

3. Nineteenth-century whaleships were generally in the range of up to 400-ton vessels, and their surviving bow decorations are small, like the billethead carving on the 314-ton 1840-built *Charles W. Morgan,* the billethead on the 371-ton whaleship *Lagoda,* and the small, bust-style figurehead on the 110-ton whaleship *Eunice H. Adams.*

4. Nancy Shoemaker's research illuminates Falmouth, Massachusetts, shipowner Elijah Swift's use of an Indian theme in naming his vessels *Massasoit, Metacom, Indian Chief, Gay Head, Hobomok, Pocahontas, Popmunnet,* and *Uncas.* Another vessel of that era includes *Awashonks,* constructed in Falmouth, Massachusetts, in 1830 and designed with a small, female Indian bust figurehead that is currently in the New Bedford Whaling Museum collection. Within the context of hundreds of North American whaleships, diverse naming practices are evident, with examples that include a military officer (*Charles Morris*), shipping family member (*Eunice H. Adams*), and explorer (*Bartholomew Gosnold*). See Nancy Shoemaker, *Native American Whalemen and the World: Indigenous Encounters and the Contingency of Race* (Chapel Hill: University of North Carolina Press, 2015).

5. Frederick Fried, *Artists in Wood, American Carvers of Cigar-Store Indians, Show Figures, and Circus Wagons* (New York: Random House, 1970) remains a strong source about ship carvers also producing store figures, wagons, architectural pieces, and more. The subject is also addressed in Ralph Sessions, *The Shipcarvers' Art: Figureheads and Cigar-Store Indians in Nineteenth Century America* (Princeton, NJ: Princeton University Press, 2005).

6. This photo was rediscovered and provided by Carolina Rivas Cruz, director of the Isla Negra House Museum. Javier Ormeño Bustos at the Pablo Neruda Foundation advised the author that, based on the uniform of the street policeman, the location of the photo is likely Santiago, Chile.

7. Neruda's opus *Canto General* includes the poem translated as "Education of the Chieftain." According to the Pablo Neruda Foundation, the 2017 edition of Neruda's *Memoirs* includes, forty-four years after his passing, a chapter in which Neruda reflects on the situation of the Mapuche in Temuco, where he grew up. Also, in the twenty-first century, a Chilean navy vessel was named *Galvarino* for the Mapuche warrior, depicted in Alonso de Ercilla's *La Araucana,* who, after being captured by the Spanish, puts spears in his amputated arms to continue fighting. Modern Chilean

military vessels paying homage to native Indian figures, according to the foundation, include *Lautaro, Elicura,* and *Alacalufe.*

8. Neruda, *Memoirs,* 162–63.

9. The Pablo Neruda Foundation advises that, next to French scholar Jean Baudrillard (1929–2007), Whitman was a kind of poetic father to Neruda. Whitman's large portrait is in Neruda's La Sebastiana home office in Valparaiso.

10. George Catlin (painter), American (1796–1872). These images are in the collection of the National Gallery of Art, Washington, DC, and available through its website.

11. Thibault Leroy, Christophe Plomion, Antoine Kremer, "Oak Symbolism in the Light of Genomics," *New Phytologist,* 226, no. 4 (June 10, 2019): 1012–17, accessed Jan. 14, 2024, at https://nph.onlinelibrary.wiley.com/doi/epdf/10.1111/nph.15987. This article points to evidence of early reliance on acorns as an essential food source, and it asserts that the shared history of humans and oaks generated cultural and emotional relationships that translated into symbols.

12. Javier Ormeño Bustos, Pablo Neruda Foundation, personal communication with the author, Oct. 2015.

13. Arthur H. Clark. *The Clipper Ship Era: An Epitome of Famous American and British Clipper Ships, Their Owners, Commanders, and Crews 1843–1869* (Camden, ME: G. P. Putnam's Sons, 1910), 369.

14. "American Indians as Symbols/Icons," encyclopedia.com, accessed July 21, 2017.

15. Charles Kingsley, *Westward Ho!* (London: Chapman and Hall, 1855). Additionally, the figurehead for the medium clipper *Minnehaha,* built by Donald McKay, was based on the actress Juliet Barrett Barrow (1827–?) in character as Minnehaha. Her recitations in the 1850s as this character from Henry Wadsworth Longfellow's epic poem *Hiawatha* were immensely popular on both sides of the Atlantic. See colonialwilliamsburg.org, Ship's Figurehead: Minnehaha, accessed Sept. 10, 2024.

16. Octavius T. Howe and Frederick C. Matthews, *American Clipper Ships* (Mineola, NY: Dover, 1986), vol. 2, 572.

17. It is unclear whether *Sierra Nevada* received a replacement figurehead after her 1855 collision with *Jane Leach.* The ship was later named *Royal Dane* as a tribute to Danish Princess Alexandra, wife of the Prince of Wales who became Edward VII. Under different British ownership, the vessel wrecked off the coast of Chile in 1877. Howe and Matthews, *American Clipper Ships,* vol. 2, 576.

18. *Boston Daily Atlas,* Sept. 21, 1852, description of the 1,650-ton (old measurement) vessel *Westward Ho!* Bruzelius.info, accessed Dec. 14, 2023.

19. Howe and Matthews, *American Clipper Ships,* vol. 2, 688.

20. "Clipper Ship 'Red Jacket'—In the Ice off Cape Horn, on Her Passage from Australia, to Liverpool, August 1854," lithographed and published by Nathaniel Currier, bequest of Adele S. Colgate (1962), Metropolian Museum of Art, metmuseum.org, accessed Dec. 16, 2023.

21. Carol A. Olsen, "Red Jacket Legacy," Dec. 2, 2020, Hullartships.com.

22. John Mason of Boston was a nineteenth-century North American ship carver.

Information on him could be found on the Penobscot Marine Museum website, which was accessed Aug. 27, 2022, but appears to be no longer accessible.

23. Hon. Albert H. Tracy letter to author William Leete Stone referencing a speech in *Life and Times of Red-Jacket, Or Sa-go-ye-wat-haw: Being the Sequel to the History of the Six Nations* (New York: Wiley and Putnam, 1841), 364, Google Books, books. google.com, accessed Apr. 28, 2017. The speech is also cited in J. Niles Hubbard, *An Account of Sa-Go-Ye-Wat-Ha* or *Red Jacket and His People, 1750-1830* (Albany, NY: Noel Munsell's Sons, 1886), 316. Red Jacket, a famed orator and a man of distinction among the Six Nations, died in 1830. Near the end of his life, he spoke at the launch of a schooner named for him, saying directly to the vessel: "You have had a great name given to you— strive to deserve it. Be brave and daring. Go boldly into the great lakes, and fear neither the swift winds nor the strong waves. Be not frightened nor overcome by them, for it is by resisting storms and tempests that I, whose name you bear, obtained my renown. Let my great example inspire you to courage and lead you to glory."

24. Robert Burns, *Tam O'Shanter* (1791), Poetry Foundation, poetryfoundation. com, accessed Dec. 14, 2023.

25. Carol A. Olsen, "Ship Figureheads from Literature," presentation at the Seventh Maritime Heritage Conference, Norfolk, Virginia, 2001, and Carol A. Olsen, "Literary Masterpieces in Wood" *Sea History Magazine* (Summer 2002): 15–18.

26. Among the reasons the Nobel committee awarded Pablo Neruda the 1971 Nobel Prize in Literature was that he produced "poetry that with the action of an elemental force brings alive a continent's destiny and dreams." See nobelprize.org, accessed Dec. 18, 2023.

27. Feinstein, *Pablo Neruda,* 339–40.

28. Ricardo Garreton, Paula Ugarte, and Carolina Aguero, "Technical Restoration Report," unpublished report prepared for the Pablo Neruda Foundation, Dec. 1989.

29. "Notes on the History of Maritime Quarantine in Queensland, 19th Century," comp. C. R. Wiburd, Quarantine Officer, Brisbane, ca. 1910, 377–78, Espace Library, espace.library.uq., accessed Dec. 18, 2023.

30. National Maritime Museum, *Valhalla: The Tresco Ships' Figurehead Collection* (Greenwich, England, 1984) 25.

31. Pablo Neruda, "Poetry Is an Occupation," *Memoirs,* 320–22. The Fidel Castro story is similar to another incident a year later in Paris, when Pablo Picasso became indignant that an unwelcome photographer quickly took a picture of Neruda and Picasso in private discussion over lunch. To an infuriated Picasso, Neruda shouted, "Sit down, he only wanted to photograph the chicken!" Matilde Urrutia also told that story in *My Life with Pablo Neruda,* 158.

32. The writings of Alexander Sergeyevich Pushkin (1799–1837) included novels, poems, fairy tales, and drama. *Boris Gudonov* and *Eugene Onegin* are among his most notable works, and he is widely recognized as the father of modern Russian literature.

33. The Pushkin reference is in the poem "The Shipwright," originally called "El Armador" by Neruda, in the book *The House in the Sand,* 75. Originally published as *Una casa en la arena* (Barcelona: Lumen, 1966), Neruda uses, with respect to the

figurehead's face, a Spanish word that translates as "romantic," but it also seems to be a nod to Pushkin, who was writing during the Romantic literary period that spanned approximately from 1790 to 1850.

34. Urrutia, *My Life with Pablo Neruda*, 268–70.

35. The *El Nacional* article was provided to the author by Javier Ormeño Bustos of the Pablo Neruda Foundation in a personal email on July 27, 2017.

36. Julián Amich Bert, *Mascarones de Proa y Exvotos Marineros* (Barcelona-Buenos Aires: Editorial Argos, S.A., 1949), 23. This book, which belonged to Pablo Neruda, is currently housed in the Pablo Neruda Foundation library. I find that the published image annotated by Neruda is less similar to Neruda's carving than, for example, the image now designated as Gentleman and catalogued as OF72 at The Mariners' Museum in Newport News, Virginia. Notably, Neruda gives no indication of having seen the latter carving.

37. The three Neruda figures that are comparable to images in the Index of American Design are the décor pieces Jenny Lind and Woman with Shawl, as well as the carving I refer to as Venezuela Man. In the Index of American Design, the latter figure is labeled Commodore Perry, but despite its similarity in appearance to that North American hero, there never has been certainty about whom the figure represents. As one consequence, The Mariners' Museum now refers to their figure OF72 as Gentleman, rather than Commodore Perry. The Index of American Design was created to provide drawings of some of North America's best handmade art, for the purpose of making the images available to artists and manufacturers to encourage them to produce new sellable art. The original effort to create the Index of American Design, now housed at the National Gallery of Art in Washington, DC, and accessible at nga.gov, took place during the economic hardships following the Great Depression. Elizabeth Moutal was the talented artist who made the rendering of the so-called Commodore Perry figurehead in watercolor, with white heightening over graphite (fig. 1.7).

38. Garreton, Ugarte, and Aguero, "Technical Restoration Report."

39. Charlie Ritchie, National Gallery of Art, made original Index of American Design images available for review in Mar. 2017.

40. Carol A. Olsen, "Nineteenth and Twentieth Century Ship Figureheads at Mystic Seaport Museum" (master's thesis, Texas A&M University 1984), 117.

41. Clarence P. Hornung, *Treasury of American Design and Antiques: A Pictorial Survey of Popular Folk Arts Based on Watercolor Renderings in the Index of American Design, at the National Gallery* (New York: Harry N. Abrams, 1972), two vols. in one, 19, fig. 28.

42. The museum, now known as M/S Maritime Museum of Denmark, has relocated to Helsingør, Denmark.

43. Hansen, *Galionsfiguren*, 84.

44. Julián Amich Bert, *Mascarones de Proa y Exvotos Marineros* (Spain: Argos, 1949), 23, depicts a male bust figure. On Neruda's library copy, he has written a personal note in the margin.

45. A letter and other pertinent documents were emailed to the author on Apr. 23, 2017, by Mr. William Peniston, librarian/archivist at the Newark Museum in Newark,

New Jersey. This documentation revealed that Ralph Warren Burnham was the Boston antiques dealer who originally purchased what later became catalogued as OF72 at The Mariners' Museum. Information shows that in 1931 Burnham had arranged to loan the figure to the Newark Museum in New Jersey. Burnham's letter to Miss Beatrice Winser, director, Newark Museum, dated Oct. 15, 1931, read: "I have been trying for some time to ascertain the history of this piece of sculpture and just where it was used but I have been unable to line it up well. The party from whom I purchased it travelled extensively in Rhode Island and Maine, searching for things, and I think he told me it came from Rhode Island but I am not positive for he brought me in many beautiful things also from Maine. He was going to give me details of it as far as he knew but never did so and he has died. At the time I purchased this piece he had another of Andrew Jackson. . . . But it was not to be compared in glory to the bust of *Perry* as it did not possess that, well, I don't know what to call it, look that *Perry* has. This bust when it left the sculptor's hands no doubt was beautiful to a certain degree but time has mellowed it so that it is quite beyond describing. . . . I have placed a value of $5000 on *Perry* which I think is ample for transportation or insurance purposes but not for sale purposes. If anyone becomes interested in it while on exhibition at your museum and are really serious . . . arrangements may be made, and while I am not offering for sale yet, at the same time, if anyone wants it badly enough to pay what it is worth as compared with other things and in consideration of what other things have brought, I would reluctantly let it go. There are many artists here in Massachusetts that hope I will never sell it and who are willing to pay me $1.00 a year just to come and have a look at it, so they say. Very truly yours, R.W. Burnham."

46. Deborah Chotner, Virginia Tuttle Clayton, Elizabeth Stillinger, and Erika Doss, *Drawing on America's Past: Folk Art, Modernism, and the Index of American Design* (Washington, DC: National Gallery of Art, 2002), 98.

47. Chotner, Clayton, Stillinger, and Doss, *Drawing on America's Past,* 248.

48. Pauline A. Pinckney, *American Figureheads and Their Carvers* (New York: Norton, 1940), pl. XIII.

Chapter Two

1. Douglas Fetherling, "Pablo Neruda Recollecting the Collector in Chile," in *Literary Trips: Following in the Footsteps of Fame,* vol. 2: 233–43, ed. Victoria Brooks (Vancouver, BC: Great Escapes Publishing, 2001). After seeing this article, I was able to speak with Beatriz Hausner in late 2016.

2. Neruda was also a fan of Edgar Allan Poe and sometimes had Poe's picture hanging near his work area.

3. Susana Wald, email to the author, Sept. 6, 2018, confirmed this information.

4. Alex Zisman, "An interview with Ludwig Zeller," *Review: Literature and the Arts of the Americas* 11 (Fall/Winter 1977): 167, translated by Dallas Gavin. Ludwig Zeller grew up in the Atacama Desert in northern Chile, where his father, a German chemical engineer, worked in the production of sulfuric acid and dynamite. Zeller attended secondary school in Antofagasta before continuing his education in Santiago and

embarking on his own career. As of now, no ship bearing attribution to the figurehead that Zeller brought from the north has been identified.

5. Henry Wadsworth Longfellow, "The Building of the Ship." Poetry Foundation, poetryfoundation.org, accessed Dec. 18, 2023.

6. *Okeia* ship information accessed at Passengers in History, https://passengers.history.sa.gov.au, accessed Aug. 18, 2022. This site is an initiative of the South Australian Maritime Museum.

7. Javier Ormeño Bustos at the Pablo Neruda Foundation located Mrs. Marta Espinoza and, soon after, interviewed her on Nov. 4, 2017. Her husband, Mr. Jorge Celery Zolezzi, born 1924, had been an interior decorator after studying at the school of arts and crafts.

8. Javier Ormeño Bustos's transcription of his interview with Mrs. Marta Espinoza indicates that when Neruda offered to buy the figurehead in installments with letters or third-party checks, it was rejected. The interview also refers to ". . . the play *Romeo and Juliet* by William Shakespeare that Neruda worked on from the autumn of 1963 until the beginning of March 1964 and that it meant income for copyright." Feinstein pointed out that Neruda was invited to do this translation to help mark the four-hundredth anniversary of Shakespeare's birth. See Feinstein, *Pablo Neruda,* 339.

9. Ship name searches for Micaela and anglicized variations of the name have not yielded applicable information. The Micaela carving's dimensions suggest that the figure may be from a vessel in the 1,400- to 1,600-ton range.

10. Pablo Neruda, "La Micaela" in *Una casa en la arena.* The translation can be found in *The House in the Sand,* 93.

11. Mary H. Northend, "The Garden of Figureheads," *International Studio* (Sept. 1922): 505–8.

12. John Goodall, *Parish Church Treasures: The Nation's Greatest Art Collection* (London and New York: Bloomsbury, 2015), 246.

13. A photo of the figurehead from the 1,367-ton iron barque, *Derry Castle,* which was built at Glasgow, Scotland, in 1883, is available at the National Library of New Zealand, natlib.govt.nz, accessed Dec. 20, 2023.

14. I was present at the *Dictator* onsite memorial ceremonies in Virginia Beach, Virginia, in 1983, which included the launch of a small boat from the beach and laying of a wreath of flowers in the waters of the Atlantic Ocean. Ongoing remembrances are highlighted in Cindy Butler Focke, "Victims and Life-Savers Continue to Be Honored after Norwegian Shipwreck off Virginia Beach in 1891," *Virginia Pilot,* Mar. 27, 2017, pilotonline.com, accessed Aug. 14, 2022.

15. P. N. Thomas, *British Figureheads & Ship Carvers* (Albrighton, England: Waine Research Publications, 1995), 56.

16. "The Wreck of the Derry Castle the Sufferings of the Crew," *Otago Witness,* Sept. 30, 1887, 20, and "Wreck of the Derry Castle 15 Lives Lost," *Otaga Witness,* Sept. 30, 1887, 20, at home.rootsweb.com, accessed Dec. 20, 2023.

17. When answering a question about whether all of his material originated with him, Neruda said in an interview: "To look for originality at all costs is a modern condition. In our time, the writer wants to call attention to himself, and this superficial

preoccupation takes on fetishistic characteristics. Each person tries to find a road whereby he will stand out, neither for profundity nor for discovery, but for the imposition of a special diversity. The most original artist will change phases in accord with the time, the epoch. The great example is Picasso, who begins by nourishing himself from the painting and sculpture of Africa or the primitive arts, and then goes on with such a power of transformation that his works, characterized by his splendid originality, seem to be stages in the cultural geology of the world." Neruda, "Pablo Neruda: The Art of Poetry."

18. Jean H. Lipman, *American Folk Art in Wood, Metal, and Stone* (New York: Pantheon, 1948). This book was reprinted by Courier Corporation in 1972.

19. Neruda, "Ceremony/Ceremonia," in *The House in the Sand*, trans. Dennis Maloney and Clark M. Zlotchew, 77.

20. Neruda employs comical puns in describing the robbers, a technique evident in his reference to "My beloved followers, Pedregala and Matazan." According to personal communicaton from Javier Ormeño Bustos to the author, in Sept. 2017, when Neruda uses the term "Pedregala," he is playfully referring to Mária Camila Martner Garcia Matazan, who was skillful at making stone murals and had earned the moniker "stoner." She had, in fact, created a stone mural at Isla Negra above the second fireplace, and another at Isla Negra's outside bar area. Matazan, on the other hand, is a portmanteau of "mata" (kill) and "zan" (healthy), signifying a doctor who kills healthy people, and akin to the colloquial word "Matasano," which Neruda modified to "Matazan" to approximate the English term "quack doctor." Neruda's intention was humorous since he so highly valued Velasco's medical capabilities that Velasco was his own personal physician. Velasco's expertise also extended to art history, which he taught at the University of Valparaiso. Velasco and his wife were among Neruda's closest friends, and they lived on the first floors of Neruda's Valparaiso home, La Sebastiana.

21. Eisner, *Neruda,* 209.

22. María A. Salgado, "Alfonsina Storni (1892–1938), Argentina," in *Spanish American Woman Writers: A Bio-Bibliographical Source Book,* ed. Diane E. Marting (Westport, CT: Greenwood Press, 1990).

23. Pablo Neruda, "To a Ship's Figurehead (Elegy), in *Canto General,*, trans. Jack Schmitt (Berkeley: University of California Press, 1991), 357. Reprinted by permission of the publisher.

24. This description draws on Zteve T. Evans, "El Caleuche: The Ghost Ship of Chilote Mythology," Folkrealm Studies, https://folkrealmstudies.weebly.com/el-caleuche-the-ghost-ship-of-chilote-folklore.html, accessed Dec. 26, 2023. Evans speculates that the origins of El Caleuche may derive from Chileans seeing night-time sailing ships that had rounded Cape Horn.

25. Javier Ormeño Bustos, Pablo Neruda Foundation, communication by telephone with the author, May 2018, revealed that Neruda's *Memoirs* exhibit chronological inconsistencies, with dates occasionally not aligning with documented events. Ormeño Bustos further notes that the published *Memoirs* represent final drafts pending editing, as Neruda continued to write until his sudden death. Additionally, a significant portion of Neruda's recollections are based on articles and conferences from

as early as the 1950s. In 1974, Matilde Urrutia, Neruda's widow, collaborated with Miguel Otero Silva in the final editing of Neruda's *Memoirs*.

26. Mantell, *Yo Soy Pablo Neruda,* from minute 17:00.

27. This carving's designer does not use the common pledge pose of one arm positioned across the chest. Neruda's carving instead is generally similar to artist Antonio Canova's neoclassical marble sculpture of undraped Venus as she holds fabric to the center of her chest. Canova was a commercially successful artist who saw to it that his sculptural works were widely published as engravings. Shipowners and ship carvers could have accessed his published work.

28. Reference to the 2021 private sale of the Glory of the Seas figurehead is published at hylandgranby.com, accessed May 22, 2023. Several years before the 2021 sale, the author was permitted to examine the Glory of the Seas figurehead at India House in New York City.

29. W. H. Bunting, *Portrait of a Port: Boston 1852–1914* (Cambridge, MA: Belknap Press, 1994), 78.

30. In a sculpture dated c. 1822–23 with accession no. 2003.21.1 and credited to the workshop of Antonio Canova, Venus gathers fabric at the front of her body in the pose of the original 1810 *Venus Italica*. Bequest of Lillian Rojtman Berkman, 2001, Metropolitian Museum, Metmuseum.org, accessed Aug. 27, 2022.

31. A vessel's official hull number remains constant, as does the vessel name, until an owner chooses to change the latter. This stability helps avoid confusion in a world filled with thousands of ships. Pablo Neruda's poem "La Sirena" employs the Spanish term "Sirena" and "Sirena de Glasgow," but the translation of the poem renders the vessel name as "Mermaid" and "Mermaid of Glasgow." See Neruda, "La Sirena," in *The House in the Sand,* trans. Maloney and Zlotchew, 80–81.

32. Caledonian Maritime Research Trust, clydemaritimeforms.co.uk, accessed Dec. 27, 2023, and Watt Library Newspaper Ship Index, downloaded Dec. 27, 2023.

33. Referred to in Spanish as *Compañía de Vapores del Pacifico,* the Pacific Steam Navigation Company's *Serena* was a steel screw three-mast schooner of 2,394 gross tons, built in 1881 by R. Napier & Sons. Her official number was 84110, signal letters VRFL, and homeport Liverpool.

34. Pablo Neruda, *Confiesco que he vivido* (Chile: Estate of Pablo Neruda, 1974), is the Spanish original that later became *Memoirs*. The information in either cannot be considered entirely reliable since Neruda passed away as his Spanish version was being edited, leaving Matilde Urrutia and Migel Otero Silva to do the final preparation for publication. The English translation reads: "They removed the lovely figure from the ship's prow and hid it in a storehouse down in the port. I got to know her years later, when my escape and exile were a thing of the past. As I write these memoirs here beside the sea, that handsome woman carved in wood who has a Greek face like all the figureheads on old sailing ships, gazes at me with her wistful beauty" (175).

35. This information and an accompanying photo were provided by the Pablo Neruda Foundation.

36. "The Nobel Prize in Literature 1945, Gabriela Mistral," Nobelprize.org, accessed Jan. 12, 2024.

37. Pablo Neruda, "The Medusa I" in *The House in the Sand,* trans. Maloney and Zlotchew, 67, 69.

38. Pablo Neruda, "The Medusa II," in *The House in the Sand,* trans. Maloney and Zlotchew, 71, 73.

39. Eisner, *Neruda,* relates that Neruda sent letters of affection to a woman named Laura Arrué through his friend Homero Arce, whose job was with the Chilean postal service. The reason Neruda did not hear back is that Homero Arce had fallen in love with Laura himself, and never delivered Neruda's letters (174–75).

40. A choir concept for ship figureheads is found in Clara Florida Guerney's 1871 book *The Merman and the Figure-head: A Christmas Story.* In this tale, Master Isaac Torrey, a merchant of Salem, declares that the full-length figurehead for his brig will be a namesake sea nymph. When Clerk Ichabod Sterns objects, Torre defiantly retorts, "If I chose to name [my ship] after the whole choir of all the nymphs that ever swam in the sea—Panope and Melite, Arethusa, Leucothea, Thetis, Cymodoce—what have you to say against it? Isn't she to swim the seas and make her living out of the winds and waves?" Sterns responded that it was a "heathenish kind of name for a ship [sailing] out of our decent Christian town of Salem."

41. George Brown Goode, *The Fisheries and Fishery Industries of the United States,* section V, *History and Methods of the Fisheries,* vol. 2, "Narrative of an Antarctic Sealing Voyage in the ship Neptune 1796-1799" London: Forgotten Books, 2018. Originally published Washington, DC, 1887. Reprint, 460–63.

42. Urrutia, *My Life with Pablo Neruda,* 111.

43. Ever the collector, Neruda eagerly acquired seashells, taking them as he walked various beaches of the world and buying even more in European specialty shops. They were objects that had captivated Neruda from an early age, and his collection of rare sea shells remains one of the key displays at Isla Negra.

44. In one of the most influential works in western culture, *Metamorphosis* tells the story of Aphrodite transforming Pygmalion's beautiful carved sculpture into a wife for him. Ovid's Metamorphoses, Book X, "Orpheus Sings: Pygmalion and the Statue," lines 243–97, trans. A. S. Kline, Ovid Collection University of Virginia, ovid.lib.virginia.edu, accessed Dec. 26, 2023.

45. Javier Ormeño Bustos's discussions with Rafael Plaza, May 2018.

46. Mystic Seaport's Rhine figurehead from the Greenock, Scotland-built 1886 vessel for J. Nourse is among figureheads with low-placed ears.

47. Large necklaces on figureheads are shown in Olsen, "Nineteenth and Twentieth Century Ship Figureheads," 144, 145.

48. Neruda, "The Medusa II," in *The House in the Sand,* trans. Maloney and Zlotchew, 71, 73.

49. Carla figurehead dimensions recorded by the author.

50. Chris Read, reference librarian at the State Library of South Australia, emailed the author on Sept. 22, 2016, regarding the A. D. Edwardes Collection photograph PRG 1373-9-50 titled "The 'Lonsdale' in an unidentified port." Mr. Read advised that the barque "Lonsdale," circa 1900, in the photograph is indeed the shipwrecked vessel now resting at Punta Arenas. According to the Lloyd's Register of Shipping, the

Lonsdale, a steel ship of 1,756 tons was built in Londonderry, Northern Ireland, and, in 1889, was registered in Liverpool as part of the Iredale fleet. Mr. Read noted that the *Lonsdale* does not appear in Lloyd's Register after 1909. He added, "For the period I checked, there was no ship registered with Lloyds with the name 'Lord Lonsdale.'" Notably, in the Dale Line fleet of ships, each vessel had a name ending in "dale." One significant aspect of the *Lonsdale* photo identification by the State Library of South Australia is the discrepancy in the ship's name, which appears mistakenly as *Lord Lonsdale* on a commemorative plaque at the site of the hulk in Punta Arenas.

51. Previously this letter by Antonio Sapunar Ojeda has been interpreted by some to mean that *Lonsdale,* cut down to a pontoon, was used to transport a figurehead. However, given the vessel's history and condition, its use as a working hull seems very unlikely by 1948. More particularly, the letter refers to the vessel as nationalized, and then makes an exception for the vessel's figurehead to be sent north.

52. A digital image of this signed declaration that is dated Jan. 7, 1974, was made available to me from shipwreck research information produced by marine archaeologist Christopher Pollet in Chile and the IANS: Project FONDART 10577.

53. Javier Ormeño Bustos at the Pablo Neruda Foundation informed me that the distance from Punta Arenas to the port of San Antonio, just south of Isla Negra, is sufficient to be considered "north of the country" for the people in Punta Arenas and other parts of Patagonia. The 1947 letter from the foundation's archives was written in capital letters in Spanish and has been translated into English for me by Javier Ormeño Bustos. The original text reads:

CERTIFICO QUE UNA FIGURA DE MADERA CONUN PESO APROXIMADE DE DOSCIENTOS CINCUENTA ILOS PROCEDE DEL PONTON "LONSDALE" DE MI PROPIEDAD QUE ESTA EN DESGUACE EN LA PLAY FRENTE AL PARQUE "MARIA BEHETY" Y QUE DUE DECLARADO "TECNICAMENTE NAUFRAGADO" QUEDANDO AUTOMATICAMENTE NACIONALIZADOS LOS MATERIALES PROCEDENTE DE DICHO PONTON.

DOY EL PRESENTE A PETITION DEL SENOR ANTONIO PERUZOVIC Y PARA LOS EFECTOS DE PODER DESPACHAR LA MENCIONADA FIGURA DE MADERA AL NORTE DEL PAIS.

PUNTA ARENAS 28 DE OCTUBRE DE 1947

ANTONIO SAPUNAR OJEDA

54. Approximate weight suggested is calculated using the figure dimensions and seasoned pine wood density.

55. Information about the Dale Line operations, aspects of management, and J. D. Newton are drawn from "J. D. Newton's Dale Line," at Mighty Seas, mighty.seas.co.uk, accessed Dec. 26, 2023.

56. *Lonsdale*'s official number is 96,382, and her signal letters are LKTH.

57. William Shakespeare, *Henry VIII* (scene 3, act 2, line 521) reads: "Be just, and fear not, Let all the ends thou aim'st at be they country's, They God's, and truth's; then

if thou fall'st, O Cromwell, Thou fall'st a blessed martyr!" Shakespeare-online.com, accessed Dec. 26, 2023.

58. In 1889, Peter Iredale's business with his own son, J. Henry Iredale, dissolved, leading to the establishment of the new enterprise, P. Iredale & Porter, a collaboration between Peter Iredale and his son-in-law.

59. "Fire on a Barque," *Newcastle Morning Herald and Miners' Advocate*, Mar. 16, 1910, 4. This article was made available by the State Library of South Australia.

60. "Twixt Fire and Flood. Crew's Escape from a Burning Ship." *Brisbane, Qld*, Mar. 25, 1910, 23. This article was provided by the State Library of South Australia.

61. Capt. Frank H. Shaw, *Seas of Memory* (London: Oldbourne, 1958,) as cited in Thomas P. Iredale, "Peter Iredale Biography" at iredale.de, accessed Dec. 27, 2023.

62. Iredale, "Peter Iredale Biography."

63. Jay Sivell, "Lost at Sea, A Sailor's Life–22 The Nitrate Coast, Chile 1912," monkbarns.wordpress.com, accessed Dec. 27, 2023. Drawing on the life of Bert Sivell, his sailor grandfather, Jay Sivell details the significant role the nitrate trade played in Chile's maritime history.

Chapter Three

1. Now known as PEN International, this organization's purpose is to "promote literature and defend freedom of expression worldwide." Arthur Miller, the newly elected president of PEN, extended an invitation to Neruda to speak at the 1966 New York City Conference. The Pablo Neruda Foundation advises that six hundred poets and writers from fifty-six countries attended.

2. In the absence of incontrovertible evidence that this figurehead represents Jenny Lind, we may also consider the likeness of The Mariners' Museum's figurehead to the opera star whose married name was Anna Thillon (1819–1903). After performing in Europe, Thillon starred from 1851 to 1855 in U.S. theater, living first in San Francisco and then in New York. Her painted portrait by artist Henry Willard, at the University of Michigan Art Museum, has very similar facial and body shape features, and she wears an off-the-shoulder dress with a central brooch. Jenny Lind's appearance in paintings and drawings was sometimes made to look a little more attractive than she seems to have been in person. In referring to family documents, Sarah Jenny Dunsmure, the great-great-granddaughter of Jenny Lind, states that her famous relative was troubled about her appearance, especially her "potato nose" and called herself a "broad-nosed . . . girl." See Sarah Jenny Dunsmure, *Jenny Lind: The Story of the Swedish Nightingale* (United Kingdom: RedDoor, 2015, 8). Even the most flattering images show its roundness. We may never know the definite identity of The Mariners' Museum figurehead and by extension that of the popular version owned by Neruda.

3. Urrutia, *My Life with Pablo Neruda*, 186, 233. Urrutia acknowledges that even this purchase stretched their finances at the time. She describes how she and Neruda left this shop otherwise empty-handed because this "colorful, delicate figurine" cost all their money. She recounts Neruda's debts at shops for antiques, seashells, and books and indicates that he would spend money in anticipation of prizes. Items were

sometimes loaned to them, prompting Neruda to once remark, "If they found out how poor we really are, they'd never lend us anything" (188).

4. Marion V. Brewington, *Shipcarvers of North America* (New York: Dover, 1972), fig. 51, 55. This object is catalogued as OF8 at The Mariners' Museum.

5. A clipper card for *The Always Popular A1 First Class Clipper Ship Prima Donna* features four nineteenth-century opera vocalists, three of whom appear to me to resemble Marietta Alboni, Adelina Patti, and Caroline Barbot. This image can be found at the Prima Donna entry on wikipedia, accessed Dec. 27, 2023. This c. 1855 image is taken from Westward by Sea: A Maritime Perspective on American Expansion, 1820–1890, part of the American Memory collection at the Library of Congress.

6. "Prima donna," merriam-webster.com, accessed Jan. 12, 2024.

7. Howe and Matthews, *American Clipper Ships vol.* 1, 4, provides shipbuilder and figurehead information. Also, a carte de visite of celebrated vocalist Adelina Patti (1843–1919) shows her with a bird on her finger, presumably as a symbol of melodious singing. It was produced by the London Stereoscopic and Photographic Company. See Library of Nineteenth-Century Photography, 19thcenturyphotos.com, accessed Dec. 27, 2023.

8. Carol A. Olsen, "Fishing vessel's spiritual and protective dove emblem," Hullartships.com, accessed Dec. 23, 2023.

9. A wood carving, earlier considered a scarecrow, was found in a barn in Sweden. Karl-Eric Svärdskog's 2001 book, *Jenny Lind and the Clipper Nightingale,* argues that this carving was indeed *Nightingale*'s figurehead. When the carving was auctioned at Sotheby's, New York, in 2008, it garnered only $120,000. Prior to the sale, a telephone interview took place with American antique dealer Ryan Cooper, who stepped up to challenge Svärdskog's attribution. Wendy Moonan, "The Auction Block Is the Next Stop for a Well-Traveled Lady," *New York Times,* Jan. 4, 2008, nytimes.org, accessed Aug. 29, 2022. Additionally, auction information for the carving as Lot 197 in 2008 is available at sothebys.com, accessed Aug. 29, 2022.

10. The American Swedish Historical Museum, Philadelphia, Pennsylvania, is a repository for Jenny Lind materials, including music, poems, news articles, autographs, daguerreotypes, personal letters, diary material, concert programs, and tickets. The National Library of Sweden also houses abundant Jenny Lind materials.

11. An irony of Neruda's story is that Jenny Lind was admired not only for the high quality of her voice and theatrical capabilities, but also for the virtuous way in which she conducted herself.

12. Holger Cahill served as the National Director of the Federal Art Project of the Works Progress Administration from 1935 to 1942, a crucial period that overlapped the Great Depression. During this time, he played a role in selecting the original figurehead known as Jenny Lind for representation in the Index of American Design. Whether the index directly influenced the production of the various popular variations of the Jenny Lind figurehead remains unknown, but it is a plausible scenario. Numerous likenesses of Jenny Lind persist, and some are still available today, notably at Preston's in Long Island, New York. Regardless of the origins of this phenomenon, Neruda eventually became the proud owner of one of these likenesses.

13. Charlie Ritchie, a representative of the National Gallery of Art, identified artist Mary Humes as the likely creator of the drawing of Jenny Lind. In an email correspondence with the author on Mar. 4, 2017, Ritchie stated: "There is one figurehead [rendering] associated with Jenny Lind. I do not think it is by Elizabeth Moutal. It is a Virginia project rendering and the accompanying documentation sheet says the drawing was assigned to artist Mary E. Humes, active c. 1935. The rendering is in the style of Mary Humes's other Index renderings, even though this rendering has no artist signature. The associated documentation sheet is dated June 22nd, 1938, so the rendering was probably executed somewhere around that time. The original [figurehead] was in the collection of The Mariners' Museum in Newport News, Virginia, when it was rendered and is still there. It is also in 1938 that artist Elizabeth Moutal is credited with visiting The Mariners' Museum to do a drawing for the Index of American Design of what was then called the 'Commodore Perry' figurehead."

14. Urrutia, *My Life with Pablo Neruda*, 233.

15. Brewington, *Shipcarvers of North America*, fig. 36, Figurehead by Isaac Fowle, Courtesy Bostonian Society.

16. The earliest I find the original Shawl Lady figurehead called a "shop figure" or "advertisement" is in David A. Wasson, "Silent Pilots" *The Outlook*, 109, no. 4, (Jan. 27, 1915): 206–13, with captioned illustration at 209. Wasson gives the carver's name as Towle rather than Isaac Fowle.

Next, the Nov. 26, 1936, Index of American Design (IAD) Data Report Sheet, now in the IAD Archives in Washington DC, has for the original Shawl Lady figurehead the handwritten note "used as his shop sign" after the typed words "made by Isaac Fowle." It also has suggested carving dates of 1820, 1830, and 1850 for the figure written in, with some crossed off.

Pauline Pinckney, in *American Figureheads*, captions Plate X showing a picture of the original Shawl Lady figurehead as "Carved by Isaac Fowle, this life-size figure served to mark his Boston shop. Old State House, Boston."

Another date for the Shawl Lady figurehead is "probably before 1832" as shown by E. O. Christensen, who wrote the 1950 edition of *The Index of American Design* (New York: Macmillan, 1950) and *Early American Woodcarving* (Cleveland, OH: World, 1952).

In 1962, Brewington, *Shipcarvers of North America*, shows as fig. 36 what is Elizabeth Moutal's Index of American Design drawing of the original Shawl Lady figurehead, although attribution to Moutal or the Index is not given. Brewington proposes that hundreds of carvings went through the doors of Isaac Fowle and later his two sons' carving business, and "that one is a full length figure, never affixed to a vessel, and 'done by Isaac Fowle'" (42). Brewington does not say why he believes this.

Robert Bishop, *American Folk Sculpture* (New York: Dutton, 1974), says this carving was by Isaac Fowle, c. 1820, and that it was a shop figure. No provenance is provided.

The late Ralph Sessions authored "The Shipcarver's Art: Figureheads in Nineteenth Century New York and Boston," *Folk Art* (Summer 2005): 44–51, in which he says, without offering more information, that this figure is by Fowle and that it served

as a shop figure. He repeats this in his book *The Shipcarvers' Art*, 48–49, and pl. 18, where he labels this figure "Lady with a *Scarf*" and asserts it is the only figure definitely documented to Isaac Fowle, that it never was mounted on a ship, and that it was a figurehead sample and shop sign.

This repeated information over the course of nearly a hundred years concerning the supposed sculptor, date, and the carving's function is addressed in the note below.

17. In 2014, with agreement from and in the presence of curatorial staff, I was able to inspect the original Lady with Shawl carving at Old State House in Boston, and I had subsequent discussion about the material on which the supposed carver, date, and carving function are based. In a 2017 phone call between the author and Sira Dooley Fairchild, collections manager and exhibitions coordinator of the Bostonian Society (located at the Old State House, Boston) and an email to the author from Ms. Fairchild dated Oct. 17, 2017, staff members admitted they "haven't seen any evidence that calls into question the attribution to Fowle, but (as mentioned in our 2017 telephone conversation) little to no provenance information was gathered in the 1890s when this piece came into their collection. For this piece, [we] have nothing beyond the accession record which states that it was carved by [Isaac] Fowle."

This means that the carver attribution is based on an 1890s comment. If the 1820 date traditionally cited for the original figurehead is correct, that certainly could plant the carving firmly within the career of Isaac Howard Fowle, who lived from 1783 to 1872, but another problem is raised. The garment's fitted bodice, pointed waist, and tight, short sleeves are characteristic of mid-nineteenth-century dress, rather than 1820s women's clothing, Isaac Fowle reportedly worked until the 1840s. His sons did continue in the ship-carving business past the mid-nineteenth century.

18. It is intriguing to contemplate ways in which an original figurehead might remain in excellent condition. One looks, for example, to the context of the newbuild *Sarah Cowles,* made known in an Apr. 17, 1851, newspaper advertisement for her upcoming first transatlantic voyage. Three weeks later, on May 7, an advertisement in the *New York Commercial Advertiser* showed that the vessel's name had been abruptly changed to *Nightingale* in honor of the popular singer Jenny Lind. If that ship's name change proved troubling to anyone, particularly if a portrait figurehead had already been carved to resemble Sarah Cowles, what would be done with it? Perhaps closet it away and eventually donate it to a museum? The name change from *Sarah Cowles* to *Nightingale* for the 1851 clipper is referenced at bruzelius.info, accessed Dec. 19, 2023. Alternately, we may look to the story of Donald McKay's *Great Republic,* which burned before making an initial commercial trip. The hull damage necessitated rebuilding the bow shape, which made unusable its original eagle figurehead, and it is currently preserved at Mystic Seaport Museum in very good condition. Finally, Brewington reports that the completed *Cassandra Adams* figurehead was not placed on its vessel because Cassandra Adams's father considered it immodest. Instead, he ordered another carved figurehead that was less revealing, and that fatherly gesture would have left behind a newly carved, unused figurehead. See Brewington, *Shipcarvers of North America,* 93 and fig. 88. These examples illustrate reasons other than

shop sign usage as why a nineteenth-century figurehead could remain in very good condition.

19. Among rare exceptions is the deerhound figurehead (Lot 164) attributed to the 1869 British yacht *Gelert*. The carving was sold at auction Apr. 30, 2019, for a price exceeding expectations. See charlesmillerltd.com, accessed Dec. 18, 2023.

20. Neruda, "The Marie Celeste," in *The House in the Sand*, trans. Maloney and Zlotchew, 83.

21. "El Olor del regreso," *Vistazo*, no. 12 (Nov. 11, 1952). This article and its translation were provided to me on Aug. 10, 2017, by Javier Ormeño Bustos at the Pablo Neruda Foundation.

22. The Santiago home named "Los Guindos" is where the Marie Celeste carving was delivered in 1952. It was the home Neruda shared with his wife at that time, Delia del Carril.

23. In 1862 after being abandoned at sea and with no trace of those onboard, the *Mary Celeste* was discovered, boarded, and sailed to port by a few crew from *Dei Gratia*. *Mary Celeste* had several subsequent years of sailing. Her career ended on Jan. 3, 1885, when she was intentionally wrecked on a coral reef in a fraudulent attempt to gain insurance money. Charges were brought for this crime.

24. Neruda, *Memoirs*, "Bottles and Figureheads" section.

25. The Spanish term is *encina*.

26. Brian Hicks, *Ghost Ship: The Mysterious True Story of the* Mary Celeste *and Her Missing Crew* (New York: Ballantine Books, 2004), 59.

27. Garreton, Ugarte, and Aguero, "Technical Restoration Report."

28. Following a visit to the ancient site of Machu Picchu, in 1945 Neruda wrote "The Heights of Macchu Picchu." It is part of his epic poem *Canto General*, portraying the prehistory and history of Latin America.

29. The Spanish title for the poem is "Donde Estará La Guillermina."

30. Oviedo wrote about this 1966 event in his 1979 article, "Phantoms of Isla Negra." *Revista Hoy* (Edición extraordinaria: November 1979): 28–29.

31. Pablo Neruda, *Where Can Guillermina Be?* Trans. Alastair Reid *New York Review of Books*, Oct. 3, 1974, accessed at nybooks.com, Feb. 26, 2024.

32. Neruda, "The Art of Poetry."

33. Jorge Edwards, *Adios, Poeta . . . Pablo Neruda y su tiempo* (Barcelona: Tusquets Editores, SA, 2004), 128.

34. Edwards, *Adiós, Poeta*, 132–33.

35. This is distinct from the Viareggio Prize for Literature, which had been awarded decades prior to this time. Neruda's award, the International Viareggio Versilia prize, is referred to in David Schidlowsky, *Neruda Y Su Tiempo*, vol. 2, 1189. Reference to this citation was provided to me by Javier Ormeño Bustos at the Pablo Neruda Foundation.

36. This description draws on Edwards, *Adios, Poeta*, 132–34.

37. Neruda, *Memoirs*, 11. Neruda refers to Emilio Salgari (1862–1911), who was knighted by the Queen of Italy.

38. Matilde Urrutia, *My Life with Pablo Neruda*, trans. Alexandria Giardino (Stanford, California: Stanford General Books, 2004) 227 describes that in 1971, when he

was Ambassador to France, Neruda decorated his office with well-loved objects. Ur-rutia says that among them was this figure, which she claims he bought at a Paris an-tique shop. Urrutia *My Life with Pablo Neruda,*227. Additionally, on Aug. 21, 2017, I received a photo of the figurine when it was in the Paris Embassy. The photo identifi-cation was "indice 5288.jpg," sent to me by Javier Ormeño Bustos at the Pablo Neruda Foundation. It was provided to him from the Pablo Neruda Archives, Isla Negra, by Carolina Rivas Cruz, director at Isla Negra.

39. Brewington, *Shipcarvers of North America,* 13, fig. 13.

40. Lawrence Sondhaus, *Naval Warfare, 1815–1914,* (London, New York: Rout-ledge, 2001), 20.

41. Javier Ormeño Bustos, Pablo Neruda Foundation, interview with the author, 2017. Ormeño Bustos discussed Neruda's fascination with Lord Thomas Cochrane; in addition to a collection of Cochrane biographies, he owned two Cochrane portraits, dedicated poems to Cochrane and to the Independence of Chile, and participated in commemorating the Cochrane-led battle in Valdivia, Chile. Ormeño Bustos also noted that, in the 1960s and possibly early 1970s, Neruda communicated with Doug-las Cochrane, a descendant of Lord Cochrane.

42. Sondhaus, *Naval Warfare, 1815–1914,* 20, describes *Rising Star* as a fully rigged, corvette-style steamer.

43. Sondhaus, *Naval Warfare, 1815–1914,* 20.

44. The Pablo Neruda Foundation "Technical Restoration Report" accurately as-serts that these carvings are not from ships. However, on 70–72, it mistakenly inter-changes the names and images of La Bonita/Beauty as La Novia/Girlfriend. The foun-dation confirms the corrected names and photos as shown in this book.

45. This is noteworthy in the context of Neruda's *Micaela* carving, which was also found on a beach.

46. Information about the *Ambassador* and its figurehead was first made known to me by Christophe Pollet, marine archaeologist with the Instituto de Arqueologia Nautica y Subacuática (IANS) in Chile.

47. "The West Coast Expedition," *North Otago Times,* Dec. 20, 1867, 2.

48. *Jenk's Portland Gazette,* July 6, 1801. The date of the captain's sighting was Sat-urday, July 4.

49. Professor Eduardo de Rivera Silva, personal communication to the author, Nov. 2015, National Maritime Museum, Valparaiso, Chile, during a tour when the carved head from *Liffey* was displayed in the museum. A subsequent email to the au-thor from Eduardo Rivera, dated Mar. 8, 2024, advised that the torso of the *Liffey* fig-urehead is now considered lost.

50. The *Rhine* figurehead from a James Nourse vessel is displayed at Mystic Sea-port Museum.

51. A photograph of Neruda's sister Laurita at the long table in front of the Isla Negra picture window shows in the background a small, souvenir-style classical head from antiquity mounted for table display. This raises the question of whether that could have helped inspire the creation of these female heads for Neruda's collection, which presumably are meant to look like surviving pieces of figureheads.

52. Oscar Wilde, *The Picture of Dorian Gray,* first published in *Lippincott's Monthly Magazine,* July 1890.

53. Pablo Neruda, "La Bonita/Beauty," in *The House in the Sand,* trans. Maloney and Zlotchew, 90–91.

54. Pablo Neruda, "Epithalamium" in *The Captain's Verses,* trans. Donald D. Walsh (New York: New Directions Books), 2004, 131.

55. Pablo Neruda, "La mamadre"/"The More-Mother," in *Isla Negra: A Notebook,* trans. Alastair Reid (New York: Farrar, Straus, and Giroux, 1981), 9. Javier Ormeño Bustos at the Pablo Neruda Foundation comments on the beautiful wordplay for Neruda's stepmother with "mamadre" being the fusion of "mama" and "madre," both meaning mother, or two times mother as the name for Neruda's second mother.

56. Neruda, *Memoirs,* 3.

57. Javier Ormeño Bustos, personal communication to the author, Jan. 15, 2017. At the Pablo Neruda Foundation, he provided the word count for "rose," which far outstrips other high-use words in Neruda's writing, such as "honey" (miel), which appears 151 times and "bees" ("abeja"), which appears 112 times.

58. Luis Rubila Solis, "E ombre de la Rosa en la Poesia de Pablo Neruda," *Literatura y Linguistica* (2000) no. 12: 21–42, accessible at www.scielo.cl.

Appendix B

1. Museo Marítimo Nacional, museomaritimo.cl.

2. The loss of the Chilean navy wooden vessel *Esmeralda* to Peru on May 21, 1879, was a significant event in Chilean history. *Esmeralda* sank during the Battle of Iquique in action against Peru's ironclad *Huascar.*

3. "Report of the Chilean National Commission on Truth and Reconciliation," *United States Institute of Peace* (website) Oct. 4, 2002, accessed Sept. 4, 2022, accessible at www.usip.org/sites/default/files/resources/collections/truth_commissions/Chile90-Report/Chile90-Report.pdf. See also "Chile: Torture and the Naval Training Ship the Esmeralda," Amnesty International, June 25, 2003, amnestyinternational.org, accessed Sept. 4, 2022, and "Findings of 'on the spot' Observations in the Republic of Chile, July 22–August 2, 1974," Inter-American Commission on Human Rights, Organization of American States, October 25, 1974, oas.org, accessed Sept. 4, 2022.

4. Jack Nicas, "Chile Says 'No' to Left-Leaning Constitution After 3 Years of Debate," *New York Times,* Sept. 4, 2022, updated Sept. 6, 2022, nytimes.org, accessed Dec. 14, 2023, and Jack Nicas, "Chile's Voters Reject a New, Conservative Constitution," *New York Times,* Dec. 17, 2023, nytimes.org, accessed Dec. 30, 2023.

5. Vessel *Esmeralda* information was accessed at Tall Ships America, tallshipsamerica.org, on Sept. 4, 2022. On Dec. 14, 2023, Esmeralda's information is on Sail Training International, sailtraininginternational.org. Also see Buque Escuela "Esmeralda," www.esmeralda.cl, accessed Jan. 1, 2024.

6. Jessica Law, "Red List 2020: Andean Condor Heads List of Raptors in Steep Decline," Society for the Protection of Nature in Lebanon, Dec. 15, 2020, spnl.org, accessed Dec. 14, 2023.

7. Carol A. Olsen, "Esmeralda's Condor Figurehead," Aug. 11, 2021, hullartships.com.

8. Joseph Stromberg, "The Capsule That Saved the Chilean Miners," *Smithsonian Magazine,* Jan. 2012, smithsonianmag.com, accessed Dec. 14, 2023.

9. "List of Harland and Wolff Ships," theyard.info, accessed Mar. 22, 2024.

10. "Victoria (r. 1837–1901)," The Royal Archives, royal.uk, accessed Dec. 14, 2023.

11. The Royal Titles Act (39 & 40 Vict, c.10). Oxford Reference, oxfordreference.com, accessed Jan. 7, 2024.

12. Eduardo Rivera Silva, curator, Museo Maritimo Nacional, email to the author, Mar. 13, 2024.

Bibliography

FILM, VIDEO, RECORDINGS

Arévalo, Hugo, director. *Una Casa en la Arena*. Accesssed at outube.com, 16:14, Aug. 12, 2022.

Mantell, Harold author. *Yo soy Pablo Neruda*. 1967. Produced by Harold Mantell Inc., New York. Hugh M. Hefner Moving Image Archive, USC School of Cinematic Arts. Accessed at vimeo.com, Aug. 20, 2022.

Neruda, Pablo. *Alturas de Machu Picchu*. Recorded June 22, 1966. Library of Congress, Archive of Hispanic Literature on Tape, LOC Recording Laboratory, Studio B. tem 93842532. Accessed at Library of Congress website, loc.gov, Aug. 12, 2022.

University of San Diego Extended Studies. "*Reverse Engineering the Star of India—3D Scanning in Action*." Accessed at youtube.com, 43:21, Apr. 9, 2024.

MANUSCRIPT COLLECTIONS

Fernando Alegría Papers, Online Archive of California, oac.cdlib.org.

Carl Everingham Collection. MS160 Box 1. The Mariners' Museum Library.

Pablo Neruda Foundation documents for shipping a figurehead:

Antonio Sapunar Ojeda (as owner of the shipwreck, certifying the provenance of the figurehead);

Antonio Peruzovic (person authorized to ship a figurehead north)

Martinovic & Barria Limited (import representation company)

Galdames & Bargetto (custom agents)

Belisario Garcia (mention in authorization to remove figurehead)

Pablo Neruda Foundation documents for shipping Guillermina:

Emilio Oviedo's Sept. 25, 1966, typed and signed letter to Pablo Neruda from the Lima office of the Embassy of Chile conveys information about the expected airfreight arrival on Sept. 25, 1966, in Cerillos, Chile, of the Guillermina figure. The carving is to reach Neruda soon afterward. An image of the letter is attached to Javier Ormeño Bustos's email to the author on Sept. 26, 2017.

Pablo Neruda Foundation personal correspondence:

From "Norge," Aug. 14, 1968, letter mailed from 06 St. Paul de Vence, France, to Pablo Neruda calling him the most magic of figures of the prow.

Other Correspondence:

Rivera Silva, Eduardo. Email to the author, Mar. 21, 2024.

PHOTOGRAPHY COLLECTIONS

Pablo Neruda Foundation, Isla Negra and Santiago, Chile.

The Mariners' Museum, and Park, Newport News, Virginia. Figureheads of Ships VM308F47 folio containing photo of vessel *Iris*.

State Library of South Australia, A.D. Edwardes Photo Collection. Photographs of *Lonsdale* and *Langdale*.

ORAL SOURCES

Hausner, Beatriz. Hausner, regarding "Woman Holding Hair" figurehead. Interview with the author, Sept.2017.

Espinoza, Mrs. Marta, regarding Micaela figurehead. Interview with Javier Ormeño Bustos, Nov. 2017.

Garreton, Ricardo, conservator, regarding treatments to Neruda figureheads. Interviewed with Javier Ormeño Bustos, 2016.

Pollet, Christophe, Institute of Nautical and Subaquatic Archaeology, Santiago, Chile, regarding Punta Arenas and other shipwreck investigations. Interview with the author, Sept. 2017.

WRITTEN SOURCES BY PABLO NERUDA

Neruda, Pablo. *Canto General*. Translated by Jack Schmitt. Berkeley: University of California Press, 1991. First published by Talleres Gráficos de la Nacion, 1950, Mexico.

———. *The Captain's Verses. Love Poems*. Translated by Donald D. Walsh. New York: New Directions Books, 2004.

———. "El Olor del regreso." Vistazo, Santiago, Chile, no. 12 (Nov. 11, 1952). Written Oct. 22, 1952. Translated by Javier Ormeño Bustos, Aug. 10, 2017, for research purposes for this book.

———. *The House in the Sand*. Translated by Dennis Maloney and Clark M. Zlotchew. Buffalo, NY: White Pine Press, 2004. Originally published as *Una casa en la arena*. Barcelona: Lumen, 1966.

———. *Isla Negra: A Notebook*. Translated by Alastair Reid. New York: Farrar, Straus and Giroux, 1981. Originally published in Spanish as *Isla Negra* by Editorial Losada, S.A. 1964, Buenos Aires.

———. Memoirs. Translated by Hardie St. Martin. New York: Farrar, Straus and Giroux, 1977.

———. "Nobel Lecture: 'Towards the Splendid City.' Delivered Dec. 13, 1971." Accessed at nobelprize.org, Aug. 12, 2022.

———. *100 Love Sonnets (Cien Sonetos de Amor)*. Translated by Stephen Tapscott. Austin: University of Texas Press, 1996.

———. "Pablo Neruda, The Art of Poetry no. 14." Translated by Ronald Christ. *The Paris Review* no. 51, Winter 1971. Accessed at parisreview.org., Feb. 10, 2017.

———. *Selected Odes of Pablo Neruda*. Translated by Margaret Sayers Peden. Berkeley, CA: University of California Press, 1990. Originally published as *Odas Elementales*. Buenos Aires: Losada, 1954.

———. *Twenty Love Poems and a Song of Despair.* Translated by W. S. Merwin. Mineola, NY: Dover, 2006. Originally published as *Veinte Poemas de Amor y una Canción Desperada* in Chile in 1924.

———. *Una Casa en la Arena.* Photographs by Sergio Larrain. Barcelona: Lumen, 1971. Original 1966 publication included photographs taken from 1957 to 1966. In the 1971 republication, Jenny Lind, Sir Henry Morgan, and Guillermina were added, and Milton Rogvin was the photographer.

OTHER WRITTEN SOURCES

Allyn, Nancy Elizabeth. "Defining American Design: A History of the Index of American Design, 1935–1942." Master's thesis, University of Maryland, 1982.

Amich Bert, Julian. *Mascarones de Proa y Exvotos Marineros.* Spain: Argos, 1949.

Armenti, Peter. "How the Library of Congress Helped Get Pablo Neruda's Poetry Translated into English." From the Catbird Seat: Poetry & Literature at the Library of Congress, July 31, 2015. Accessed at blogs.loc.gov/catbird/, Aug. 18, 2022.

———. *Mary Celeste: The Greatest Mystery of the Sea.* Harlow, UK: Longmans Education Ltd., 2007.

Blumberg, Jess. "*Abandoned Ship: The* Mary Celeste.*" Smithsonian Magazine* Nov. 2007. Accessed at smithsonian.com, Aug. 12, 2022.

Board of Trade Wreck Report for 'Indian Chief,' 1881, Transcription No. 925. Accessed at plimsoll.org, Sept. 8, 2017.

Boyle, R. J., et al. *William Rush American Sculptor.* Philadelphia: Pennsylvania Academy of the Fine Arts, 1982.

Brewington, Marion V. *Shipcarvers of North America.* New York: Dover, 1972.

Bunting, W. H. *Portrait of a Port: Boston, 1852–1914.* Cambridge, MA: Belknap Press, 1994.

Chapman, Peter. *Bananas How the United Fruit Company Shaped the World.* Edinburgh, Scotland: Canongate, 2007.

Chotner, Deborah, et al. *Drawing on America's Past, Folk Art, Modernism, and the Index of American Design.* Washington, DC: National Gallery of Art, 2002.

Clark, Arthur H. *The Clipper Ship Era, An Epitome of Famous American and British Clipper Ships, Their Owners, Commanders, and Crews, 1843–1869.* Camden, ME: G. P. Putnam's Sons, 1910.

Collard, Ian. *Pacific Steam Navigation Company Fleet List & History.* Stroud, Gloucestershire, UK: Amberley Publishing, 2014.

Congressional Edition, House Document 58–16, Serial Set 4669, *Thirty-fifth annual list of merchant vessels of the United States, for the year ended June 30, 1903.* Washington, DC: Government Printing Office, 1903. Accessed at Google Books, Sept. 6, 2017.

Cordingly, David. *Under The Black Flag: The Romance and the Reality of Life among the Pirates.* New York: Random House, 2006.

Costa, Giancarlo. *Figureheads: Carving on Ships from Ancient Times to the Twentieth Century.* Great Britain: United Nautical Publishers, 1981.

Dawes, Greg. *Verses against the Darkness: Pablo Neruda's Poetry and Politics.* Lewisburg, PA: Bucknell University Press, 2006.

Dunsmure, Sarah Jenny. *Jenny Lind: The Story of the Swedish Nightingale*. United Kingdom: RedDoor, 2015.

Edwards, Jorge. *Adiós, Poeta . . . Pablo Neruda y su tiempo*. Translated in part by Javier Ormeño Bustos. Barcelona: Tusquets Editores, SA, 2004.

Edmundson, William. *A History of the British Presence in Chile from Bloody Mary to Charles Darwin and the Decline of British Influence*. New York: Palgrave Macmillan, 2009.

Eisner, Mark. *Neruda: The Poet's Calling*. New York: Ecco, 2018.

Ercilla y Zúñiga, Alonso de. *The Araucana*. Translated by Charles Maxwell Lancaster and Paul Thomas Manchester. Nashville, TN: Vanderbilt University Press, 2014.

Ericksen, George E. *Geology and Origin of the Chilean Nitrate Deposits*. Geological Survey Professional Paper 1188, U.S. Department of the Interior, Washington, DC, 1981. Prepared in cooperation with the Instituto de Investigaciones Geológicas de Chile.

Exquemelin, Alexander. *The Buccaneers of America: A True Account of the Famous Adventures and Daring Deeds of Sir Henry Morgan and Other Notorious Freebooters of the Spanish Main*. Pantianos Classics, 1914.

Feinstein, Adam. *Pablo Neruda: A Passion for Life*. UK: Bloomsbury, 2005.

Fernandez Illanes, Samuel. *Testimonios sobre Pablo Neruda durante su embajada en Francia*. Santiago, Chile: RIL Editores, 2004.

Fetherling, Douglas, and Victoria Brooks, eds. "Pablo Neruda: Recollecting the Collector in Chile." In *Literary Trips: Following in the Footsteps of Fame*. vol. 2: 233–43. Vancouver, BC: GreatestEscapes.com, 2001. Accessed at Google Books, Aug. 24, 2022.

"Fire on a Barque." *Newcastle Morning Herald and Miners Advocate*, Mar 16, 1910. This article was made available by the State Library of South Australia, Adelaide, Australia.

Flood, Alison. "Nobel Winner Pablo Neruda Was Almost Denied Prize Because of Odes to Stalin." *The Guardian*, Jan. 5, 2022. Accessed at theguardian.com, Sept. 10, 2022.

Focke, Cindy Butler. "Victims and Life-savers Continue to be Honored after Norwegian Shipwreck off Virginia Beach in 1891." *Virginian-Pilot*, Mar. 27, 2017. Accessed at pilotonline.com, Aug. 14, 2022.

Frere-Cook, Gervis, ed. *The Decorative Arts of the Mariner*. Boston: Little Brown, 1966.

Fried, Frederick. *Artists in Wood: American Carvers of Cigar-Store Indians Show Figures, and Circus Wagons*. New York: Random House, 1970.

Garreton, Ricardo, Paula Ugarte, and Carolina Aguero. Unpublished "Technical Restoration Report." Isla Negra: Pablo Neruda Foundation, 1989.

Goodall, John. *Parish Church Treasures: The Nation's Greatest Art Collection*. London: Bloomsbury Continuum, 2015.

Goode, George Brown. *The Fisheries and Fishery Industries of the United States, Section V History and Methods of the Fisheries, Volume II*. "Narrative of an Antarctic Sealing Voyage in the ship Neptune 1796–1799," 460–63. London: Forgotten Books, 2018. Originally published Washington, DC: 1887.

———. *The Fisheries and Fishery Industries of the United States, Section V: The Deck Plan and Seectional Plan of Whaling Bark Alice Knowles of New Bedford, Massachusetts, Volume II.* Plates 189 and 234.

Greenhill, Basil, and John Jackman. *The Grain Races: The Baltic Background.* London: Conway Maritime Press, 1986.

Guernsey, Clara F. *The Merman and The Figure-Head: A Christmas Story.* Philadelphia: J. B Lippincott & Co., 1871.

Hamilton, Georgia W. *Silent Pilots,* Mystic, CT: Mystic Seaport Museum, 1984.

Hansen, Hans Jürgen. *Galionsfigüren.* Munich: Stalling Verlag GmbH, 1979.

Hansen, Hans Jürgen, and Clas Broder Hansen. *Ships' Figureheads.* Pennsylvania: Schiffer Publishing, 1990.

Hasluck, Paul N., ed. *Manual of Traditional Wood Carving.* Mineola, NY: Dover, 1977.

Hibbett, Christopher. *Queen Victoria: A Personal History.* London, HarperCollins, 2000.

Hicks, Brian. *Ghost Ship: The Mysterious True Story of the Mary Celeste and Her Missing Crew.* New York: Ballantine Books, 2004.

Hollet, David. *From Cumberland to Cape Horn: The Sailing Fleet of Thomas & John Brocklebank of Whitehaven and Liverpool 1770–1900.* London: Fairplay Publications, 1984.

Honour, H. "America as Seen in the Fanciful Vision of Europe," *Smithsonian* 6 no. 11 (Feb. 1976): 54–59.

———. "Canova's Statues of Venus." *Burlington Magazine* 114, no. 835 (Oct. 1972) 658–71. Accessed at burlington.co.uk, Nov. 16, 2023.

Hornung, Clarence P. *Treasury of American Design and Antiques, 2 Volumes in 1: A Pictorial Survey of Popular Folk Arts Based on Watercolor Renderings in the Index of American Design, At the National Gallery of Art.* New York: Harry N. Abrams, 1972.

Howe, Octavius T., and Frederick C. Matthews. *American Clipper Ships 1833–1858,* vols. 1 and 2. Mineola, NY: Dover, 1986. Originally published as Publications of the Marine Research Society, Salem, Massachusetts, 1926–27.

Hubbard, J. Niles. *An Account of Sa-Go-Ye-Wat-Ha or Red Jacket and His People, 1750–1830.* Albany, NY: Joel Munsell's Sons, 1886.

Hunt, Clare. "Indian Figureheads: Carvings from Royal Navy Ships Built at Bombay." *The Mariner's Mirror* 108, no. 3 (Aug. 2022): 306–22.

Jensen, Ole Lisberg. *Figurehead and other Ship Ornaments at the Maritime Museum of Gothenburg.* Translated by Elisabeth Pålsson. Gothenburg: 1984.

Klein, Naomi. *The Shock Doctrine: The Rise of Disaster Capitalism.* New York: Henry Holt, 2007.

Knoblock, Glenn A. *The American Clipper Ship, 1845–1920: A Comprehensive History, with a Listing of Builders and Their Ships.* Jefferson, NC: McFarland, 2014.

Laughton, L. G. Carr. *Old Ship Figure-Heads and Sterns.* New York: Burt Franklin, 1973. Originally published London: Halton & Company, 1925.

Lipman, Jean H. *American Folk Art in Wood, Metal, and Stone.* Courier Corporation, 1972. Originally published by Pantheon in 1948.

Lubbock, Basil. *The Coolie Ships and Oil Sailers.* Glasgow, Scotland: Brown, Son & Ferguson, 1955.

MacLean, Duncan. *Clipper Ships and Packets 1851–1853.* Log Chips, Washington, D.C. 1952. Written 1851–1853 for *The Atlas of Boston.* Originally published by John Lyman.

Martinic B., Mateo. "Mascarones del Mar Magallanico." Department of History and Geography, History Section, Institute of Patagonia, Punta Arenas, Chile, July-Aug. 1980, 379–87.

Martinez, Brett. "Neruda y el mascarón de proa de Puerto Cabello." *Imagen,* no. 32. Caracas. Jan. 25, 1972 / Feb. 1, 1972, 1007.

Mason, Adelbert. *Herald Before the Mast: The Life and Works of John W. Mason, 19th Century Shipcarver.* New Brunswick, ME: Audenreed Press, 1999.

Maxwell, William, ed. *The Virginia Historical Register, and Literary Notebook.* "Jenny Lind's Concert." Vol. IV for the year 1851, 55. Richmond, Virginia: Printed for the Proprietor by MacFarlane & Fergusson, 1851. Accessed at Google Books, Dec. 4, 2023.

Maynard, Joyce. "In Chile, Where Pablo Neruda Lived and Loved." *New York Times,* Dec. 16, 2015.

McDonnell, Patrick J. "Whale Sightings Off Chile Raises Hopes." *Los Angeles Times,* Apr. 28, 2008. Accessed at latimes.com, Nov. 16, 2023.

McKay, L. [Lauchlan]. *The Practical Ship-Builder: Containing the Best Mechanical and Philosophical Principles for the Construction of Different Classes of Vessels, and the Practical Adaptation of Their Several Parts, with the Rules Carefully Detailed.* New York: Collins, Keese and Co., 1839.

McKay, Richard C. *Some Famous Sailing Ships and Their Builder, Donald McKay.* New York: G. P. Putnam's Sons, 1928.

Moriarty, Catherine. "'The Museum Eye Must Be Abandoned': Figureheads as Popular Art." *Sculpture Journal* 24, no. 2 (2015): 229–48.

Montes, Hugo. *Machu Picchu en la Poesía de Pablo Neruda.* Santiago, Chile: Hugo Montes Brunet, 2009.

Moonan, Wendy. "The Auction Block is the Next Step for a Well-Traveled Lady." *New York Times,* Jan. 4, 2008. Accessed at nytimes.com, Nov. 16, 2023.

National Maritime Museum (Great Britain). *"Valhalla" the Tresco Ships' Figurehead Collection* (Outstations Series). Greenwich, England: Natonal Maritme Museum, 1984.

Negre, Pierre Lucien. *Décorations & Figures de Proue: Histoire, Symboles, Legendes.* France: Rupella, 1989.

"The New Packet Ship Commodore Perry." *Boston Daily Atlas,* Sept. 30, 1854. Transcribed by Lars Bruzelius. Accessed at Bruzelius.info, Aug. 19, 2022.

Newark Museum. Exhibit Catalogue, no. 2. Newark, 1931.

Nicas, Jack. "Chile's Voters Reject a New, Conservative Constitution," *New York Times,* Dec. 17, 2023. Accessed at nytimes.com, Dec. 30, 2023.

———. "Chile Soundly Rejects Proposed Constitution's Broad, Bold Changes." *New York Times,* Sept. 25, 2022, A8.

———. "Chile Says 'No' to Left-Leaning Constitution After 3 Years of Debate," *New York Times,* Sept. 4, 2022, updated Sept. 6, 2022. Accessed at nytimes.com, Dec. 14, 2023.

———. "Was Neruda Poisoned?" *New York Times,* Feb. 15, 2023. Accessed at nytimes.

com, Nov. 16, 2023. A version of this article appears in print on February 16, 2023, Sec. A, Page 10, of the New York edition as "Inquiry Ends on Mystery Over Neruda's Death Amid 1973 Chilean Turmoil."

Northend, Mary H. "The Garden of Figureheads." *International Studio*, Sept. 1922, 505–8.

Norton, Peter. *Figureheads*. Greenwich: National Maritime Museum, 1972.

Olsen, Carol A., "The Bengtsson Figurehead Collection: Selected Images from the Gunnar and Majlis Bengtsson Figurehead and Drawings Collection at The Collector's Hotels in Stockholm, Sweden." Unpublished manuscript, 2015.

———. "Dragon Racing: A 2000-Year-Old Tradition flourishes in Hong Kong." *Sea History*, Summer 1989, 36–37.

———. "Fishing Vessel's Spiritual and Protective Dove Emblem." Hullartships.com, Dec. 22, 2022.

———. "Literary Masterpieces in Wood." *Sea History* (Summer 2002): 15–18.

———. "Nineteenth and Twentieth Century Figureheads from the Mystic Seaport Museum Collection." Master's thesis, Texas A&M University, 1984.

———. "Political Figureheads." Hullartships.com, Mar. 30, 2021.

———. "Red Jacket Legacy." Hullartships.com, Dec. 12, 2020.

———. "Stylistic Developments of Ship Figureheads of the United States East Coast," *International Journal of Nautical Archaeology and Underwater Exploration* 8, no. 4 (1981): 321–32.

Oviedo, Emilio. "El Amigo Pablo." *Revista Hoy* (Edición extraordinaria: November 1979): 28–29. Accessed at Pablo Neruda Foundation website, funducionneruda.org, Sept. 5, 2022.

"Pablo Neruda se Llevara La Proa De un Viejo Velero." *El Nacional* (Venezuela), Feb. 27, 1959.

Pastene, Luis A., and Daniel Quiroz. "An Outline of the History of Whaling in Chile." Accessed at academia.edu, Sept. 7, 2017.

Peters, Andrew. *Ship Decoration 1630–1780*. Great Britain: Seaforth Publishing, 2013.

Peterson, William. "Campbell and Colby: Shipcarvers at Mystic Seaport." *The Log of Mystic Seaport* 29, no. 3 (Oct. 1977): 66–71.

Philbrick, Nathaniel. *In the Heart of the Sea: The Tragedy of the Whaleship Essex*. London: Penguin, 2001.

Pinckney, Pauline A. *American Figureheads and Their Carvers*. New York: Norton, 1940.

Pulvertaft, David. *The Warship Figureheads of Portsmouth*. Stroud, Gloucestershire, UK: The History Press, 2009.

Recht, Mike. "Antique Dealer Tries to Restore Ship Figurehead." Southcoasttoday.com, July 5, 1999, updated July 11, 2011.

Rubilar Solis, Luis. "El Nombre de la Rosa en La Poesia de Pablo Neruda." *Literatura y Lingüistica* no. 12 (2000): 21–42.

Schidlowsky, David. *Neruda y su tiempo: las furias y las penas—tomo 2 1950–1973*, vol. 2. 1st ed. Santiago de Chile: RIL Editores, 2008.

Schroeder, John H. *Matthew Calbraith Perry: Antebellum Sailor and Diplomat*. Annapolis: Naval Institute Press, 2001.

Schultz, Eric B., and Michael J. Tougias. *King Philip's War: The History and Legacy of America's Forgotten Conflict.* Woodstock, VT: Countryman Press, 1999.

Sessions, Ralph. *The Shipcarvers' Art: Figureheads and Cigar-Store Indians in Nineteenth-Century America.* Princeton, NJ: Princeton University Press, 2005.

———. "The Shipcarver's Art: Figureheads in Nineteenth-Century New York and Boston." *Folk Art* (Summer 2005): 44–51.

Shaw, Capt. Frank H. *Seas of Memory.* London: Oldbourne Book Co., 1958.

Shoemaker, Nancy. *Native American Whalemen and the World: Indigenous Encounters and the Contingency of Race.* Chapel Hill: University of North Carolina Press, 2015.

Skogsjö, Håkan, *The Åland Maritime Museum.* Translated by Peter Andersson. Finland: Åland Maritime Museum, 1991.

State Street Trust Company. *Some Ships of the Clipper Ship Era, Their Builders, Owners, and Captains.* Boston: Walton Advertising and Printing Company, 1913. Accessed at Archive.org, Nov. 28, 2023.

Stone, William Leete. *Life and Times of Red-Jacket, Or Sa-go-ye-wat-ha: Being the Sequel to the History of the Six Nations.* New York: Wiley and Putnam, 1841. Accessed at Google Books, Apr. 28, 2017.

"Surrender of Chief Joseph of the Nez Perces Indians." (Oneida, NY) *American Socialist,* Oct. 25, 1877. Accessed at tarenewspapers.com, Sept. 8, 2017.

Teitelbaum, Volodia. *Neruda: An Intimate Biography.* Translated by Beverly J. DeLong-Tonelli. Austin: University of Texas Press, 2013.

Thomas, P. N. *British Figurehead & Ship Carvers.* Albrighton, England: Waine Research Publications, 1995.

"Twixt Fire and Flood: Crew's Escape From a Burning Ship." *Brisbane QLD,* Mar. 25, 1910, 23.

Urrutia, Matilde. *My Life with Pablo Neruda.* Translated by Alexandria Giardino. Stanford, CA: Stanford University Press, 2004.

Vaughn, Alden T. *Transatlantic Encounters: American Indians in Britain, 1500–1776.* New York: Cambridge University Press, 2006.

Wachsmann, Shelley. *Seagoing Ships & Seamanship in the Bronze Age Levant.* College Station: Texas A&M University Press, 1998.

Wasson, David A. "The Silent Pilots." (New York) *The Outlook,* Jan. 27, 1915, vol. 109, no. 4: 206–13.

Wiburd, C. R. "Notes on the History of Maritime Quarantine in Queensland, 19th Century." *Journal of the Royal Historical Society of Queensland* 3, no. 5: 269–83.

Wilde, Oscar. *The Picture of Dorian Gray.* First published in *Lippincott's Monthly Magazine,* July 1890.

"The Wreck of the Castle Derry: The Sufferings of the Crew." (Dunedin, New Zealand) *Otaga Witness,* Sept. 30, 1887, 20.

"Wreck of the Castle Derry: 15 Lives Lost." (Dunedin, New Zealand) *Otaga Witness,* Oct. 7, 1887, 16. Papers Past, National Library of New Zealand. Accessed at Paperspast.natlib.govt.nz, Aug. 24, 2022. Originally published in (Melbourne, Victoria) *The Argus,* Sept. 23, 1887, 6.

Zisman, Alex. "An interview with Ludwig Zeller." Translated by Dallas Gavin. *Review: Literature and Arts of the Americas* 11, no. 21–22 (Fall/Winter 1977): 167–74. Accessed at Taylorandfrancis.com, Nov. 30, 2023.

ADDITIONAL ONLINE SOURCES

"Adelina Patti." The Library of Nineteenth-Century Photography. Accessed at 19thcenturyphotos, Nov. 14, 2023.

"American Indians as Symbols/Icons." Accessed at encyclopedia .com, Dec. 9, 2023.

"Buildings Shake in Valparaiso, Chile After 8.3 Magnitude Earthquake," *The Guardian,* Sept. 16, 2015. Accessed at theguardian.com, Dec. 9, 2023.

"CHILE: Torture and the Naval Training Ship the 'Esmeralda,'" June 25, 2003. Accessed at amnesty.org, Dec. 10, 2023.

"Derry Castle: A Tragedy Immortalized." Accessed at home.rootsweb.com, Dec. 9, 2023.

Evans, Zteve T. "El Caleche: The Ghost Ship of Chilote Mythology." Folk Realm Studies. Word Press, Dec. 1, 2015. Accessed December 9, 2023.

"Figurehead from Clipper Ship 'Glory of the Seas' carved by Herbert Gleason in Boston 1869." *Hyland Granby Antiques* (website). Accessed December 8, 2023.

Inter-American Commission on Human Rights (IACHR). "Findings of 'On the Spot' Observations in the Republic of Chile, July 22–August 2, 1974." Accessed at *"List of Harland and Wolff Ships,"* theyard.info, Mar. 22, 2024.

Iredale, Thomas P. "Biography of Peter Iredale." Accessed at Iredale.de, Sept. 14, 2017.

"J. D. Newton's Dale Line." Accessed at mightyseas.co.uk, Dec. 8, 2023.

Leroy, Thibault, Christophe Plomion, Antoine Kremer. "Oak Symbolism in the Light of Genomics," *New Phytologist* 226, no. 4 (June 10, 2019) 1012–1017. Accessed at nph.onlinelibrary.wiley.com/journal/14698137, Jan. 14, 2024.

Longfellow, Henry Wadsworth. "The Building of the Ship." Accessed at poetryfoundation.org, Dec. 7, 2023.

"Mary Celeste Memorial—Spencer's Island, Nova Scotia." Accessed at lost-at-sea-memorials.com (website), Dec. 8, 2023.

"May 22, 1960 CE: Valdivia Earthquake Strikes Chile." Accessed at nationalgeographic.com, Dec. 8, 2023.

"M8.3 Earthquake Strikes Off Coast of Illapel, Chile, Tsunami Alert Issued." CGTN, YouTube. September 16, 2015. Accessed on Dec. 9, 2023.

"NH 115258 Wooden figurehead from USS DELAWARE of Tamanend, Chief of the Delaware Indians (D. 1693)." Accessed at the Naval History and Heritage Command website, history.navy.mil, Dec. 9, 2023.

"The Nobel Prize in Literature, 1945, Gabriela Mistral." Accessed at nobelprize.org, Jan. 12, 2024.

"Prima donna." Accessed at merriam-webster.com, Jan. 12, 2024.

"Red Jacket." Accessed at bruzelius.info, Dec. 9, 2023.

"Report of the Chilean National Commission on Truth and Reconciliation." Accessed at the United States Institute of Peace website, usip.org, Dec. 10, 2023.

"Ring of Fire." Accessed at education.nationalgeographic.org, Nov. 14, 2023.

"The Royal Titles Act" (39 & 40 Vict. c.10). Accessed at oxforderfernce.org, Jan. 7, 2024.

"A sailor's life—22. The nitrate coast, Chile, 1912." Accessed at Lost at sea website, monkbarns.wordpress.com, Dec. 8, 2023.

"Scottish Built Ships, The History of Shipbuilding in Scotland." Accessed at Caledonian Maritime Research Trust website, www.clydeships.co.uk, Nov. 14, 2023.

Shakespeare, William. *Henry VIII, scene* 3, act 2, line 526. Accessed at folger.edu, Dec. 9, 2023.

US Department of State, Office of the Historian. "The Allende Years and the Pinochet Coup, 1969–1973." Accessed at history.state.gov, Dec. 9, 2023.

"Venus Italica sculpture, Antonio Canova workshop, c.1822–23." Accessed at metmuseum.org, Dec. 8, 2023.

Watt Library Newspaper Ship Index. Accessed at Inverclyde.gov, Dec. 6, 2023.

Whalemen's Shipping List and Merchants' Transcript, September 20, 1887. Accessed at mysticseaport.org, Dec. 6, 2023.

"The Wreck of the Peter Iredale." Accessed at oregonhistoryproject.org, Dec. 8, 2023.

Index

Page numbers in italics refer to figures.